GREEK SCULPTURE
The Classical Period

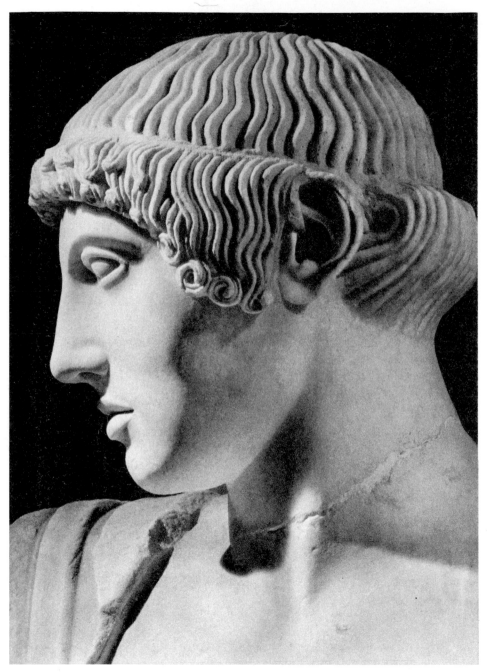

Olympia, Temple of Zeus. West Pediment. See *21.3*

GREEK SCULPTURE

The Classical Period

a handbook

JOHN BOARDMAN

412 illustrations

THAMES AND HUDSON

304232

ISBN 0500234191

Printed and bound in Hungary

CONTENTS

Preface

This volume is a sequel to *Greek Sculpture, The Archaic Period* (hereafter *GSAP*) published in 1978. The intention had once been to include in it an account of Greek sculpture in the colonies as well as that of the Early Classical period, but it has seemed better to deal only with the Greek homeland, and to embrace all the remaining fifth century BC, which includes the prime period of Classical sculpture in the commonly accepted use of the term. Within these years Greek sculptors refined their techniques and confirmed their ability to create realistic images of the human body, in action or repose, without surrendering their profound concern with proportion and design. Later centuries explored realism further, and the Roman admiration for all things Greek ensured that the idiom remained central to the future development of Western art. The familiarity of the idiom does not make it easier for us to understand or appreciate. We do well to remind ourselves that in this century and in Greece, for the first time in the history of man, artists succeeded in reconciling a strong sense of form with total realism, that they both consciously sought the ideal in figure representation, and explored the possibilities of rendering emotion, mood, even the individuality of portraiture. It marks a crucial stage which determined that one culture at least in man's history was to adopt a wholly new approach to the function and expression of its visual arts.

This was a period of anxiety and excitement throughout the Greek world. It saw the threat of conquest by Persia, a democracy – Athens – creating an empire and then losing it. In Athens Aeschylus, Sophocles, Euripides and Aristophanes wrought their versions of Greek myth-history to counsel and entertain the citizenry. History, in the real sense of the word, was born, and a philosophy which explored the working of man's intellect and not only of the world around him. So far as they could, the visual arts too answered the mood of the day, but their message is less clearly read than the texts of philosophers, historians and poets, and far more difficult to comprehend.

Our evidence for the fifth century is so different from that for the Archaic period that part of the first chapter has been devoted to sources. It will help explain why, in one respect, this book is not laid out in quite

7

the manner of most text-books on Greek sculpture. In these chapters I have rigorously segregated Roman copies (presumed) of Classical statues, except where their fifth-century originals can certainly or almost certainly be identified. Attempts at such identification with a particular statue are generally found to depend on the barest mention of a work whose subject and apparent fate seem to fit, and attributions to named sculptors depend on mainly subjective criteria which are themselves derived from equally suspect identifications. Not surprisingly, there is virtually never agreement over a single piece and the likelihood of consensus over most of them lessens all the time. It is, of course, valuable to assemble, compare and identify the relationships of copies which appear to be based on a single original. But it is the deductions from such studies, leading to attributions which are then used to demonstrate the development and history of Classical sculpture, that suddenly remove the subject from the reasonably verifiable to the purely speculative and potentially misleading. The scholarly ingenuity and time spent on such attribution studies (*Kopienforschung*) seems to grow as the years pass, yet with diminishing returns, and is perhaps the oddest phenomenon in all Classical scholarship. Only major new finds bring new hope. It seems to me wrong that such guesses should be accorded a status comparable with that of discussion of original works, yet in some sculpture handbooks copies and originals are not even distinguished explicitly one from the other. It is very likely that lost works known only by name are to be identified in the many copies made for Roman patrons in Italy, the Empire and the Greek East, which have survived, and it is understandable that scholars should attempt such identifications, but with such general lack of agreement it may be safer to admit that we are still exploring the unknowable, and we impair a student's appreciation of original works by giving them undue prominence. We need be in no hurry to discover the whole truth, nor be too disappointed if it eludes us. It has been well remarked that the only copy [122] which in recent years has been positively identified as a result of the find of parts of its original had never been attributed by scholars to its true author. I would not, however, go to the further extreme, fashionable in some quarters, of seeing as late pastiches many generally accepted Classical originals and copies.

The original sculpture which has survived, however, is seldom the very best. From Olympia and the Parthenon we have what must surely be the best architectural sculptures of their period, but the very best work was in bronze and the few surviving examples do little more than remind us how much we miss. There were assuredly great works in marble, and some can still be admired, though seldom complete and always lacking their original colours. We are, as it were, trying to appreciate Shakes-

peare's genius as a playwright from *As You Like It*, some sonnets and Lamb's *Tales*.

The purpose of this volume, as with *GSAP*, has been to introduce to the student and general reader what evidence we have for the appearance and development of sculpture in the fifth century. A balance had to be struck between text, illustration and documentation to do justice to as much as could reasonably be fitted into the 252 pages of the volumes of this series. Figure captions therefore carry information which might have seemed otiose in the text. Measurements are in metres; the material is marble unless otherwise stated; dates are all BC. The photographs are numerous and some, perforce, small. They are supplemented by drawings made for this book by Marion Cox. Photographs of casts have been used where convenient. Casts record appearance accurately, without the blemish which often disfigures the original. And in a collection such as that of the Ashmolean Museum Cast Gallery at Oxford it is possible to dictate angle and lighting more freely than in most museums. There are good cast galleries in Britain, notably in Oxford and in Cambridge, and the interested reader may learn more from them than from the large plates of an art book. Studio lighting does not always best suit marble statues. For originals we turn especially, outside Greece itself, to the British Museum, to the Louvre, Berlin, Munich and Rome, while other museums of Europe and the United States are well supplied with Roman copies, but on these the modern restorer may have taken us even a stage further from the original than had the Roman copyist.

Chapter One

TECHNIQUES AND SOURCES

Techniques

The work of creating a life-size marble statue, from quarry block to a figure ready for display, is said to require the labour of one man-year. The material may not in antiquity have seemed particularly precious – Greece had mountains of fine white marble in Attica and the Islands – but quarrying it took some skill, and much time and labour. Greek sculptors had turned from the more easily worked limestones to marble in the seventh century B C, and by the fifth century most of their work in stone was in marble except where access to quarries posed problems or the appetite for the best in materials was not demanding. The major sculpture of other early cultures was sometimes of even harder material (granite or porphyry in Egypt), but not commonly white, nor, except for alabaster which was not often used for large figures, endued with the potential for translucency of marble. That the most accessible of durable stones for the Greek workshops had characteristics which lent themselves to the realistic imitation of human flesh may have played no small part in the direction, speed and success of developments in sculpture of Greek lands in the Classical period and later.

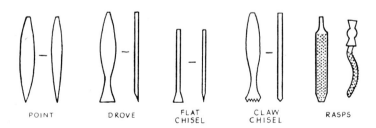

POINT DROVE FLAT CHISEL CLAW CHISEL RASPS

The techniques of carving marble were uncomplicated. Almost the full set of tools was in use within one hundred years of the adoption of the material. A new device was invented (the claw chisel), and the only significant progress was to be in the more imaginative use of the drill. The early techniques and tools are described in *GSAP* 18–20, 79–81. The

drill was used especially to deal with hollowed areas, notably folds in dress, but was used vertical to the plane being cut, simply to remove stone by grinding or to produce a line of holes which could be broken into a continuous groove by the chisel. Only later than the period described in this volume was the drill used at an angle to the stone surface to cut a continuous groove (the 'running drill'). Point and drove removed the larger, safe areas from the block; claw chisel, rasp and flat chisel worked towards the final surface which was finished by light abrasion. The Greek sculptor – indeed most Greek artists – took pains to remove traces of technique, and they are apparent only in obscure corners on fifth-century work where an all-round finish was generally sought. There are a few exceptions, however.

It is not easy to judge how fine a surface was left and it is generally held that high polish is the hallmark of the Roman period, not the Greek. Polished, waxed marble counterfeits human flesh marvellously but this was not an effect likely to be sought before the Hellenistic period, and even in the Classical period flesh parts of marble statues may have been painted over. We too readily project into Classical antiquity expectations about marble sculpture which have been formed by the practices of Renaissance and Neo-Classical artists, who saw Greek sculpture in polished Roman versions, stripped by time of any paint or accoutrements which might sully the pristine, breathing white. The observation of a highly polished area in a protected corner of a pedimental figure from the Parthenon might warn us about any generalizations on either finish or colour.

Hair, eyes, lips and dress were certainly painted on Classical marbles, and we are only less sure about whether or how often flesh parts might also have been tinted (sunburned men and gods, pale women and goddesses). Some equipment, especially weapons or harness, would have been added in bronze. Reliefs were given dark painted backgrounds, red or blue, but the background might also have been painted with insignia or details of setting and architecture, even parts of figure and dress which could not or need not be carved.

An exceptional type of marble statue is the acrolithic in which flesh parts – heads, hands, feet – are worked in marble and fitted to a wooden body (always missing, of course). There are a few examples in Classical Greece. The scheme is economical and may in part also be inspired by the more primitive practice of adorning a pillar with a head or mask and then dressing it (cf. *ARFH* fig. 311; and herms *GSAP* fig. 169). With this function in mind it might seem to have best served cult statues, which were often given ritual dress on festive occasions, but the few acrolithic pieces in Classical Greece are quite small, and the one colossal, an acrolith described by Pliny, the Athena Areia at Plataea by Phidias, had a gilt

wooden body. This is only economical to the extent that it did not employ ivory for the flesh parts, as did the great Classical chryselephantine cult statues, like the Athena Parthenos. We know something of smaller chryselephantine figures of the Archaic period (*GSAP* 80, 89, fig. 127) but in the Classical, as we shall see, we know even less than we do of the acroliths, but the discovery of the workshop in which Phidias made the chryselephantine Zeus for the temple at Olympia (see Chapter 4) has told us something about their technique. The studio matched the size of the temple interior (cella) in which the statue was to be placed, and the work must have been erected there for eventual reassembly in its final home. It appears that a jigsaw of fired clay moulds was prepared from a full-size model, on which sheets of gold could be pressed to their correct size and shape. It seems, then, that they were not fastened to a fully carved wooden body, which is what we might have expected, since this would have rendered the mould intermediaries unnecessary. Moulds were found for coloured glass inlays in furniture (the Zeus was enthroned) and dress, simple ivory tools for working gold and a goldsmith's hammer. Pausanias' description of the statue mentioned inlays of other metals, ivory, ebony and stone as well as figure-painting on the furniture. The floor before the statue was a shallow pool of oil, and there was a similar one of water in Athens before the Athena in the Parthenon. Both oil and water played their parts in the preservation of ivory (to fill pores and maintain humidity) and there were probably reflective properties too which were appreciated. In the corner of his workshop Phidias discarded an Athenian clay mug with 'I belong to Phidias' written on its base, an unexpected personal memento.

The finest Classical statues were executed in bronze. Techniques of hollow casting for life-size figures had been perfected by the end of the Archaic period (*GSAP* 81) but we lack scientific studies of most of the very few major bronzes surviving and some details of the process still escape us. Most large figures were cast in parts which were then brazed together: the Delphi charioteer [*34*] is in seven pieces – head, upper and lower torso, arms, feet. The technique was especially necessary for added spiral locks which could not easily be cast in one piece with a head: e.g. [*12*]. It was not impossible, however, to cast the whole figure by the direct method.

There were two methods of casting, both, it seems, practised in our period although not always easily identified and a lively debate on the matter continues. For casting by the direct method the figure was modelled in clay, if necessary on metal armatures. The surface was finished, with all the desired detail, in hard wax, and the whole then encased in clay. Core and mantle were held in position by pegs thrust through them and the wax melted out, to be replaced by molten bronze.

The mantle was then broken away and the core, if possible, chipped out. The finished work needed scraping down and polishing, blemishes patched, and there would often be need too for cold work with chisel and graver on the cast surface. The Late Archaic Piraeus kouros (*GSAP* fig. 150) was made this way, since its armatures and core were found still within it. It is doubtful whether a statue could easily be cast in pieces by the direct method since this would mean either cutting up the wax-covered model, which seems well-nigh impossible, or modelling each section separately, not as a whole, which could hardly either help or please the artist.

The alternative technique, the indirect method, works from the outside in, as it were. It involves taking piece-moulds from the completely modelled clay figure, coating the inside of the moulds with wax, reassembling them for the major parts to be cast, fitting a clay core and then proceeding to cast 'cire perdue' in the usual way. With this technique the original model survived and, probably, the piece-moulds. With the direct, there was no possibility of casting replicas, nor are any to be found in our period. Identification of the indirect method depends on observation of the inside of the finished bronze, to judge whether the wax, exactly replaced by the bronze, shows signs of having been applied from within. The evidence is sometimes equivocal since, if the original figure was carefully finished for direct casting, the wax sheets laid upon it might well present neat undersides, observable as the inner surface of the bronze. Fingerprints or drips in this position are decisive for the indirect method, smoothly jointed sheets are not. The indirect method seems attested for some Classical bronzes but if piece-moulds were used it is remarkable that the joints between the pieces were always so successfully worked away (compare the network of ridges on the surface of plaster casts of Classical statues, which mark the joins of piece-moulds and are not always smoothed away). Small bronzes were cast from solid wax models, 'cire perdue', but also sometimes from piece-moulds.

On the bigger statues eyes were inlaid with glass or stone; lips, nipples and teeth were distinguished from the body by inlays in ruddy copper or silver, which could also be used for decoration on dress. The body of the statue would appear bright and shining, its tone depending on the alloy used, ranging from red to brassy, which could be controlled. There is evidence in inscriptions for the continued attention of statue-cleaners and polishers in the big sanctuaries, and although the patina admired today may also have been appreciated on old bronzes by some Roman collectors, it was avoided and removed in the Greek period. The condition in which Roman bronzes were found, and Pliny's observation that, in his day, bronzes could be treated with bitumen, led to the production of black bronzes in the Renaissance and has ensured that this

appearance even for ancient bronzes remains more familiar to us than that intended by the Greek metal-worker.

The model for a bronze was fashioned in clay and wax to the size and detail of the desired finished statue, which was cast directly on or from it. The marble sculptor needed guiding to the form he was trying to release from a block of stone. We know, from unfinished statues, that the Greek sculptor worked from all sides of the block, so that any detailed drawings on its outer faces would have been destroyed immediately, and it is difficult to believe that they were redrawn on the increasingly irregular new surfaces as they appeared. He could have had full-size drawings of his figure to which he could refer and, for the simpler, symmetrical Archaic, this, or drawings on the block and the help of a grid determining the placing of important features, would have sufficed (see *GSAP* 20–1). For the more subtly posed figures of the Classical period such a process certainly would not have sufficed, and we must assume some sort of model in the round. That the statues were still designed basically for one viewpoint would not have much simplified the problem. The modern sculptor in stone making a Classical figure works from a full-size model made of clay or plaster. This figure can be read into a block of stone by measurements taken from a fixed grid or frame and transferred to the block by drilling in to the appropriate depth. This 'pointing' process was employed in the copyists' studios from the second century BC. It can be used also to enlarge or reduce from the dimensions of the model. No such complicated process was in use earlier but something similar might have been, measuring off details from a triangulation of points on the figure, which would have had to be translated to its near final surface in the block by other means. It has been suspected for the pedimental sculptures at Olympia, where also, however, it is likely that very detailed models were not used, or at least not life-size, since if they had, certain anatomical or drapery errors would have been avoided. We shall see that the Classical sculptor was much concerned with the mathematical, proportional accuracy of his figures, and the only way of controlling this in marble would have been to work from a full-scale model: the major bronzes, in which these principles of proportion were normally expressed, presented no such problems since their models were mechanically reproduced.

The marble statues were carved with their feet in one piece with a shallow plinth which was then set in a stone base and fastened by lead or clamps. A bronze statue had tenons cast or attached beneath the feet, which were slotted into the base block and set with lead.

Sources: original works

The development of Greek sculpture in the Archaic period could be demonstrated wholly in terms of surviving original works. Moreover, since there must have been relatively few major works in bronze, which could only exceptionally survive the attentions of metal-seekers, the surviving record is probably a fairly accurate one of the full range of quality, subject and style, and what we miss most is major works in wood which might have added something to our understanding, particularly of the early years.

From the fifth century we are still well supplied with major works in marble, especially architectural sculpture, but we know that the most important works, mainly individual dedications in sanctuaries or cult statues, were in bronze or precious materials. Remarkably few bronzes have survived – barely a dozen – and their high quality brings home how much poorer the record is on which we must judge the real sculptural achievements of our period. Few of the surviving bronzes are from controlled excavations [34, 138]; several have been recovered from wrecks of ships [35, 37–9] in which they were being carried in the Roman period to new homes, usually in Italy. Of those that reached their new homes none has survived: marble fares a little better. The plunder of Greek works of art by the Romans began by the end of the third century BC with booty from the Greek cities of South Italy, and from the second century on Greece too lay open to Roman cupidity. An imposing list of major works by named Greek sculptors which were exhibited in Rome can be drawn up from the pages of Pliny (1st century AD) and these represent a small proportion of the thousands of works plundered. A few anonymous marbles have survived [46, 133–4, 145, 153?].

In Greece itself most of the surviving original marbles are architectural, and most of these have been excavated over the last two hundred years, the only major complex perilously remaining mainly above ground having been that on the Parthenon. There are few other originals from the Acropolis where, as at Olympia and Delphi, the empty statue bases bear mute testimony to the many bronzes, since stolen or melted down.

Sources: copies

Another important but perplexing (see Preface) source of information about Classical sculpture is ancient copies. Artists were naturally inspired to reflect the appearance and style of major works in other media or at other scales [7–9, 64, 102, 185]. It is suspected that even by the end of the fifth century there was production of reduced versions of cult statues (see

p. 214) while the pose or details of major works could be mirrored in figures devised for reliefs or drawn on vases, or adjusted and abbreviated to decorate jewellery and coins. The concept of an exact replica, at the same or reduced size, did not come easily to the Classical artist, and the apparent exceptions are unusual and uncharacteristic. Since the originals are lost these approximations to, and echoes of, the major works are almost impossible to interpret, and they can never lead us to any particularly accurate idea of the appearance of their models.

This, however, we are vouchsafed by copies of a much later date. The Roman interest in collecting Greek originals led to a brisk trade also in copies of famous works. These could be in bronze but we know most of them in marble, which survives more readily, and it is these marbles that populate most museums outside Greece itself; not that they are lacking in Greece and the Near East, since the fashion spread rapidly throughout the Roman Empire, reviving significantly in periods of philhellene emperors like Hadrian.

The courts and temples of the Hellenistic kings, as at Pergamum, had been adorned with versions of Classical statues, but these were generally free essays in the Classical manner. The industry that served the Roman patrons produced copies as accurate as techniques and skills permitted. This might seem the saving of our subject, but there are problems. First, the copies are almost never specifically identified for us by inscription, and in this respect our best information comes from portrait-busts mounted as herms (like the Greek sacred pillars, GSAP fig. 169) and inscribed, as [188, 246], but the original was a whole figure, which we usually lack, and some portrait-herms carry demonstrably wrong or fanciful names.

Secondly, even fewer copies can be certainly identified from descriptions of them given in ancient authors, where we are commonly given no more than a name and a location. Thirdly, the detail and quality of the original are considerably impaired by the process of translating a bronze into a marble, quite apart from the irreparable loss of a master's finishing touch. Marble had not the tensile strength of bronze, hence the struts, pillars and tree-trunks introduced to strengthen the figures; e.g. [60, 62–3, 66–70, 72, 223, 227–37]. Pose may be adjusted for the same reason, and misunderstanding of the dress or attributes of the original could lead to misleading errors. Technical details may often betray the period in which the copies were made because they differ from the original treatment and from that of other periods of copying. Fourthly, heads or attributes could be transposed from one type to another, just as many a Classical type could be used as base for a Roman portrait head. When only one or two apparent copies are preserved these shortcomings must leave us very uneasy about their value as evidence for any Classical

16

original. Where several copies agree closely with each other in both size and detail we may feel more confident that they reflect an original with some accuracy. Finally, however, it is left to our own judgement whether the original of such copies was created in the Classical period, when, and even by whom. It is becoming increasingly clear that the Roman studios could turn out Classicizing pastiches which can only be detected through what we judge to be internal stylistic anachronisms or inconsistencies, or on technical grounds. There are many original works in a plausible Classical style in various media from the first century BC, and the 'Neo-Attic' studios in Greece produced relief-decorated vases and slabs with figures based on fifth-century originals, while elegant Archaising, swallow-tail folds and the like, became increasingly fashionable. These are all easy to detect, however. Greek artists working in Italy, like Pasiteles and Stephanus, could produce original works in the Classical style, and it is possible that we could sometimes be misled by statues and reliefs from their studios. It was sometimes the same or neighbour studios that were doing the copying of Greek originals, and the late creations and pastiches could themselves be copied.

There are two other miniaturist sources of copies of Classical figures. Statues of gods or heroes often formed the subject of intaglios for gem-stones of the first century BC and later. Some give finely detailed versions of heads [*103*], most are too small or too freely interpreted by the engraver to be of positive value, and they are never identified on the stone. Problems are posed too by Neo-Classical versions of the later eighteenth and nineteenth centuries which are sometimes very difficult to detect. And on Greek coinage of the Roman period famous local statues are sometimes represented: *GSAP* figs 125, cf. 126, 185; [*180–2, 207b*]. These have the merit of being easily placed, but a local moneyer was not bound to favour a local type, the scale is minute and detail minimal.

All these considerations have led to my cautious presentation of the evidence of copies, as explained in the Preface.

Bronze copies of statues could be made by casting from the original with piece-moulds in the indirect method, but this seems very rarely to have been practised. Marble copies were pointed off from full-size models. The technique was certainly practised from the second century BC, and a simpler version may have been employed even in the Classical period for making finished works from life-size or even reduced models (see above). Obviously, this could virtually never be done directly from the original statue, in sanctuary or market place, and the copyist worked from plaster casts like those in the teaching galleries of our universities. The casts were made from piece-moulds taken from the originals. Lucian has Zeus comment on the pitch smeared daily over a statue of Hermes in the Athenian Agora by sculptors preparing it for casting.

A remarkable find in 1952 at Baiae on the Bay of Naples has preserved scraps of casts from Greek original sculptures. These must have been used in the copyists' studios. They include pieces of a number of famous statues known to us otherwise only from marble copies (here [4] and pieces of our [187, 190–2, 202, 214, 234]) and give us the opportunity to draw direct, if sometimes trivial, comparisons between copy and original, such as we are very rarely allowed otherwise (exceptions – [122, 144]). They also include casts from original Greek statues otherwise wholly unknown to us although Roman marble copies (for which these casts had been made) may one day be identified [11]. It seems that the casts were reinforced by iron or wood armatures in the legs, with other parts of the body and dress stiffened by bone or straw. They show that on some figures the copyist had deliberately fleshed out the physique of the original. They reveal too details of work – how the eyelashes of a bronze were protected when the mould was made, leaving them lumpy on the cast [4], and how hollow folds and undercutting were plugged before moulding. The modern caster recognizes the techniques readily enough.

Sources: literature

No treatise by an ancient sculptor about his work has survived (e.g., Polyclitus' Canon: see p. 205) and no treatise dealing specifically with the history of sculpture. Contemporary literature is extremely reticent, and it is exceptional to find in Euripides' play *Ion* a character who is bothering to comment on the sculptural decoration of a temple in the set (supposedly at Delphi). From later periods there is some wealth of relevant asides – in Cicero (mid-1st century BC) in a period when Greek culture was highly fashionable in Rome; in the works of literary scholars like Quintilian (1st century AD) who sought analogies in the visual arts; in the wider ranging entertainments of essayists like Lucian (2nd century AD). The geographer Strabo (died AD 21 or later) could have told us more, but seldom bothers with more than names. But there are two major sources who between them account for most of the useful testimonia we can deploy.

Pliny the Elder, who died observing the eruption of Vesuvius in AD 79, wrote a *Natural History* which was in the nature of an encyclopaedia drawing on a wide variety of written sources (2,000 he said), including the Hellenistic treatises on art criticism. He lists his sources separately in an index but the remarks in his main text are not individually attributed. The most influential source is generally thought to be Xenocrates of Sicyon, a third-century writer. Pliny has a long section on bronze statues (Book 34.5–93) discussing material, types and the works of the principal

artists whom he dates by their floruit to Olympiads (periods of 4 years), defining studios and naming pupils. His descriptions of individual statues are laconic but occasionally assist in the identification of copies, and of more interest are the critical comments which he takes from his sources and which tell us what Hellenistic scholars thought of the achievements of Classical sculptors. This is not, of course, the same as the view which would have been taken in the very different world and society for which the sculptures had been created, and we are vividly aware of the intrusion of obfuscatory art-historical jargon. The short section on clay modelling (Book 35.151-8) and the comparatively short one on marble sculpture (Book 36.9-44) are presented in the same manner.

Pausanias is our other major source, writing a guide to Greece in the second century AD. He too used written sources, but probably with less discrimination than Pliny. He expresses his own view from time to time, but in his descriptions of sanctuaries and cities he is often very much at the mercy of what he was told by guides or priests, neither of them necessarily reliable repositories of accurate information. Sometimes he seems simply to have been careless. Where we can check his statements or descriptions by the sites or monuments he describes we often find them faulty. Where we cannot check them our only recourse is to be mildly suspicious at all times. In his descriptions of scenes his interpretation is, naturally enough, that of his own day, and we have to imagine what he saw, and attempt to reinterpret it in the light of the period in which it was made.

In the following chapters I mention, where appropriate, the literary sources for attributions or descriptions, by their authors' names (Paus., Pliny, etc.) but generally without further detail of the texts, which can be found in the various published compendia.

With so little contemporary evidence about artists surviving, except on inscribed bases from which the original statue has almost always escaped, we are forced to rely heavily upon sources like Pliny and Pausanias if we wish to put names to things or styles, even things or styles which we can only observe in what we take to be accurate Roman copies. But names are not everything; indeed, in the study of ancient art, they are next to nothing.

Chapter Two

EARLY CLASSICAL SCULPTURE: INTRODUCTION

The physical turmoil of Greek history in the early decades of the fifth century was answered in Greek art by what appears to be sure and steady progress, and the gradual changes in style encouraged effortlessly, it seems, a revolution in the sculptor's approach to his craft. This marks a turning point in Western art.

In less than a hundred and fifty years the Greek sculptor had perfected his technical command of the medium in which most of the finest Archaic sculpture was executed – white marble. It is not an easy material, nor, on reflection, can we judge it an obvious choice for the execution of images in relief or in the round. We have reflected on its properties in the last chapter. It lends itself to clear, sharply defined masses and pattern no less than to subtlety of contour and even, as later generations were to discover, to the expression of the soft, the vaguely defined, the sensual. The Archaic sculptor explored its potential in creating three-dimensional patterns which represented the human body. Style evolved slowly, as technique improved, and the changes, which must have been admitted because the results were more satisfying and the functions of the figure were thus better served, also led to renderings which were closer to life, closer (for the whole body at least) than any achieved by other ancient cultures. Not that there is anything inherently good about realism in art, but once the Greeks discovered how much more it could express than the conventions, symbols and patterns of Archaism, they made a virtue of it.

Down to around 500 what realism there was in Greek art, especially in the rendering of the naked male, was literally superficial. The figures conveyed no more than the sum of their parts, fairly accurately delineated and fairly accurately juxtaposed. Soon, though, even this triumph of realism could, it was found, be improved upon. It is apparent from drawing (on vases) more readily than in sculpture that the artist was beginning to observe his subject consciously, and not simply reproducing what he had been taught of the conventions for representing a man or a god or an animal. Closer observation was not confined to detail, but it was the problem set by the proper rendering of detail on bodies not at attention but at ease or in motion, which led to a closer observation also of structure, and with it a growing understanding of how a body moves,

how its weight is carried, how a shift in pose can affect the placing of limbs, torso, head. The sculptors of the last of the kouroi, like the Athenian Aristodikos of about 510–500 [1], did not need to worry too much about this. Their figures were evenly poised, in balance. Figures in violent action, running or fighting, could be composed like articulated dolls, although there was growing awareness of the problems of rendering a twisting figure, since so many were still basically conceived in two dimensions rather than three, including even those cut in the round to be set in temple pediments. The so-called 'Kritian boy' from the Athenian Acropolis [2], probably earlier than 480, betrays the new awareness, weight shifted on to one leg, the other slack, with hip lowered and the shoulder and head lightly inclined. Now look ahead through this book, at [20.1, 36, 38–9, 65–9, 72, 184–6, 223, 227–35] to see how, through the century, this calm assurance in showing the standing figure is improved upon. But even the earliest of the figures abruptly remove us from the world of Archaic rigidity and pattern into one in which art takes on the task of representing, even counterfeiting life, and not merely creating tokens of life.

Greek art in the Iron Age began with little or nothing by way of figure decoration but with abstract pattern, eventually applied to the construction of man-symbols, whole scenes and even narrative. The formal demands of pure pattern long remained close to the artist's consciousness, and as time passed were expressed in sophisticated theories of mensuration and proportion. All this might seem alien to an art which, to the casual observer, seemed in pursuit of the real, but the demands of pattern and proportion were more consciously served by the Archaic artist than any positive desire to make his works more like the world around him. This remained true even after the possibilities of realism were recognized in the early fifth century, and when a sculptor, Polyclitus, came to write a book about his art later in the century, it was not an anatomical text-book but an essay about the ideal proportions to be observed in making images of the human body, and based as much or more on mathematics than on the life class. These tendencies to observe proportion and to idealize rather than particularize figures were more positive stimuli than a search for realistic anatomical presentation, which came almost accidentally. They are tendencies which held back obsessive realism in art and, for instance, life-like rather than idealized portraiture, until after the period studied in this book. Fifth-century sculpture showed the artist working towards a satisfactory reconciliation of all these apparently contradictory aims – an art which mirrors life, that expresses an ideal in human images, that acknowledges the dominance of pattern and proportion.

The Archaic sculptor's patterns were of surface anatomy and dress, his

21

theory of proportion an approximation to nature based on a workable but artificial scale of mensuration. In the Early Classical period, the subject of this and the next six chapters, progress, other than in an understanding of the structure of the human body, seems almost muted. In male figures, once the break with Archaism had been made, the presentation of relaxed or vigorous figures developed the Archaic themes in the new idiom, without going far beyond them. In female figures a different dress style (the peplos) dispenses with the patterned finery of the Archaic chiton, and allows subtlety of pose to be made more readily apparent in the simple break of a line of folds. Of compositional progress we can judge little, since architectural sculpture is still defined by the rigid frame of pediment or metope, but in drawing we can see a new understanding of the use of space. Where the Archaic artist tended to compose almost introspectively, within the field offered him, and even his free-standing figures, like Aristodikos, seem essentially self-contained, the Classical figures are both in and of their environment, and the accommodation of a figure or of figures within a group to their setting and to their viewers is more consciously planned. The Classical figure may seem to remove itself from us, through a bid to express a human/ divine ideal or mood, but it still involves the viewer more intimately than the Archaic.

The following chapters look at what little is known of the original statues of the Early Classical period, including the remarkable architectural complex at Olympia, and we shall have to deal with the problem of the use of copies in our studies – a problem which becomes more acute later in the century. Early Classical is a convenient title for a style which is not merely experimental or transitional, as it has also been called, but which has a clear character of its own. We do not do it justice by judging it simply in terms of the full Classical which it heralds. Indeed, we shall see that in some respects it has qualities which the Classical lacked or chose to set aside. After the Archaic, sculpture looks austere, and 'Severe' is a useful and intelligible term which has been applied to it and is used here, where convenient.

In the Early Classical period Athens figures little, for reasons which will become clear, and we have less sculpture from the first half of the fifth century than we had for the second half of the sixth. The Persian invasions of Greece at Marathon (involving only Athens) in 490 and then in 480/79, diverted Athens' attention from major sculptural projects until the mid-century. In other parts of Greece there was either no rebuilding to be done, or it was deliberately deferred (a remark that reveals how much we rely on the survival of architectural sculpture), and there is a pause in major state enterprises until Athens sets the pace again. Olympia found the need for a new temple, whose sculptures have

fortunately survived, and, with the other national sanctuary at Delphi, attracted rich offerings, but their survival rate has been low. With Athens quiescent, the rest of mainland Greece anxious or exhausted, and East Greece still troubled by Persia, the period does not present itself as one of busy experiment and innovation, but its achievements are real, and its few masterpieces lose nothing by comparison with what was to follow.

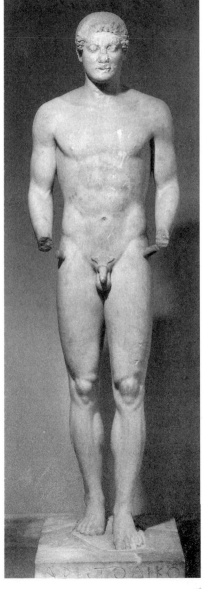

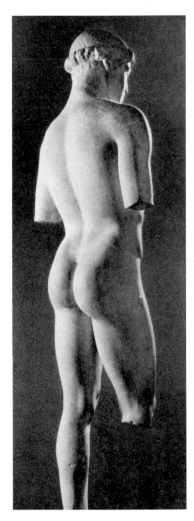

1 (left) Kouros from near Mt Olympus (Attica). The base is inscribed 'of Aristodikos'. About 510–00. (Athens 3938. H. 1.95)

2 (above) Youth from the Acropolis, the 'Kritian boy' (the nickname from similarity to 6). About 490–80. (Act. 689. H.0.86, about half life-size)

Chapter Three

EARLY CLASSICAL MEN AND WOMEN: I

In the Archaic period the two most important sculptural types, in which artists displayed their growing command in representing plausible anatomy and dress, edging all the time by a sort of natural selection towards a more realistic image (see *GSAP* 65), were the standing nude man and the dressed woman – the kouros and kore. The same two basic types remain important in Greek sculpture through the Classical period and we shall consider each of them before going on to look at larger complexes, as at Olympia, in which they are also to be found, and at the figures in other poses.

We begin perversely, however, by ignoring our principle of relegating copies to a separate chapter and by describing a group from a city, Athens, that we have just declared relatively barren in this period. The reason is that the group *is* known by scraps of its original (in casts), and that it demonstrates very well many of the problems of the use of texts and copies in our study. The group is that of the Tyrannicides.

Statues of the slayers of the tyrant Hipparchus (in 514), made by Antenor, had been set up in the Athenian Agora at the end of the sixth century (*GSAP* 83; or, as some believe, only after Marathon, 490). The group was removed by the Persian king Xerxes in 480, and replaced by the Athenians with another group, by Kritios and Nesiotes, dated 477/6 in a later chronicle (the Parian Marble). The sculptors' names appear again as collaborators on six bases for bronze statues from the Acropolis. The nature of the collaboration is not clear (at least, the bases show that it was not a matter of one statue each): a near-contemporary Athenian red-figure vase (*ARFH* fig. 262.2-3) shows two craftsmen working on bronze statues. The Tyrannicides were bronze too.

The group itself can be recognized painted as a shield device for Athena on fourth-century vases [7], on coins [8] and on a marble throne [9] (the scene on *ARFH* fig. 199 is about as close as contemporary vase-painters get to sculptures – hints at the poses, the quarry added and the placing changed). In two dimensions or low relief the figures' legs overlap, not their bodies, sometimes with one in front, sometimes the other; but in the original side view of the group one probably obscured the other. The young man Harmodios advances with raised sword, to

slash: Aristogeiton stretches out one arm with hanging cloak, in a protective gesture and holds his sword-arm back. Both poses are old ones but the group gave them a special significance in later works, especially for heroes, and for the Athenian hero Theseus (cf. [19, 113]).

The viewer at the front of the group is in the position of the victim. The interesting suggestion has been made that they might have been back to back. Ancient representations are not quite decisive on this point, for the reason given above, and the fragments of the base excavated in the Agora tell only that there was one base, not two. This is a group with several major viewing points – in front, chest-on to each figure, from the back of each figure with the other then in profile – a remarkable advance on the simple frontal arrangement of earlier sculptural groups.

A copy of the group was found in Hadrian's Villa at Tivoli and there are other copies of heads and torsos [3, 5, 6]. The poses are no more adventurous than some of those on the Aphaea temple at Aegina (GSAP fig. 206), the anatomy less emphatic. The young head with its tight-curled hair is still close to the last of the Archaic kouroi – its superficial similarity to that of the Kritian boy earned the latter its sobriquet (here [2]; GSAP fig. 147). The old head is more clearly Early Classical in style but the hair is hardly more than incised with tiny flame locks (compare the more orderly, earlier Rayet head, GSAP fig. 139).

The Baiae studio, whose significance for our understanding of the Roman copies was discussed in Chapter 1, handled a Tyrannicides group, and we have from it part of Aristogeiton's head [4] and scraps of the limbs and dress from both figures. Apart from the technical details which reveal the copyist's technique, we may admire the head's finely striated, short tufty beard. Not all marble copies of the head treat the beard in just this way – closest is that shown in [5a] – and it is unlike the far freer modelling of other, later Severe heads. So, if we are misled about the date of the first Tyrannicide group, and it was in fact erected after Marathon, the cast might be from this (it had been restored to Athens from Persia by Antiochus) and represent the work of Antenor. This impasse is provoked by a poor text (Pliny) and it is aggravated by the quality of copies for, if [5a] is Antenor's, could the other Aristogeiton heads known in copy and with the more advanced treatment of beard [5b], be from the second group? I think it is easier to believe that later copyists revised their cutting of beards than that Kritios and Nesiotes made modestly updated replicas (how?) of Antenor's missing group (for which yet another copy of a head, for the earlier date, has been proposed – GSAP fig. 143). Text and copies lead us steadily away from the reality of the Baiae cast, yet only through text and copies could it have been recognized.

We turn now to the kouroi and korai. They had been grave-markers

and dedications in sanctuaries. With the fifth century the role of these types changes. The Late Archaic period had seen that breakthrough in the realization of how to represent the shift of balance in a standing figure (ponderation), with a sudden approximation to life, aided by deliberate study of life, which made a dramatic break with the pattern-conscious works of earlier years. Not that pattern and proportion were ever forgotten, as we shall see. The new life in the figures lent them a greater degree of individuality and, although this was apparent sometimes in Archaic sculpture, it became, for a while at least, more truly characteristic of the Early Classical. The new standing youths are not the generalized images of a life lost in its prime, but more often memorials to the success of a living athlete, holding athletic equipment or a libation phiale, or representations of a specific deity, generally the young Apollo, already favoured in the Archaic by an adaptation of the kouros pose to accommodate the handling of divine attributes – GSAP figs 150, 185. The change seems the more dramatic through the absence of much sculpture of this period in Athens or in Attic cemeteries, but it is supported by the evidence from other sites – Delphi, Olympia, Delos and fifth-century cemeteries elsewhere in the Greek world, either by the presence of figures in their new function, or the absence of the old.

The Kritian boy has been for us the Late Archaic paradigm of the new pose. In the next generation of such figures we have to look generally to copies for complete, life-size figures, although versions will appear in architectural sculpture, as [20.1]. We may start with the heads. The Kritian boy wore his hair rolled around a fillet [2]. His contemporary, the Blond Boy, who was in the same pose, has his long hair plaited and wound around his head and under the front locks (GSAP fig. 148). The rolled hair and plait will be hallmarks of the Early Classical, the hair on the top of the head being shown in a pattern of shallow grooves, sometimes grouped in wavy locks, radiating from the crown. A bronze head from the Acropolis shows the rolled hair [10], but the long back hair is tucked up and pinned (a krobylos). For the plait look at the copies or the fragmentary cast from Baiae which combines plait and roll and is from a fine bronze [11]. We do, however, have the head of a major bronze of these years (or so it seems: some have doubted it). The Chatsworth head [12] was found in Cyprus with much of its body, which was immediately destroyed. It seems likely to have been a kouros-like Apollo. The features are heavy and dull, and were perhaps more impressive on the whole body. The front locks are knotted in a manner novel for this period, and the side locks, some missing, cast separately.

Whole, life-size figures escape us until a slightly later phase and then for warrior figures, but the basic pose of torso and legs appears in the Olympia pediment [20.1] – flat-footed, the relaxed leg just forward and

26

moved away from the rigid, the corresponding tilt of hips and shoulders properly observed, the head inclined. Small bronzes of the period repeat the pose and must resemble the many athlete statues which were the prime exponents of the genre. [13] has an unusual hair style, but the plait is there, its loose ends oddly hanging before the ears. [14] from near Argos has the dumpy set of figures commonly associated with the Argive school, and ancitipating Polyclitus: cf. [184–5].

The corresponding female type, successor to the Archaic kore, is the peplophoros, named for her dress, the peplos, which replaces in popularity the thinner, more voluminous chiton (cf. GSAP 67f.). The chiton will still be worn, of course, even under a peplos [200], as in the Archaic period (GSAP figs 103, 115; for the dress types ibid, 68). The peplos is sleeveless, and its overfall from the neck hangs straight to belt level, or may be longer and belted on some figures, notably Athena, as [29, 41, 61, 97–101]. It is of heavier material and so, for the sculptor, it presents a pattern of strong vertical folds or, in the overfall between the breasts, catenary curves or interlocking creases.

We are better provided with original marble peplophoroi than with their brothers. Some from East Greece and the islands have skirts patterned with folds which recall the Archaic [15] but most are more austere and betray their new, Early Classical stance only in the light disturbance by one knee of their skirt folds. The subject is very popular too in small bronzes, especially those made as mirror supports [16] or in the exceptional incense-burner stand from Delphi [17]. Heads are bland, the hair centrally parted and combed back, or only lightly gathered before the ears. It is commonly bound in a scarf (mitra) or snood (sakkos), giving the characteristic deep profile view. There are peplophoroi in the Olympia pediment [20.1] and for copies of Early Classical peplophoroi and related figures see [73, 74].

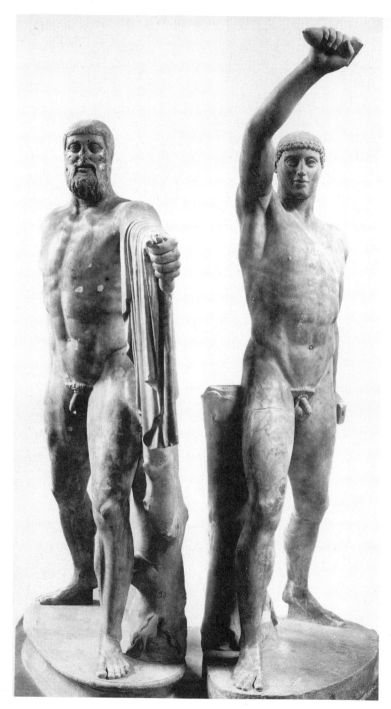

3 Harmodios and Aristogeiton, the Tyrannicides. Copy of an original group of about 475, from Hadrian's villa, Tivoli. Aristogeiton's (the older man) head is missing, restored from a copy in the Conservatori Mus., Rome. (Naples G103–4. H. 1.95)

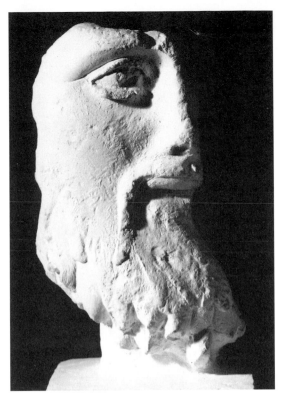

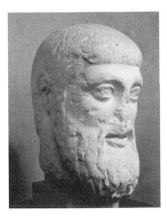

5a Head of Aristogeiton; see 3. (Rome, Conservatori; once Vatican, then restored to its torso. Cast in Oxford)

4 Head of Aristogeiton. Copy of a cast taken from the original, found at Baiae (see Ch. 2). It most closely matches 5a. (Baiae 174.479. H. 0.20. Cast in Oxford)

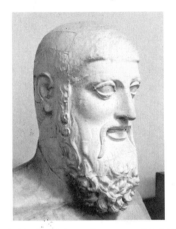

5b Head of Aristogeiton; see 3. (Madrid 176. Cast in Oxford)

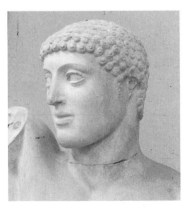

6 Head of Harmodios; see 3. (Naples. Cast in Oxford)

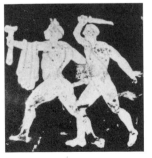

7 Shield device of Athena on a Panathenaic vase, showing the Tyrannicides 3. About 400. (London B605, from Tocra; *ABV*411, 4; *ABFH* fig. 304.1)

8 Electrum coin of Kyzikos showing the Tyrannicides 3. About 430–20. (London. Cast)

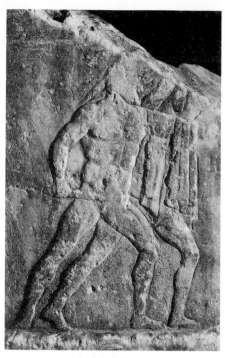

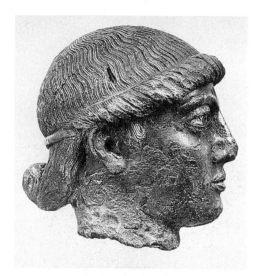

9 Detail from a marble throne (the Elgin throne) showing the Tyrannicides 3. About 300. (Malibu 74.AA.12)

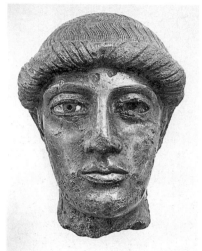

10 Bronze head from the Acropolis. The eye is inlaid with white glass, the lips and eyebrows with copper. About 460. (Athens 6590. H. 0.12)

11 Fragmentary plaster cast from a bronze original of about 470–50. Ear, earlocks and hair rolled over a plait. (Baiae 174.482. L. 0.15)

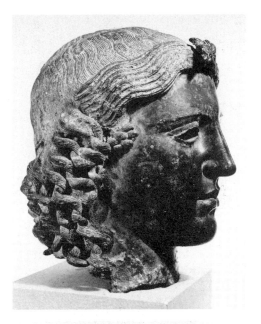

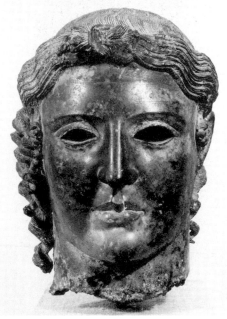

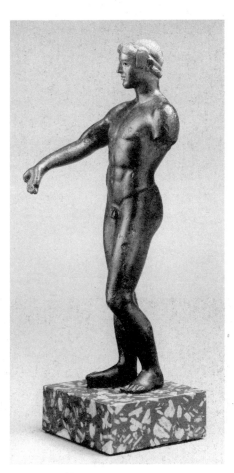

12 Bronze head of Apollo (the Chatsworth head) from Tamassos (Cyprus). About 460–50. (London 1958. 4–18.1. H. 0.31)

13 Bronze athlete, once holding a phiale, from near Tegea. About 470. (Mt Holyoke Coll. BOI.1.1926. H. 0.225)

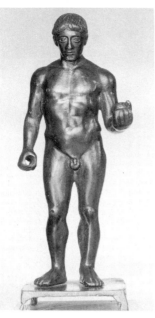

14 Bronze athlete holding a ball, from Ligourio. The footplate was fitted into a base by four studs. About 460. (Berlin misc.8089. H. 0.147)

15 (right) Woman from Xanthos (Lycia). A series of these figures may have decorated the terrace of a heroon on the acropolis. About 460. (London B318. H. 1.25)

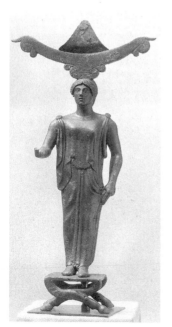

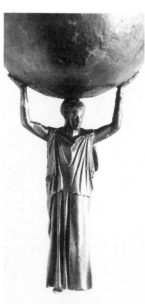

16 Bronze mirror support. She stands on a folding stool and supports the crescent-shaped holder of the mirror disc. The scheme is a common one at this period. About 470. (Boston 01.7499. H. of figure 0.18)

17 Bronze support of an incense-burner, from Delphi. She wears an ungirt peplos. About 470. (Delphi. H. of figure 0.16)

Chapter Four

OLYMPIA: THE TEMPLE OF ZEUS

The survival of one major assemblage of original marble sculpture of the Early Classical period has ensured that we are not condemned to judge it from few and isolated originals or later copies, and that the quality and promise of at least one Peloponnesian studio does not go without its due of praise. Without the Olympia sculptures we would have been deprived both of some of the greatest Greek marble sculpture of any period, and of a yardstick by which to judge the achievement and originality of the succeeding Classical style. We speak of the Olympia Master, but many and more than competent hands went to cut and finish the works. We are dealing with a school or studio controlled by a master able to inspire and direct, yet himself experimenting in the potential of a craft whose new functions of rendering narrative, expression, realism and emotion had only just begun to be realized or released. Certainty about his name eludes us, but it is difficult to believe that it does not lie among the many recorded by later writers, who were generally less interested in or knowledgeable about the authorship of architectural sculpture than that of independent dedications or monuments.

The sixth-century temple at Olympia held cult statues of a standing Zeus and seated Hera (*GSAP* 25, fig. 73). The focus for early worship of Zeus was his open-air altar. Only in the fifth century did the god of Olympia receive his own temple – an *oikos*, home for a new cult statue. Pausanias says that the temple and statue were built (i.e., paid for) from the spoils won after the destruction of Pisa by Elis. The states had disputed control of Olympia before but in 471 Elis was founded as a new, democratic city, and this may mark the victory over Pisa and inauguration of the new building. On the temple gable the Spartans placed a shield to celebrate their victory over Argos at Tanagra in 457, so the temple was complete by, say, 456, and its marble sculpture in position (though the shield might have been hoisted there later from another position). Another generation was to pass before the temple received its cult statue, Phidias' masterpiece in gold and ivory.

The temple, and its sculptures, suffered a number of accidents and repairs in their history, the earliest being already in the fourth century BC. In AD 426 it was burnt and in the next century shattered by

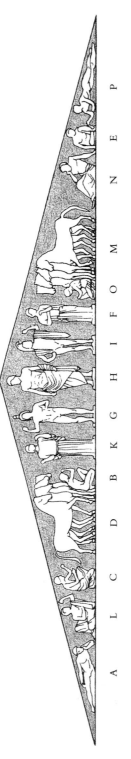

A L C D B K G H I F O M N E P

18 Olympia, Temple of Zeus. East Pediment

Pausanias thought the centre figure was a *statue* of Zeus, but this is unlikely – he is an unseen presence. The figure no doubt held a thunderbolt (or sceptre). Paus. saw young Pelops (G) to the right, Oinomaos (I) to the left and beside Pelops his bride-to-be Hippodamia, beside Oinomaos his wife Sterope. Unfortunately it is not clear whether he means Zeus' or the viewer's. At least we can identify Pelops as the younger man. Sterope is likely to be the figure in pensive mood (F), Hippodamia the one making a bride-like gesture plucking at her dress (K) and with belted peplos. Some scholars exchange the identities of F and K, and it must admitted that, in the scatter of fragments, F was found nearer G and I nearer K. Arguments from reconstructions of whole figures have also recently supported this scheme. So the placing of FGIK remains uncertain, and the identity of F and K. K has shaggier, rumpled locks. Oinomaos looks distressed, mouth part open, and Zeus inclines his head (favourably?) to his right. Paus. saw Myrtilos before Oinomaos' horses but may have been misled by the long charioteer-like dress (really a peplos) of the crouching girl O, who may be Sterope's maid, but she and other crouching figures – the naked youth and boy, B and E (but not the horse-minder C) – are variously placed in the pediment by scholars. The boy playing idly with his toes (E) has been likened to the hero Arkas as he is shown on coins. The chariots were either added in bronze or not shown at all. The old man on Pelops' side (L) is alert (he may be Amythaon); the one on Oinomaos' side (N) worried (he may be the seer Iamos). The reclining men to left and right are identified by Paus. as Alpheios and Kladeos, the local rivers. He was used to reclining river gods of later date, but may be correct here. Most of his identifications sound like roughly plausible guesswork, probably no better than ours. Late additions in bronze were a corselet and extra helmet for Pelops

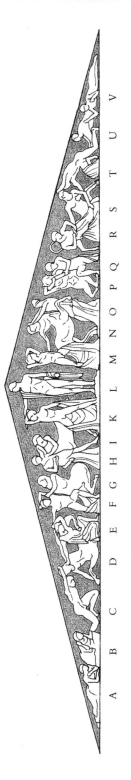

A B C D E F G H I K L M N O P Q R S T U V

19 Olympia, Temple of Zeus. West Pediment

The centre figure must be Apollo and scraps are preserved of the bow he probably held in his lowered hand. Paus. thought he was Peirithoos and a scholar has recently argued for a 'young Zeus'. Paus. saw Theseus beside him with an axe, certainly M, since the axe, pose and dress slipping down the legs are seen for Theseus on 5th cent. vases. Peirithoos must be K (Paus. thought him Kaineus, a less appropriate figure in the wedding brawl) in tyrannicide pose (cf. 3) and the group beside him his bride Deidameia and the centaur Eurytion. Some transpose the groups HIK and MNO, but this is awkward. A and V are old women, the former a replacement in Pentelic marble for a damaged or destroyed original, but in appropriate style: V has also a new arm. B and U are anguished old women in Pentelic marble, added probably in the 1st cent. BC, cut in a less congruent style. Later additions in bronze were a wreath for Eurytion (I) and the sword in S.

earthquake and then, with the rest of the site, covered with up to five metres of alluvial sand. Some of the sculptures lay wherever they had fallen, some were built into the walls of a Byzantine village. That so much survived to be recovered by the German excavations of the last century is little short of miraculous.

Pausanias names the architect of the temple, a local man called Libon, and describes or rather discusses some of the sculpture. The corner akroteria were cauldrons, the central one a Nike, all gilt. We learn that there was a competition for making the akroteria from the inscribed base of the famous Nike made by Paionios of Mende soon after 424 [*139*]. Paionios won the competition and we may get some idea of the temple Nike from the one of his which is preserved, but, from the dates, it seems that the akroteria were late additions, like Phidias' cult statue.

Of the pediments Pausanias says that the front (east) one shows the preparation for the chariot race between Pelops and Oinomaos [*18, 20*], which we might not very easily have guessed, and names several of the figures. The west pediment, with the fight of Lapiths and Centaurs, we could have identified without him. But he goes on to attribute the east to Paionios of Mende, which must be wrong and was perhaps the result of a mis-reading of the base of Paionios' Nike; and the west to Alkamenes which, if correct, can hardly refer to the Alkamenes whom we know as Phidias' pupil, so this is likely to be another mistake; or it may be that the two artists shared the making of the akroteria, not the pediments.

The Pelops story has a local chariot-racing theme appropriate for Olympia and reflects a success over Pisa (ruled by Oinomaos) such as was the occasion for the construction of the temple. In the usual story Pelops wins by bribing Oinomaos' charioteer Myrtilos to substitute wax for metal lynch-pins on his chariot, then kills Myrtilos who curses him and his house – the doomed succession of Thyestes, Atreus, Agamemnon, Orestes, so much in the minds of Athens' fifth-century dramatists. Pindar's anodyne version (of 476, so earlier than the temple) lets Pelops win by using divine horses, the gift of Poseidon, but though this seems a touch more sporting, it lacks the tragic threat of Zeus' justice which pursues wrongdoing. Instead we have a combination of apposite narrative with a moral message of divine authority, and the moment chosen recalls both the oath-taking before the race and the broken promise.

The west pediment [*19, 21*] displays a bustling challenge to and defeat of hubris, a divine and heroic stand against bestial behaviour. Pausanias thought the central figure was Peirithoos, whose marriage it was that the Centaurs disturbed, but this must be Apollo, son of Zeus and dispenser of law and order. The story is set in Thessaly and though Aracadia too is centaur–country, it could not be imagined elsewhere. The theme is much

used in fifth-century art, often, it seems, as a comment on Greek successes over the barbarians or over barbaric behaviour by fellow Greeks, but this is hardly the message here. There is still some uncertainty about the placing and identity of figures in both pediments, briefly discussed here in the captions.

The other sculptural decoration on the temple is in twelve metopes [22–3], placed six at each end over the inner porches, the outer metopes all round the temple being left blank. They depict the labours of Heracles and all but one are mentioned by Pausanias and are identifiable, although some are sadly fragmentary. Heracles, son of Zeus and founder of the games, requires no explanation here, and the metopes probably help to determine the number, although not always the identity, of the traditional twelve labours of later art and myth.

From subject we turn to composition and style. The pediment figures are roughly one and half times life-size and the gods at the centre were about 3.15 metres tall. They are carved in the round, dowelled on to the pediment background, but much of the backs of most of the figures was not finished and some were partly hollowed, to save weight. Some parts of figures were sliced off at background level, especially the centaurs, and the chariot horses were slightly angled out from the background. The depth of the pediment floor is nearly one metre. The material is island marble.

The composition of the east pediment [18] is static – only knowledge of its subject allows us to savour the tense mood. Accents are vertical, the central group in particular, four-square over the middle intercolumniation of the temple façade, seeming almost part of the architecture of the building, and the symmetry of the other figures barely and sensitively broken by the differing poses of kneeling or reclining figures, horses at rest or turning. At the west [19] the fight surges away from the centre, rolling back on itself in the symmetry of the 2–2–3 groups of figures which present a zig-zag of vigorous movement, the action somehow continuous though the groups are discrete. Here the challenge of depth is more immediate – at the east there were only the horse teams, neatly splayed in the shallow field. While the figures of the fighting groups naturally shrink back from the foreground, like a fight on a mountain path, still the girls' bodies are held or swung across the animal bodies of their attackers [21.4, 7], and provide the first (and almost the last) Greek pediment on which skill of carving and composition alone bid successfully to break the unresponsive shape of the field. Sacrificed in the attempt are the hindparts of some centaurs (D, G, P), and the sculptor's failure to make sense of the left leg of youth Q [21.6] might seem, surprisingly, to suggest that there was no very explicit three-dimensional model to guide him.

In the metopes [22–3] there is a command of varied composition in the roughly square fields which goes far beyond the skills of even so adept a designer as the artist of the Athenian Treasury at Delphi (*GSAP* fig. 213). Even where action is directed from or towards a corner (11, 12) it seems complete, and anchored by the standing figures. The horizontal element in 1 (Athena's and no doubt Hermes' arms, Heracles' thigh, the lion) enhance its mood of quiet, almost depression. There is a comparable vertical/oblique rhythm in 3, vigorous crosses (x in 4, + in 8), the pyramidal 5. The only relaxation, in the rigid, world-bearing scheme of 10, is in the interests of narrative – Athena's helping hand, Atlas' nonchalance.

1 and 3 are novel in their approach to the story, as is 12 where there was, at any rate, no precedent. Athena is seen four times, symmetrically over the whole series – 1 and 3, 10 and 12: always with a spear but in 1 girlish, in 3 a young woman, more dignified in her aegis but still bare-headed, in 10 mature almost maternal, in 12 the warrior goddess. And in 1 the artist catches the mood of the first of such a dire series of labours in the exhaustion of the young, still beardless hero. Hermes attends this inauguration, and, as go-between of hell and earth, the dragging of Cerberus on 11.

It is in the treatment of dress that Olympia leads us as directly away from the Archaic as earlier sculptors had done in their treatment of the male body. Yet it is idiosyncratic, and the distinctively Olympian in its style is not a factor of great importance for subsequent developments in the representation of the clothed body. It is apparent even in the peplos figures – Sterope and Hippodamia and the metope Athenas – whose dress has a thick, almost rubbery quality quite unlike the crispness of the Paros Nike [27] or the blanket-like peploi of other figures. 'Doughy' is the word often applied – note especially O on the east [20.5], E, R and T on the west [21.2, 8] – and scholars have thought this an indication of the plastically formed clay models which, they suppose, lay behind the finished marbles. But this implies a better understanding of the figures in the round, with their dress, than is always demonstrated. The pattern of the dress is still basically one of line rather than mass, serving (as it had to) the frontal view, and the artist has still to learn how best it can suggest the roundness of body forms beneath. On O in the east pediment [20.5] the contour of the figure does more than the drapery to show the pose, and an oblique view demonstrates that the artist had no coherent idea of how the folds might run from leg to leg (and compare C on the east), such as either observation from life or the plastic construction of a model might have taught him. He has seen that a looped fold is effective because realistic, but he disposes the loops and curlicues in unreal patterns – on the west, over the knee of T, on the girls E and R [21.2, 8].

The real world is still not, it seems, altogether the Master's model and in his treatment of human anatomy he may be ambitious, and often successful, with the composition of his struggling figures and groups, but he shows no greater understanding of the human body in action than do his contemporaries. Yet it is in this sphere that he can also display his brilliance. There are nuances of expression, mainly in faces but also in the rendering of parts of some bodies, which in earlier sculpture we see as simple convention or sometimes accidental, and which the idealizing arts of Classical Greece, especially in Athens, were to eschew. The Olympia Master not only recognized these physical nuances but accepted the challenge to attempt the rendering of them in marble, and succeeded. Little enough of this, no doubt, could be appreciated on the building, at the distance from which the features were viewed, and we can see that the Master's team made allowance in other respects for detail which could not be seen clearly, leaving hair masses on the metopes and some of the pedimental figures uncarved, to be rendered simply in paint. In anything other than architectural sculpture we might have been able yet more readily to acknowledge the unique quality of this studio's work.

In the metopes he catches brilliantly the differing moods in the expressions of the hero – the tired youth of 1, pride on 3, pinched tension on 10, concentration and a touch of unease on 11, disgust on 12; and the different ages even of Athena (an immortal who had been born full-grown!). In the east pediment Oinomaos seems anxious or impatient, the old seer N is distressed [20.4] but resigned while his opposite number L bears the wrinkles of a quiet smile [20.3]; in the west the centaur masks range from the near dignified I [21.4] to rabid N, or bestial P [21.7]. The young man Q has heavy boobyish features, wincing with pain [21.6]. Only the gods, heroes and women seem relatively impassive. Observe the progression from the soft young flesh of E in the east pediment [20.6], to the firm but not muscular B, the mature heroes and god, the well-kept middle age of the seer N [20.4]; or in the west the chubby, barely formed adolescent R [21.8], her trim foot in the clutch of the centaur's gnarled fist.

We write as though all this was the creation of one man or at least his design. The execution must have been in the hands of many and perhaps the Master himself finished some important heads or other areas. There are minor differences in the rendering of the lank and hook curls in hair and beards, and in the emphatically lidded or more restrained modelling of eyes and faces which could betray the different hands. Contrast the Athena of metope 3 with those of 1, 10 and 12, which are also remarkable for the quality of the Heracles heads. It is almost impossible to believe that the master design did not proceed from drawings to models, and perhaps even models at life-size despite the inept passage we observed in

Q at the west. Unworked bosses of stone left on some heads and elsewhere [*20.3, 21.6* – heads of L and Q] look very much like the bases for some sort of pointing process. Comparable bosses have been observed on some of the slightly earlier sculpture in the round at Persepolis, where we know that Greek-trained masons were at work. The Classical Greek artists, in all media, were at pains to disguise and eliminate all traces of their technique, and it seems that the Olympia studio, by being the sole exception, may have left us the vital clues. And if a pointing process was used we must imagine models prepared in considerable detail, in wood, or clay, or both.

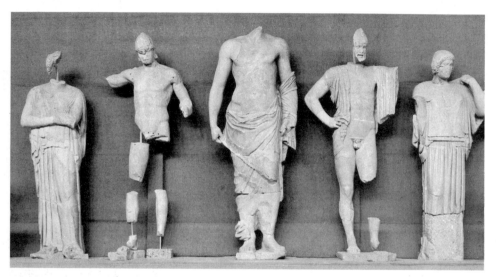

20.1 Olympia. East ped. F,G,H,I,K

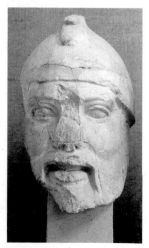

20.2 Olympia.
East ped. I

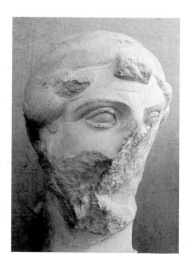

20.3 Olympia.
East ped. L

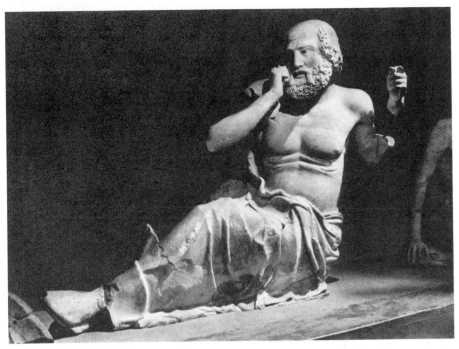

20.4 Olympia East ped. N

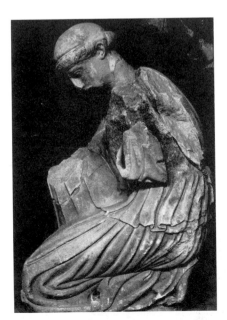

20.5 Olympia. East ped. O

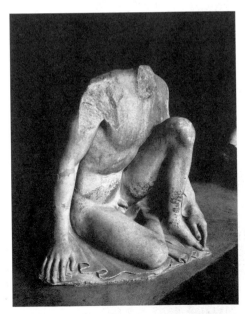

20.6 Olympia. East ped. E

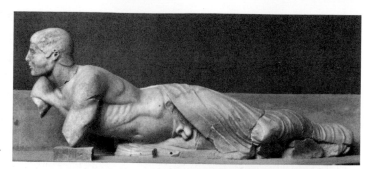

20.7 Olympia.
East ped. P

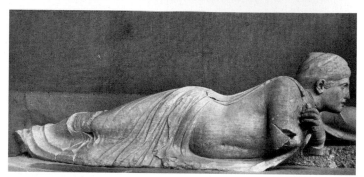

21.1 Olympia.
West ped. A

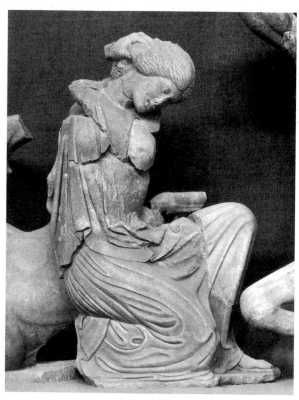

21.2 Olympia.
West ped. E

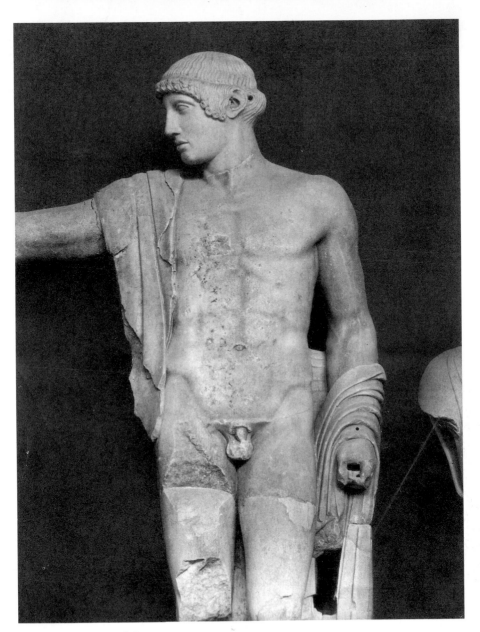

21.3 Olympia. West ped. L

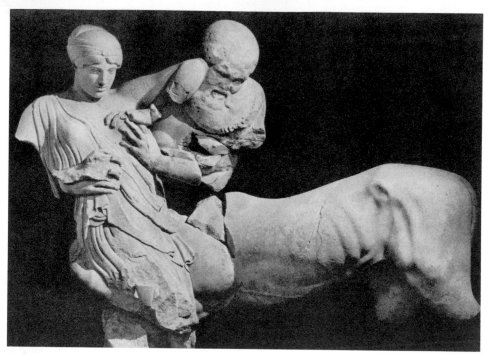

21.4 Olympia. West ped. H, I

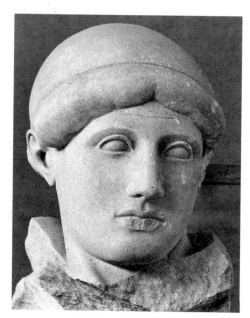

21.5 Olympia. West ped. M (Theseus)

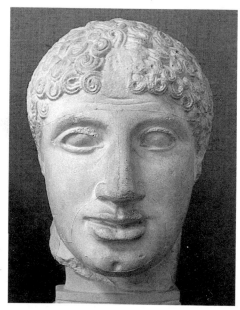

21.6 Olympia. West ped. Q

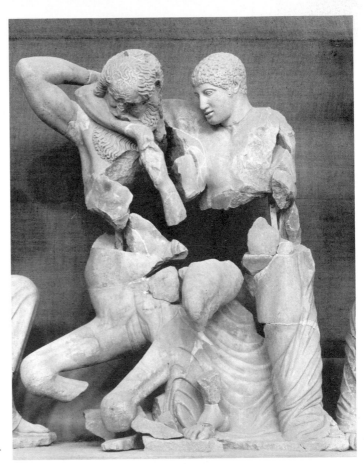

21.7 Olympia.
West ped. P, Q

21.8 (*below*) Olympia.
West ped. R, S, T

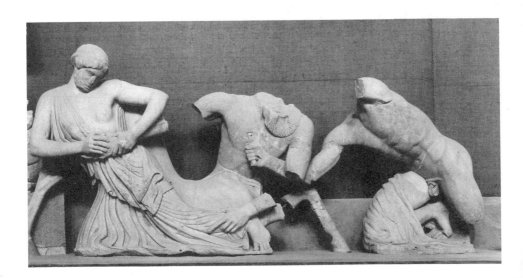

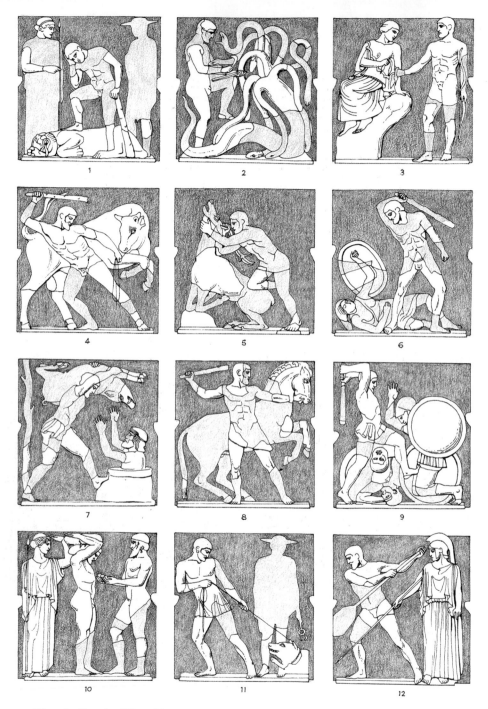

22 Olympia, Temple of Zeus. Metopes

22 Olympia, Temple of Zeus. metopes

WEST 1. Young Heracles (hereafter H) rests after killing the Nemean lion, comforted by Athena, Hermes behind him. The scheme is novel, met again only on engraved gems. Contrast the traditional *GSAP* fig.213.15 and here *111.E1*. Most of the lion is in Paris. 2. H slays the multi-headed Lernaean Hydra, a rare subject by now (*ARFH* fig.198). 3. H hands the dead Stymphalian Birds to Athena, who wears an aegis, seated on rocks (= her acropolis ?). Another novel treatment, cf. *ABFH* fig.95. All but H's trunk and legs are in Paris. 4. H fights the Cretan Bull. The upper part, except the bull's head, in Paris. 5. H fights the Kerynitian stag. 6. H slays an Amazon. His head (once given to 5) in Paris.

EAST 7. H delivers the Erymanthian Boar to Eurystheus who has taken refuge in a pithos. Traditional scheme, cf. *ARFH* fig.89. Heads in Paris. 8. H with one of the horses of Diomedes. Heads in Paris. 9. H fights the triple warrior Geryon. Much of Geryon in Paris. 10. H supports the heavens as Atlas brings him the apples of the Hesperides. Athena helps H, perhaps to shift the load back to Atlas. Cf *ABFH* fig.252. 11. H drags Cerberus from Hades. Hermes stands beyond. 12. Athena indicates to H the place at which to breach the walls of the stables of Augeas, to let in the river and cleanse them. The first treatment in art of this local myth. Exchanging 4 and 6 for 7 and 12 would put all the Peloponnesian Labours in the west, and that this was the original scheme has been suggested; but in art the territorial arrangement of the cycle comes very late. (Olympia and Paris. H. of each metope 1.60)

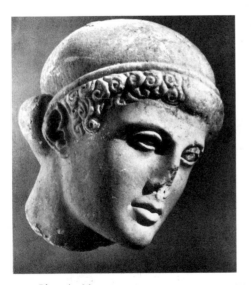

23.1 Olympia. Metope 1

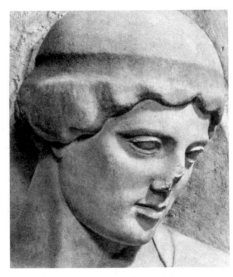

23.2 Olympia. Metope 3

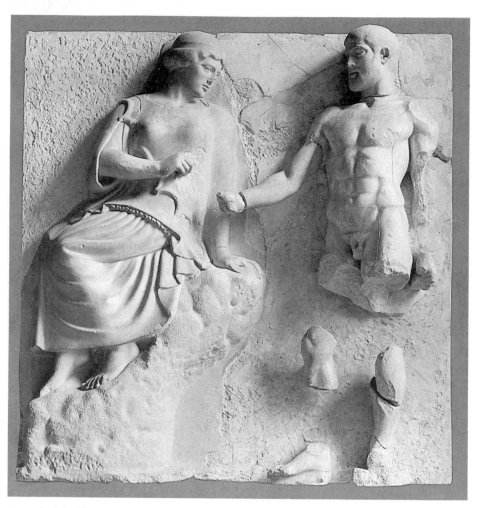

23.3 Olympia. Metope 3

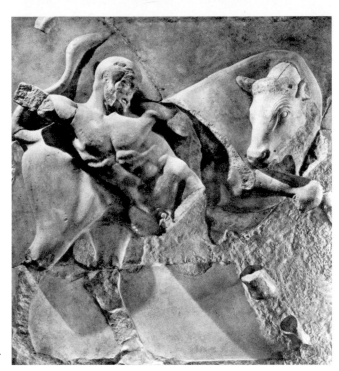

23.4 Olympia.
Metope 4

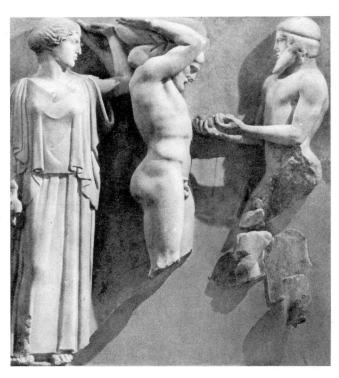

23.5 Olympia.
Metope 10

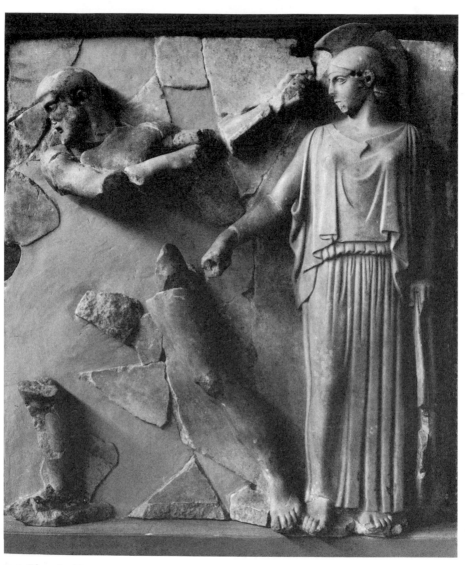

23.6 Olympia. Metope 12

Chapter Five

EARLY CLASSICAL MEN AND WOMEN: II

This chapter presents statues in poses other than those of the athletes, Apollos and peplophoroi (Chapter 3) and includes a number of important original works in bronze, some quite recently discovered, which have very considerably improved our understanding of this period and the approach to the full Classical. We start, however, with the ladies, and with an instructive piece which raises in an unexpected way the problems of contemporary replicas and later copies.

In the ruins of the Persian capital, Persepolis, was excavated the statue of a seated woman in Greek marble [24]. The type was already well-known from copies of the Roman period [25–6], but these could never have been based on the Persepolis marble, even via casts, since it was buried during Alexander's sack of the city in 330, long before such copying was practised. Original and copies are close, with minor variations of dress and seat, and the figure can be confidently identified as Penelope, patiently awaiting Odysseus' return, since it appears so named on other works. So there must have been two (at least) Penelopes, one which went to Persepolis, one which later served copyists. Such replication of marble statues had not been suspected and was presumably most unusual. The circumstances of the case elude us – could there have been a set of them, perhaps distributed to different sites in the Athenian Empire of which one reached Persepolis through gift or theft? The Persian kings commissioned sculpture so was this a requested piece? The choice of subject, in either explanation, is odd to say the least. Was the copyist's model itself a replacement of one taken by the Persians – then how is it so very like its lost model?

Female statues are not a notable field for innovation in this period but the excellent marble Nike (Victory) from Paros [27] is important since her hovering pose anticipates that of Nikai later in the century. She is a peplophoros but the dress presents a quite different pattern to that of her less mobile kin – the disturbed folds of the overfall, the Archaic interlocking folds lightly incised on the material pressed against her legs.

The famous Aegina sphinx [28] is not all lady, but the latest of a long tradition of votive and funerary studies of the monster (as *GSAP* figs 100, 224–8). Here only the unruly hair betrays a less than human personality.

Our last ladies are Athenas. The little bronze Athena flying her owl [29] hints, more than most of the small bronze peplophoroi, at a full-size statue, and since the pose is echoed in later copies it is likely that this is inspired by a contemporary major work. The de Vogüé head may be from an acrolith [30]. It is technically unusual with its fitted bronze eyelashes, but the decisive evidence for its use, the original cutting at the neck, is broken away.

Of the males the most unusual, and the earliest, still Late Archaic in conception and recalling the lunging figures of the Aegina pediments (GSAP fig. 206), is the so-called Leonidas from Sparta [31]. It is not clear whether he was a single figure or from a group, since pieces of marble shields from similar figures, apparently earlier (GSAP fig. 124), were also found on the Spartan Acropolis. What is odd is that these figures were all-marble including their armour, some of which might reasonably have been added in metal. The find place suggested the name of the hero of Thermopylae, as for a public commemorative statue. This might, indeed, have been its function, with or without such identification. The menacing pose is abetted by the icy grin.

For another Early Classical warrior, in a different medium, we turn to a clay head from the Athenian Agora [32], whose painted decoration, some of it recalling red-figure, gives us a hint of the painting which was applied to comparable marble statues. In much the same way larger clay groups show us finished works which have been plastically built, just as the models for the bronze statues had been (also in clay, with filling material and a hard wax surface). There were good examples of the Late Archaic period at Olympia (GSAP fig. 186) and from the Early Classical we have from the same site parts of a fighting group (three-quarters life-size) and a remarkable Zeus with Ganymede (half life-size), which still has much Archaic in the treatment of heads and hair [33]. This tradition of major clay sculpture is not one which has any distinguished following in the Classical period.

The Delphi charioteer [34] was the first of the major fifth-century bronzes to be found, excavated from beneath the Sacred Way at Delphi. It remains the most famous but is far from being the best. Viewing it in isolation, like a cult statue, we concentrate on part only of what had been a group – the man in his chariot car with a team of horses and a groom at their heads. It was dedicated by Polyzalos of Gela – the Sicilian tyrants reminded the homeland of their wealth by their victories in the Games (chariot-racing was expensive) and dedications. The shallow locks and ovoid head are still Archaic in their forms, like Harmodios [6]. The head is angled slightly to the right, to the viewer, and the left half of the face accordingly more broadly modelled as an optical correction. The slight twist of the figure lends it life, but does not disturb the columnar

character of the charioteer's long skirt, the lower part of which, with the fine feet, would have been hidden from view.

The striding bronze god [35] rescued from an ancient shipwreck off Cape Artemisium in 1926 (an arm) and 1928, is more probably a Zeus wielding a thunderbolt than a Poseidon with a trident, partly because the former is very familiar in this pose, partly because a trident held like a throwing spear is unfamiliar and, restored, spoils the figure; but the debate continues. The total nudity and realistic stance are awe-inspiring. The dramatic silhouette demonstrates the main, chest-on view, but there could be no compensation in the head for any oblique side-view, and the head-on aspect was no less important. But even the realism is only in spirit – limbs are elongated (notably the forward arm) and the set of the legs, profile-frontal, follows the Late Archaic formula in drawing (ARFH figs 34, 48, 115, 145) not attempted in free-standing figures before the Tyrannicides [3], without totally satisfying anatomical accuracy. The figure manages to be both vigorously threatening and static in its perfect balance. The locks radiating on the crown of the head are arranged in thick strands, sometimes overlapping. This, the plait hair-band and the loose forehead locks, are recalled vividly on a copy of an Early Classical statue, the Omphalos Apollo [66], while the beard is more realistically rendered than on the Olympia marbles, and, of course, Aristogeiton [4]. 'Olympian' is a trite but accurate description for the Zeus and he brings us close to the full Classical and the mid-century.

A smaller bronze, from Boeotia, is certainly a Poseidon since it carries a dedication to the god [36]. The pose is less aggressive than the Artemisium figure, yet not static and the god is stepping forward to greet if not to threaten.

The most important of the new bronze statues bring us to the threshold of the full Classical style. They are from wrecks off the shores of South Italy, probably en route from Greece to Rome although the Porticello head [37], found in 1969, is said to be from a Classical wreck. Its thinning locks and impressive mass of beard and moustache might suggest a portrait but the features are not especially individualized otherwise, and this is more probably a characterization of an appropriately senior citizen for a commemorative monument: certainly no deity. Its date is not easily determined, but the locks of hair and beard are luxuriant versions of Aristogeiton's or the Zeus' rather than at all close to later fifth-century work, where we are denied major bronzes to compare.

The two figures from Riace [38–9], found in 1972, are the most exciting sculptural discovery since the Artemisium Zeus. I treat them here rather than in a later chapter because in stance at least they are still Severe, although in treatment of anatomy they are more advanced than any we have studied so far. Not surprisingly, argument has quickened

53

over their date (down to Early Roman), relative date (up to fifty years between them), identity, home and sculptors. There are sufficient similarities in technique, anatomy and stance to believe them contemporary and possibly from a single group. They could easily be from one studio even if designed by different hands. The main difference between them lies in what the sculptors sought to express – the arrogant self-confidence of a young leader: the mature strength and stolidity, now a little slack and tired it may be, of an older warrior. The expression, not merely of the heads but of the set of the whole body, goes far beyond Olympia, far beyond anything left for us in marble of later in the century.

The odds against any of the few figures surviving from wrecks being identified with figures chosen for mention by Pausanias, must be long indeed, but one theory of their origin and authorship which is gaining ground is worth recording. At Delphi Pausanias saw a group by Phidias commemorating Marathon, including Athena, Apollo, Miltiades (victor at Marathon but dead soon afterwards) and Athenian heroes. It is suggested that the Riace bronzes are from this group. Similarities to copies such as the Tiber Apollo, often associated with Phidias, may seem to strengthen the theory until we recall on how little such associations are based. An alternative explanation is that they are from a group at Olympia dedicated by the Achaeans and showing the Greek heroes at Troy, also described for us by Pausanias and ascribed to the Aeginetan sculptor Onatas. Whatever their original home, and this may never be determined, they are a stunning demonstration of the relative quality of the best surviving bronzes vis-à-vis the best surviving marbles, and of the impoverished execution and impact of all later copies of Classical works. There is a deliberate air of near theatricality in the young figure, of near pathos in the older. Neither are moods we would naturally associate with fifth-century sculpture though they are subtly played upon in Classical literature. The bronzes teach us that we might expect as much of art. The veil that was lifted when the Elgin marbles were presented to the appraisal of Western scholars has proved to have left hidden still the quintessence of Classical art, and this, for the most part, must remain beyond our imagining.

24 Penelope, from Persepolis. She
wears a chiton with himation swathed
round her legs, a veil over her head.
About 460. (Tehran. H. 0.85)

26 Head of Penelope. Copy of an
original of about 460, see 24–5.
(Copenhagen, Ny Carlsberg 1944)

25 Penelope. Copy of an original of
about 460, see 24. This is restored
with the wrong head (see 26); the chin
should rest upon the right hand.
(Vatican 754. H. 1.15)

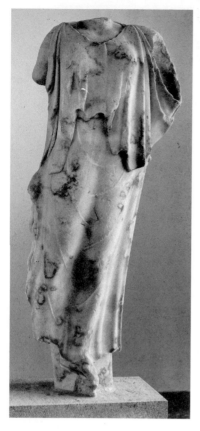

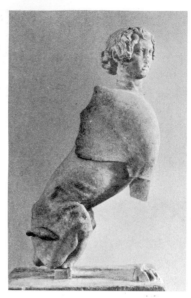

27 (*left*) Nike, from Paros. She is posed on tiptoe, leaning forward, as if hovering or alighting. Cuttings for wings at her back. About 470–60. (Paros. H. 1.38)

28 Sphinx from Aegina. A votive monument. The head is slightly turned, not frontal (as earlier votives) or turned to the side (as earlier funerary sphinxes). About 460. (Aegina. H. 0.96)

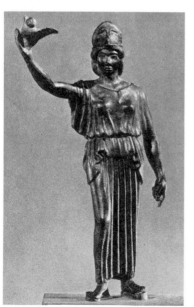

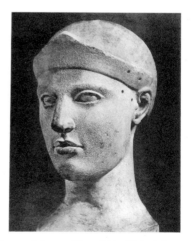

29 (*left*) Bronze Athena with owl (the Elgin Athena). She held a spear in her left hand, from her right the owl is rising. She wears Corinthian helmet and peplos with long, girt overfall. About 460–50. (New York 50.11.1. H. 0.15)

30 Head of Athena (de Vogüé head) from Aegina. Possibly an acrolith. Bronze eyelashes and bronze details of the helmet were attached by the drilled holes. About 460–50. (Paris 3109. H. chin to crown 0.20)

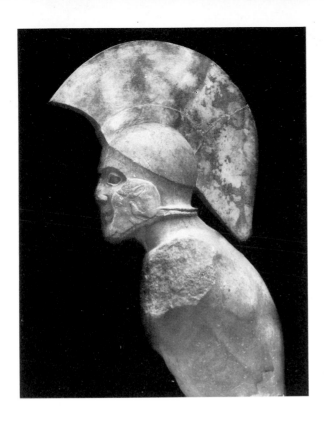

31 (*left and below left*) 'Leonidas' from the acropolis at Sparta. The eyes were inlaid. Part of the left leg was also found. About 475. (Athens 3613. H. 0.78)

32 Clay head of a warrior from the Agora, Athens. A Thracian helmet is worn with a Pegasus device in 'red figure' on the sides. Possibly from an akroterion. About 460. (Athens, Agora T3253. H. 0.21)

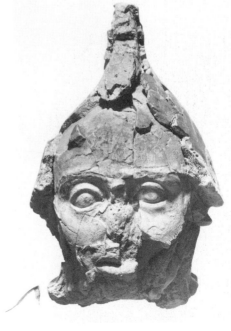

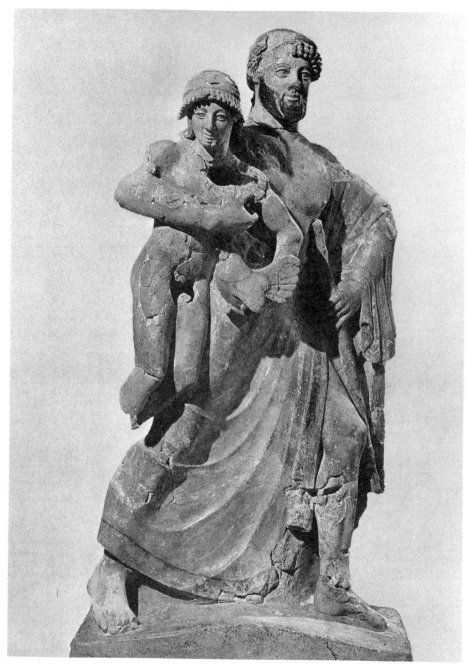

33 Clay group of Zeus abducting Ganymede, from Olympia. Zeus carries his knobbed
travelling stick, Ganymede a cock (love gift). It is on a strangely shaped base, but not,
apparently, an akroterion. Colours are blue-black, deep red (Zeus' cloak), brown (Ganymede's
brows and Zeus' nape hair), yellowish (bodies). Fifth-century Greeks would not have found
Zeus' abduction of Ganymede to be his cup-boy a degrading subject for the sanctuary. About
470. (Olympia. H. 1.10)

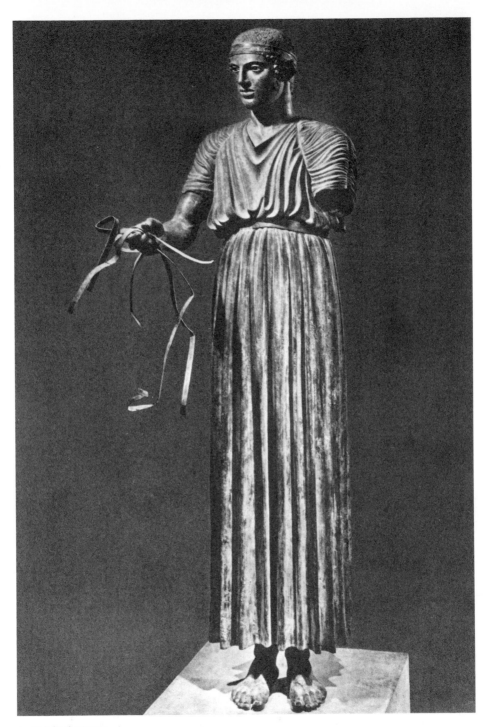

34 Delphi charioteer

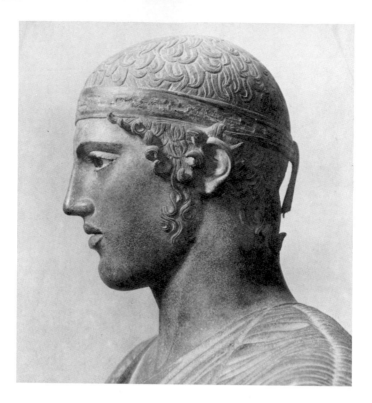

34 Delphi charioteer. Bronze, from Delphi. The long chiton was approved dress for charioteers (a windy sport) and the shoulder cords stop the dress billowing. The eyes were inlaid with glass and stone, silver for the head-band pattern, copper on the lips. He held reins and, presumably, a goad. Scraps of the chariot, horse legs and tail have been found. Dedicated for a victory in 478 or 474. An adjacent signature of Sotadas of Boeotia seems not to belong. The base reads (as restored) 'Polyzalos, victorious with his horses (chariot) dedicated me/son of Deinomenes, whom make prosper, honoured Apollo'; the first line having once read 'Polyzalos, lord of Gela dedicated (this) memorial..', which was erased, presumably because of his claim to Gela and embarrassment over his tyranny. (Delphi. H. 1.80)

1. [Μνᾶμα Πολύζαλός με Γ]έλας ἀνέ[θ]εκε[ν] ἀ[ν]άσσ[ον],
 [hυιὸς Δεινομένεος, τ]ὸν ἄεξ᾽, εὐόνυμ᾽ Ἀπολλ[ον.]

2. [Νικάσας ἵπποισι Π]ολύζαλός μ᾽ἀνέθηκ[εν],

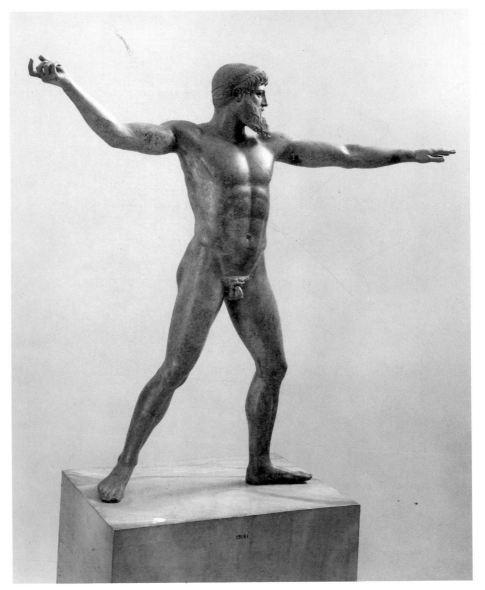

35 Bronze Zeus from the sea at Artemisium. About 460–50. (Athens Br. 15161. H. 2.09, span 2.10)

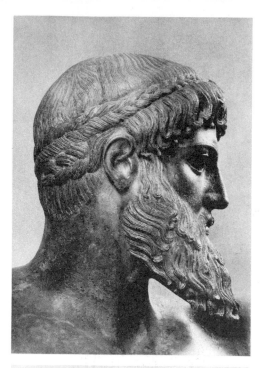

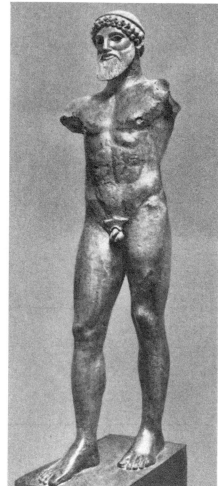

36 Bronze Poseidon from Kreusis (Boeotia).
About 460. (Athens Br. 11761. H. 1.18)

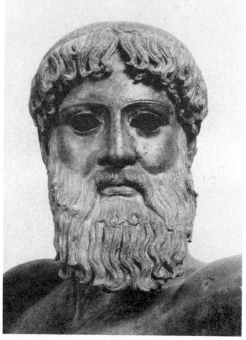

35 Artemisium Zeus

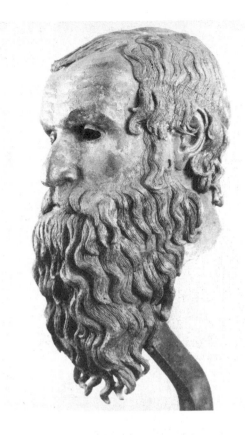

37 Bronze head from Porticello (Straits of Messina). About 450. (Reggio)

Below

38 Riace warrior (A)

39 Riace warrior (B)

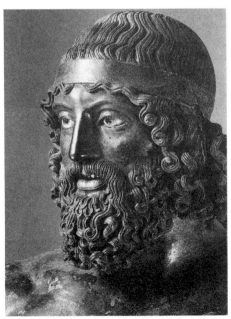

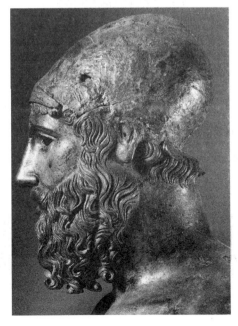

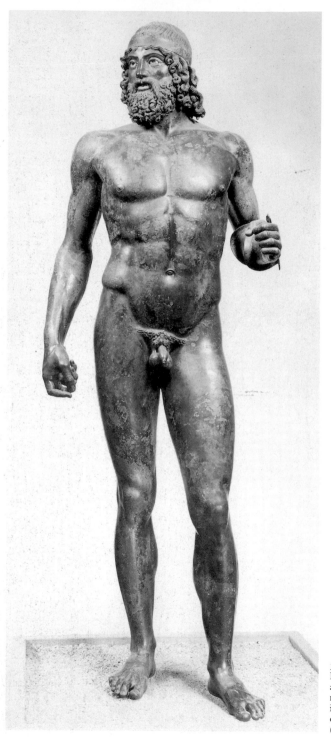

38 Bronze warrior (A) from
Riace. To be restored with spear
and shield; copper on lips and
nipples, silver on teeth, eyes
inlaid. There was perhaps a wreath
over the hairband. About 460–50.
(Reggio)

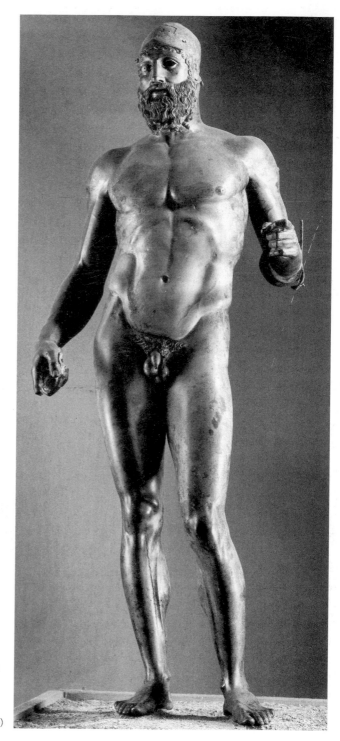

39 Bronze warrior (B) from
Riace. To be restored with sword
(?), shield and helmet; copper on
lips and nipples, the inlay of one
eye remains. The right arm and
left forearm were replaced in
antiquity. About 460–50. (Reggio)

Chapter Six

EARLY CLASSICAL RELIEF SCULPTURE

Relief sculpture with figures virtually in the round, or lightly foreshortened against their background and overlapping, yet with their main features brought into forward plane, was an invention of Greek sculptors. The most extreme forms, with figures wholly in the round, and barely attached to their ground, are to be found in the latest Archaic (*GSAP* fig. 213) but are more adventurous in the Early Classical period and sublimely so in Classical for architectural sculpture, but the Archaic period presented all other styles, from barely carved drawing, to subtler compositions successfully constructed in a shallow field. In Egypt and the Near East relief sculpture could claim to be no more than carved drawing except where, in Egypt, a background pillar had been left to help support a standing figure.

The non-architectural reliefs of the Early Classical period offer no technical advance on the Archaic although we may admire the skills of a sculptor who, in an extremely shallow field, succeeds in foreshortening his anatomically more realistic figures: this had been less of a problem while anatomy was still pattern rather than modelling.

We look first at votive and architectural reliefs, then at the grave reliefs. In both areas the Early Classical record differs from the Archaic and the full Classical in sources (minimally Athens) and stereotyped forms. In both we detect tendencies already apparent in the Late Archaic, towards some broader reliefs which can accommodate two or more figures, and towards an architectural setting for the reliefs, with side pilasters (antae) and roof or pediment. But the slim one-figure relief is not forgotten.

Votive and architectural (non-temple) reliefs

Attica offers no relief gravestones of this period and few, but interesting reliefs for other purposes. The Sunium boy [*40*] is a good example of the successful shallow modelling (only 3 cm deep) of a basically unpatterned body. Profile heads are naturally *de rigueur* on such works. The Athena from the Acropolis [*41*] is hardly more deeply modelled but can rely on the fall of her dress to suggest depth. The boy crowning himself is an

introspective figure, the Athena pensive if not mourning: both are distant in mood from the Archaic and demonstrate the new dimension of feeling which sculptors seek to express through subtler and less emphatic use of conventional poses and figures. The effect of such figures in the round or relief and at any scale, depends more now on the collusion of the viewer than on emphatic statement of pose and gesture. Both these reliefs are votive, the boy personal, the Athena possibly civic. A more explicitly votive relief suggests contact between the mortal dedicator, an artisan, and the goddess [42].

Thasos offered relief sculpture in architectural, non-temple settings in the Archaic period (*GSAP* figs 223, 263) and the tradition continues both for city-gate decoration, and in other positions in the city [43]. Here the style seems retarded Archaic. The banquet relief from Thasos [44] presents a scheme much used in later years on gravestones to depict the recent dead as heroes, but this perhaps refers to a heroized ancestor and carries no inscription to help us (cf. the Late Archaic relief from Paros, *GSAP* fig. 255, with similar scheme). From Melos comes a disc with a goddess' head, presumably a votive [45].

The Ludovisi Throne [46] was found in Rome. Features of its subject matter can be paralleled in South Italy, at Locri, and its style has seemed to some Western, but is not incompatible with a homeland Greek origin. There is no good evidence for such accomplished work in marble relief in the west at this date and the stone is Greek. Wherever it was made it is better explained stylistically in terms of homeland Greek sculpture. A companion relief, the Boston Throne [47], is also from Rome and has apparent iconographic links with Locri, but its authenticity is questioned, and it should not affect assessment of the Ludovisi piece. I illustrate it because it is well known, but modestly while it is *sub judice*.

The Ludovisi Throne is a three-sided, hollow (open-backed) relief which might have edged an altar or pit, but not a throne. The master of this fine relief loved both dress and undress – our first fine female nude. On the front the figure to the left wears a peplos, its folds slightly heavier than those of her companion's chiton skirt, whose upper part is crinkled. The naked body of the goddess between them is etched with lines of her wet raiment while the cloth held before her hangs in the catenary folds of a peplophoros overfall. At the sides we enjoy the tight cloak wrapped around the woman, the plump cushions, the girl's nakedness. The artist has still much to learn of anatomical foreshortening in shallow relief (the girl's breasts are admirable but where is her farther hip?) but he had a strong feeling here for bodies, for dress and for space-filling composition, and the relief carries in it the best of the Archaic tradition rather than intimations of the Classical. It remains a welcome enigma.

Another enigma is the Metrological Relief in Oxford [48]. It is so

called because the life-size figure appears to be demonstrating a fathom with his outstretched arms, yet the footprint cut in the ground above his right arm is one-seventh of this span and not the canonical one-sixth. Possibly it demonstrates a combination of measuring standards (Athens tried to enforce new standards in her empire but Greeks were slow to accept any national standard and clung, none too accurately, to local varieties in weights and lengths). It hardly served as a precise yardstick, like the Paris metre, and computations of exact measurements of detail taken from it are, though popular, probably misguided. The style looks East Greek: compare [49] and its grooved contour. The shape, a trimmed pediment, appears for two later monuments, both with what may be funerary subjects. It may be appropriate to a heroon-like grave building.

Grave reliefs

Whatever halted the production of gravestones in Athens at the beginning of the fifth century remained effective until about 430. We turn therefore to the rest of Greece for the Early Classical record. Archaic stelai came to distinguish figures by age, and the formula of elderly men with dogs (as *GSAP* fig. 244) is fleshed out in the new manner [50]. East Greece seems to have introduced differentiation by occupation too, so beside the athlete [57] or knight [59] we find also a lyrist [56] and other figures appropriately occupied. Stelai showing women, and of different ages, become more common: the beautiful Parian girls [51–2] and more matronly seated figures [53]. For these the broader stele is needed and they may accommodate subsidiary figures too, of attendants or a whole family. These especially somehow lend an air of both heroization and a more effectively domestic atmosphere. Comparable heroizing of the male will come with the banquet reliefs (see on [44]) and the males' stelai too admit attendant figures [57, 58].

The East Greek stelai are, in their way, conventional but the Islands are innovative with the brilliantly carved studies of young girls [51–2], both probably from Paros, and the big family from Ikaria [53]. Thessaly will present novel compositions with women, presaged in [54] with its mysterious pair. There is a scattered yield from areas of central Greece [56–8] with Boeotia specializing in fine stelai showing knights [59].

Until Attic production revitalizes the genre around 430 the history of relief gravestones in the fifth century is patchy. It is the traditions of the Late Archaic that remain dominant, providing ground for variety of theme or composition, and no new tradition is established, apart from the few local preferences which have been indicated.

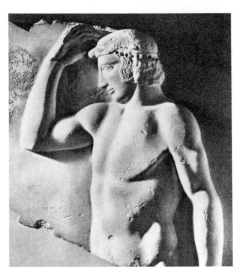

40 Relief of a boy, from temple of Athena,
Sunium. He is probably a young athlete, crowning
himself (a metal wreath fitted to the drilled holes),
but the gesture has (less plausibly) been interpreted
as funereal. The temple had been destroyed by the
Persians but this was found in later fill. About 470.
(Athens 3344. H. 0.59)

41 Relief of Athena from the Acropolis. She
wears a Corinthian helmet, the familiar peplos
with long, girt overall, and leans on her spear
contemplating a pillar. The background was
blue. The pillar has been interpreted as a
finishing post (*terma*) in an exercise ground or
the boundary stone (*horos*) of a sanctuary, but is
perhaps a list of Athenian dead since her pose
seems decidedly sorrowing, and this is the
period in which annual state burials and funeral
orations were inaugurated. About 470. (Athens
Acr. 695. H. 0.48)

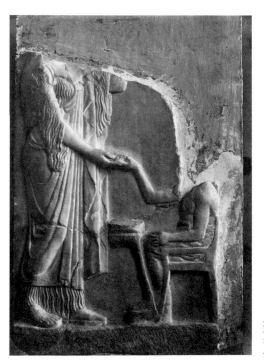

42 Relief from the Acropolis. Athena in
himation and peplos receives a tithe or offering
from an artisan seated at his work table. About
480–70. (Athens Acr. 577. H. 0.575)

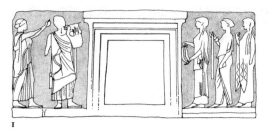

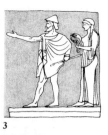

1 2 3

43 Reliefs from the Passage des Théories on Thasos, an important
route from the agora. 1. Apollo with kithara being crowned by an
attendant and, at the other side of a niche, three nymphs. 2. Three
Graces (Charites). 3. Hermes and a woman. Accompanying
inscriptions define sacrificial procedure for Apollo, the Nymphs
and Hermes. About 470. (Louvre. H. 0.92)

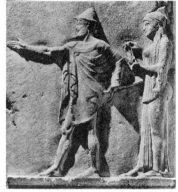

43.3

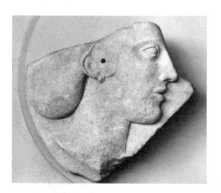

45 Disc relief from Melos. To be
restored either with a flower in the
hand raised before her (as
Aphrodite), or Selene (the Moon)
who appears as head-in-disc in this
period. About 460. (Athens 3990.
H. 0.32)

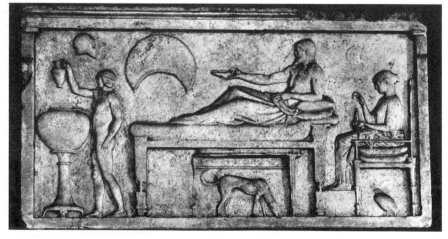

44 Banquet relief from Thasos. A hero at symposion holds out a phiale. Below his side table, a
dog; behind him his consort sits opening an alabastron (perfume bottle); in front a boy at the
wine bowl. Helmet and pelta-shield hang; a partridge under the chair. About 460. (Istanbul 578.
H. 0.625)

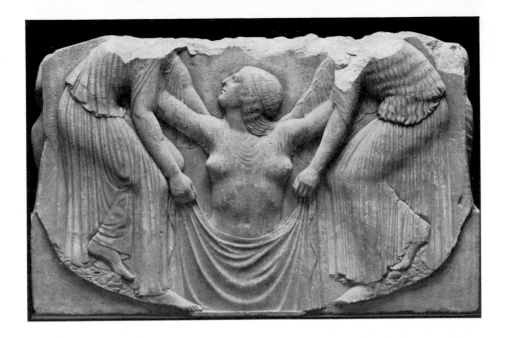

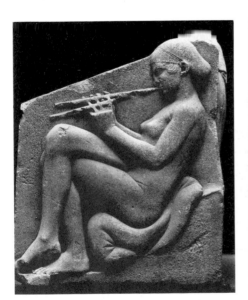
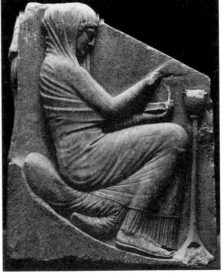

46 The 'Ludovisi Throne', from Rome (in the area of the Gardens of Sallust where other Greek statues have been recovered). Front – a goddess is helped from the sea (wet dress, pebbly beach) by two women who prepare to wrap her. Probably the birth of Aphrodite, but a child-birth has been suggested, or a return of Persephone. For Aphrodite speak the subjects at the sides, appearing to personify sacred and profane elements of her cult and function: a naked pipes-girl and a young matron placing incense on a burner (its cover hanging from it; her sandal-straps would have been painted on). The plain corner pieces would have been covered with separately carved finials. About 460. (Rome, Terme 8570. H. 1.04)

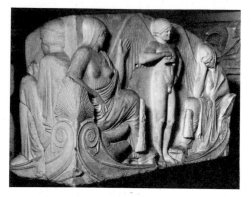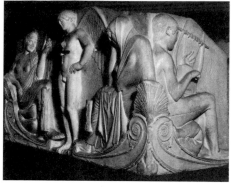

47 The 'Boston Throne', from Rome. Front – Eros weighs (the balance-arm missing) two small naked men, suspended with hands bound over the scale-pans. The women at either side register pleasure (for the lowered pan; not the usual scheme for soul-weighing in Greek art) and distress. Sides – a young lyrist and an old woman with cropped hair, spinning (this side trimmed back). The style is poorer than that of 46, imitative, it may be. (Boston 08.205. H. 0.96. Cast in Oxford)

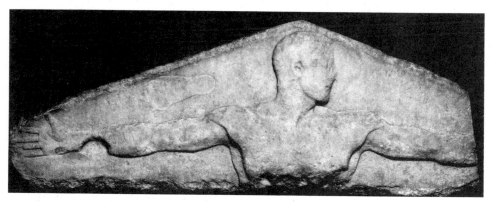

48 Metrological relief. The block is complete (except to the right) and finished below. The footprint is cut into the background, not in relief. The edge of the figure is lightly grooved where it meets the background. About 460. (Oxford L. 1.73; restored L. 2.05)

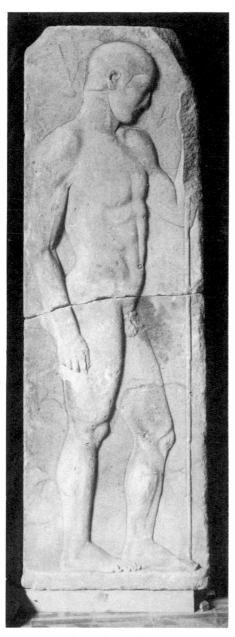

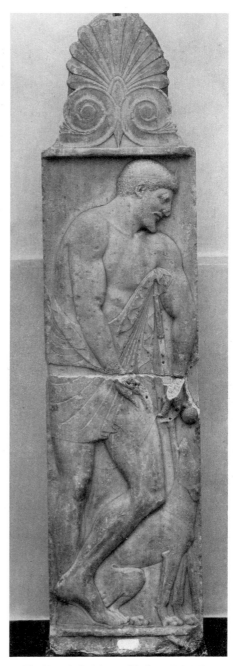

49 Gravestone from Nisyros (Dodecanese). A young athlete holding a javelin, a discus standing upright beyond his left foot. The edge of the figure is grooved; cf. *48*. About 460–50. (Istanbul 11. H. 1.83)

50 The 'Borgia Stele', possibly from Asia Minor (Sardis ?) A man and his dog. He carries an aryballos on his left wrist. Cf. *GSAP* fig.244. About 470. (Naples 98. H. 2.50)

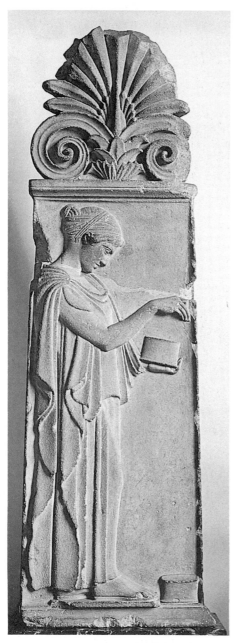

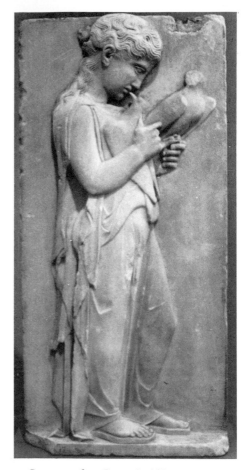

52 Gravestone from Paros. A girl in an ungirt peplos holds two doves. To be restored with a floral finial as 51. About 450. (New York 27.45. H. 0.80)

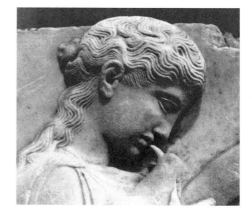

51 The 'Giustiniani Stele', possibly from Paros. A girl in an ungirt peplos lifts a necklace (?), which would have been painted, from a cylindrical box, the lid of which is on the ground before her. About 460–50. (Berlin (E) 1482. H. 1.43)

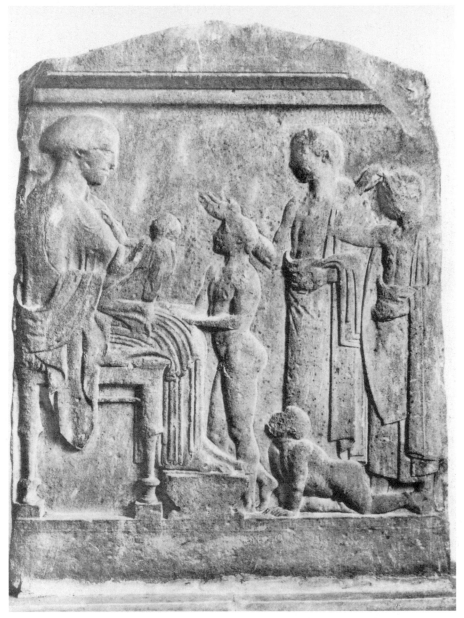

53 Gravestone from Ikaria, made by Palion of Paros, set up by Koiranos and Euryme[des, brothers of Apollonie. A seated woman with two boys and three naked children, two of them babies. (A roughly comparable scene of this date appears on the 'Leukothea Relief' found in Rome, which has four girls, from baby to grown, with the woman. Its style is provincial, its origin uncertain.) About 460. (Ikaria. H. 1.56)

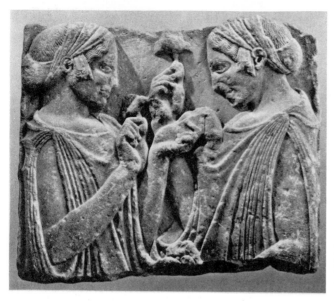

54 Gravestone from Pharsalos
(Thessaly). Two girls, wearing
peploi, holding flowers and (left)
a purse, (right) fruit (?). Some
have thought the right-hand
figure was seated. About 470–
60. (Paris 701. H. 0.57)

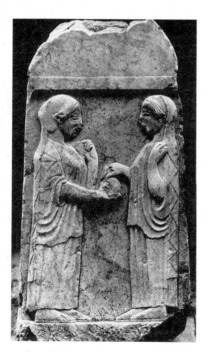

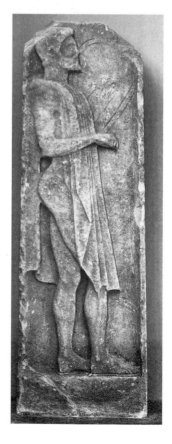

55 Gravestone from Phalanna (Thessaly). Two girls, one holding an
apple. About 460. (Larisa. H. 1.03)

56 (right) Gravestone from Vonitsa (Acarnania, W. Greece). An
elderly lyre-player. Cf. 235. About 460. (Athens 735. H. 1.88)

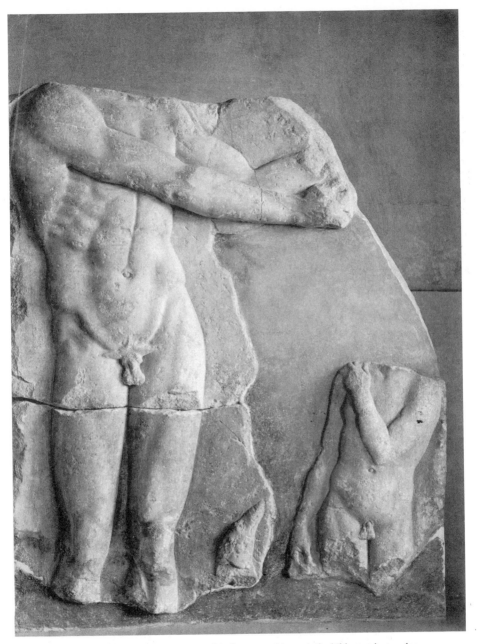

57 Gravestone from Delphi. A youth scrapes his forearm with a strigil; child attendant; a dog between them. About 470–60. (Delphi. H. 1.32)

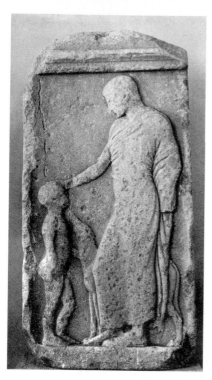

58 Gravestone from Aegina. Man, child and dog. About 450. (Aegina. H. 1.07)

59 Gravestone from near Thebes. Cavalryman wearing helmet, chlamys, chiton, greaves. The dress is mannered, Archaic. About 480–70. (Boston 99.339. H. 0.81)

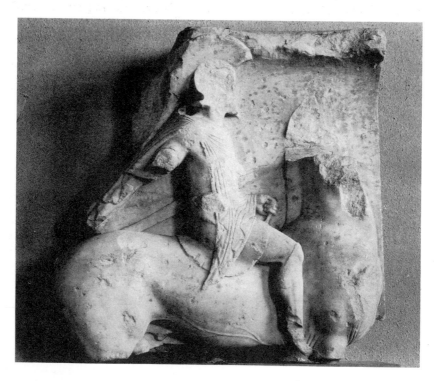

Chapter Seven

NAMES AND ATTRIBUTIONS

Kritios and Nesiotes

See above, Chapter 3, on the Tyrannicides and *GSAP* 84–5, fig. 147.

Pythagoras

was born a Samian but emigrated to Rhegion in South Italy, probably at the start of the fifth century, with a number of his other countrymen. Some ancient writers make two Pythagorases but a signature of the Samian on a dedication at Olympia by a western Greek (Astylos of Kroton) supports identity. His namesake, the philosopher-mathematician, had emigrated to Kroton a generation before, and the younger man may have shared some of his interest in theories of proportion since his work was credited with *rhythmos* and *symmetria* (Diogenes Laertius; cf. on Polyclitus, below p. 205), but also with attention to physical detail – sinews, veins, hair (Pliny). He was allegedly (Paus.) taught by a Westerner (Klearchos of Rhegion) but most of his works were in Greece, though for Westerners or a Libyan. They included athletes' statues, but also a group of Europa and the Bull for Tarentum and at Syracuse a lame man (Philoktetes?) said by Pliny to arouse the sympathy of the spectator. His dates for works range from 488 to 448, making him a forerunner and rival (Pliny) of Myron.

Kalamis

worked in Athens and was perhaps Athenian. Later namesakes have confused the record – a silversmith, and a sculptor (late fifth century) who made a chryselephantine Asklepios for Sicyon and perhaps the Apollo Alexikakos for Athens which celebrated release from the plague in the Peloponnesian War (Paus.: 2 medical statues). So his rich list of works in ancient sources may be rather unreal. The Early Classical Kalamis made horsemen for a group celebrating success at Olympia by the Syracusan tyrant Hieron in 468 (set up after his death in 467; Paus.). On the Acropolis was a Sosandra (Saver of Men), which Lucian much

admired, and which is likely to have been the Aphrodite dedicated by Kallias (Paus. and perhaps part of the base surviving), which, if by *the* Kallias, would make it Early Classical. He made a Zeus Ammon for the poet Pindar, who died around 440, at Thebes (Paus.).

Myron

came from Eleutherai, on the borders of Attica and Boeotia. He worked through the Early Classical period and perhaps later. Ageladas was said to have been his master (Pliny), as was alleged also for other major fifth-century sculptors (Phidias and Polyclitus). His datable works are of the 450's and 440's. Ancient writers saw him as standing on the threshold of realism in sculpture, though not expressing emotion. His most famous statue was a bronze cow on the Acropolis which could be mistaken as real. His work no doubt appeared primitive in many respects (Pliny singles out his treatment of hair) but was respected for its honesty, vigour and novel poses, such as his runner Ladas, on tiptoe with muscles taut. His Diskobolos (discus thrower) is easily recognized in copies from Lucian's description [60]. The head has touches of the Archaic still, the hair a cap of shallowly carved ringlets. Despite the apparent freedom of pose the figure is cut in one plane, for a single viewpoint, like high relief without a background. Pliny's mention of a group with a satyr amazed at the pipes and Athena can be reconstructed from copies of the separate figures [61–3], and reflections of the group in other arts, including a near-contemporary vase [64]. Again there is originality of pose – the satyr (Marsyas) starting forward yet hesitating: Athena's dismissive gesture. She is almost girlish, the satyr an intelligent beast. Myron's œuvre also included several other animal statues and a colossal group of Athena, Heracles and Zeus (probably the introduction of the hero to Olympus) on Samos.

60 Copy of Myron's Diskobolos, from Rome (Esquiline). '. . . stooping in the pose of one preparing to throw, turning towards the hand with the discus and gently bending the other knee, as ready to rise and cast' (Lucian). This is the only copy with the correct head (also known from separate copies). Original of about 450. (Rome, Terme 126371 'Discobolo Lancelotti'. H. 1.55)

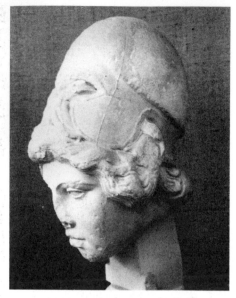

60

62a Head of Athena, see 61. (Dresden. Cast in Oxford)

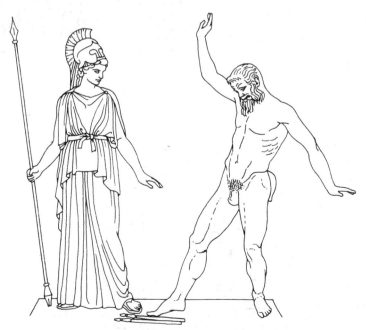

61 Restored group of Athena and Marsyas by Myron. The goddess had invented the pipes but was displeased by the appearance of her face as she played and threw them down, to be claimed by the delighted satyr. A dithyramb-play on the subject by Melanippides may have been the occasion of the dedication of the group on the Acropolis. Original of about 450.

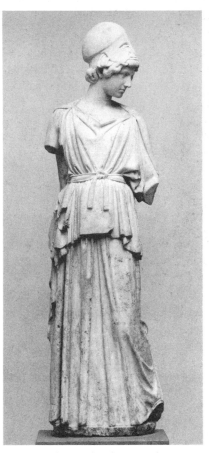

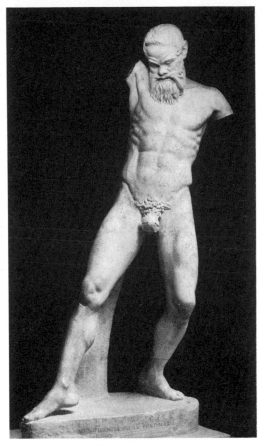

62b Copy of Myron's Athena, see *61*. (Frankfurt 147. H. 1.73)

63 Copy of Myron's Marsyas, see *61*. (Rome, Lateran BS225. H. 1.59)

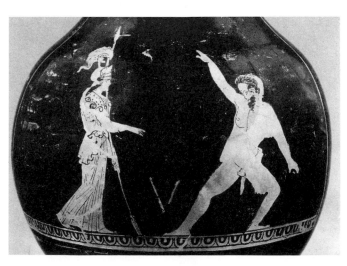

64 Athena and Marsyas on an Attic red-figure vase of about 440. (Berlin (W) 2418)

Chapter Eight

OTHER COPIES OF THE EARLY CLASSICAL

The problem of the use of copies to demonstrate the development of style or works of named artists becomes acute only with the succeeding period (Chapters 15, 16) but we have already found occasion to identify monuments and the works of known sculptors with their help (the Tyrannicides, and in the last chapter) and we rely very much on them for an adequate conception of the whole figures of Early Classical standing males which, in original, we can judge mainly in statuettes or in architectural sculpture. Thus, of the few copies presented here, half are of the 'Apollos' [65–9]. Some may copy athletes' dedications, others, especially the long-haired, the god himself. A clear dividing line between these and the copies of works of the full Classical period cannot be drawn. I have kept here the pre- or non-Polyclitan poses (no raised heels) but they include statues whose originals are, perhaps rightly, classed as Phidian, even, some say, a copy [69] of the Apollo from his famous group at Delphi to which the Riace bronzes [38–9] have been attributed. To the same group Professor Barron now gives the Athena [183], long regarded as Phidias' Lemnia, which stood in Athens. The associations are impressive but still unproven and I have left Lemnia where she has long stood in text-books.

Major figures of peplophoroi are on the whole better known in copies [73–4] than originals, but the austere style was one easily copied and the famous group of bronze dancers from Herculaneum, in poses which have more to do with dressing than dancing, are very probably late creations in the Early Classical manner.

The reader will observe that these copies are named in various ways – from the collection in which they stand or once stood; or from their most popular identification, even if demonstrably unlikely; or from a feature of their setting; or sometimes more than one of these, especially where several copies exist of the same type.

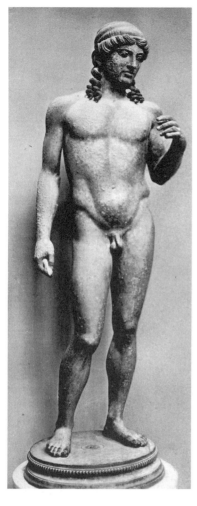

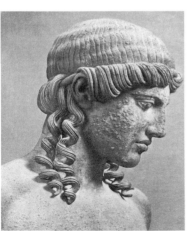

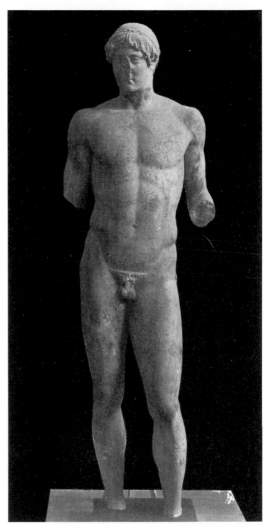

66 'Omphalos Apollo'. Copy of an original of about 460. Found in the theatre of Dionysos at Athens beside an omphalos (not relevant to it). Much copied (see 67). probably an Apollo. (Athens 45. H. 1.76)

65 (*above left and left*) 'Apollo Mantua'. Bronze copy of an original of about 460, from Pompeii. The figure is probably to be restored with a lyre. (Naples 831. H. 1.58)

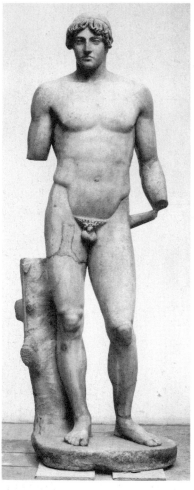

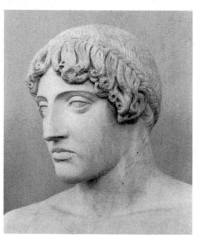

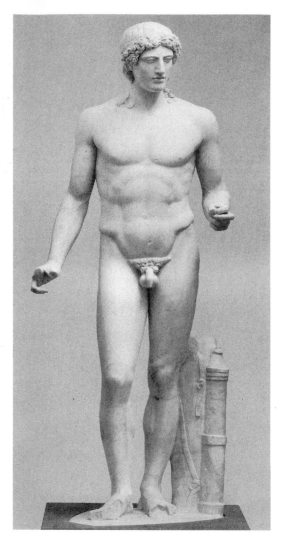

68 'Kassel Apollo'. Copy of an original of about 450. The most advanced version of the Early Classical standing male type, but conveying a greater impression of imminent motion; contrast 66—7. Certainly an Apollo, for his long hair, holding a bow in left, laurel branch in right hand. The elaboration of the hair reflects the complexity of the bronze original. Some resemblance in physique to 38–9. Commonly associated with Phidias. (Kassel SK3. H. 1.97)

67 (above left and left) 'Choiseul-Gouffier Apollo'. Copy of an original of about 460. A duller but more complete version of 66. (London 209. H. 1.78)

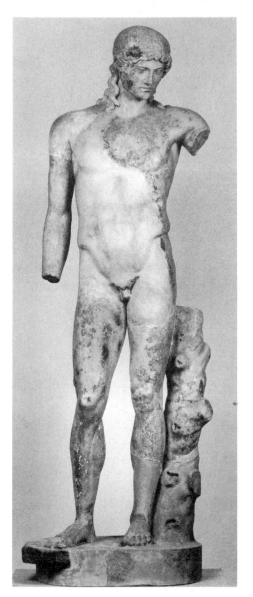 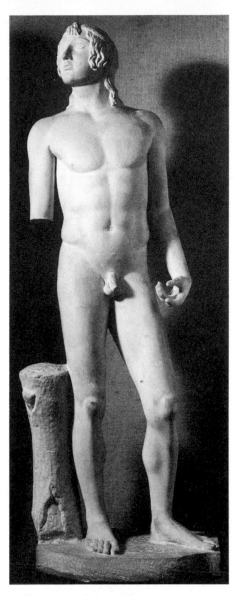

69 'Tiber Apollo'. Copy of an original of about
450. A version far more sensitive and relaxed in
stance of the type represented by *68*. Also
commonly associated with Phidias. Probably
holding laurel branch and bow. (Rome, Terme
608. H. 2.04)

70 'Eros Soranzo'. Copy of an original of about
460 (?). The general style is Severe but the pose of
the head unexpected and the figure must have been
grouped with another (if Eros, Aphrodite ?) which
perhaps better suits a 1st cent. BC date, classicising.
(Leningrad 85. H. 1.59. Cast in Oxford)

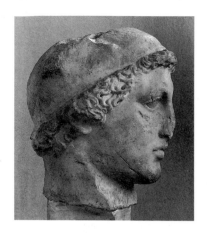

71 'Perseus' head. Copy of an original of about 450. The winged hat suggests the identification. (Rome, Conservatori. H. 0.29)

72 (*below*) Heracles. Copy of an original of about 450–40. The small boar on the tree trunk is a copyist's addition (not on other copies) and is hardly the Erymanthian. This is the earliest sculptural type of Heracles resting, a common later theme (and cf. *22.1*). Often identified as from Myron's group of Heracles, Athena and Zeus on Samos, although his companions are less readily identified in copies and there are no full-size versions. (Oxford 1928. 829. H. 0.53)

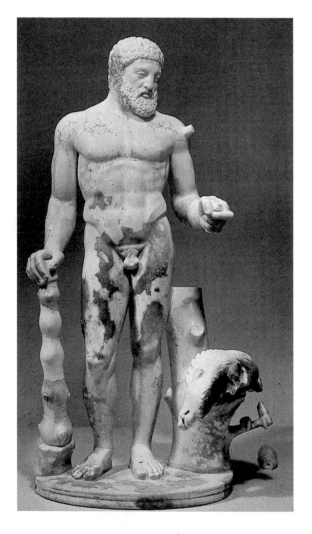

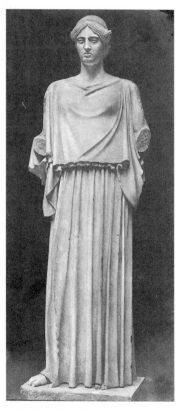

73 Ludovisi/Candia peplophoros type. Copy of an original of about 470–60. The classic peplophoros. This example has her head restored from another copy of the same type. (Rome, Terme 8577. H. 1.56)

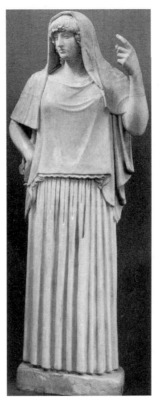

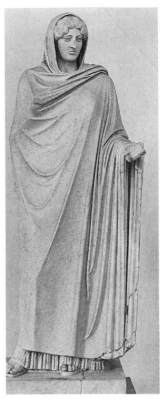

74 'Hestia Giustiniani'. Copy of an original of about 470. A matronly peplophoros, perhaps Hera or Demeter, wearing a veil. Left arm restored, probably correctly. Her stance, relaxed to her right with back of hand on hip leaves the vertical folds of her skirt undisturbed. (Rome, Villa Albani, Torlonia 490. H. 1.90. Cast in Oxford)

75 (far right) 'Europa'/'Aspasia'/ 'Sosandra'/'Amelung's goddess'. Copy of an original of about 460–50. Heavily swathed in himation. Amelung's reconstruction of the type was confirmed by discovery of an unfinished but complete copy at Baiae. A statuette version is inscribed 'Europa' and she appears similarly dressed on a vase of about 410–00, so this is probably the correct identification. The body was much used for Roman portrait statues. (Berlin (E) K166 + 167:605 + 1158)

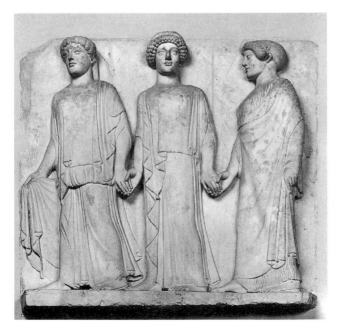

76 Charites (the Three Graces). Copy of an original of about 470–60 (?). The style is Severe but the variety of hairstyle and vagaries in dress have suggested a late pastiche. However, copies also appear on slabs from the Piraeus (with 109) which suggest an earlier model. Paus. saw Charites by Socrates (not the philosopher, as he says, but perhaps the Boeotian who had worked for Pindar) on the Acropolis (see on 189). (Vatican 'Chiaramonti relief'. H. 0.83)

Chapter Nine

CLASSICAL SCULPTURE AND ATHENS: INTRODUCTION

The relative poverty of Athens' record in the Early Classical period will have been observed by the attentive reader: no major complexes of architectural sculpture, no major grave monuments, a few votive reliefs, and statues, some of bronze, for the Acropolis, attested by their bases or from literature. In 480 and 479 the Persians occupied Athens, sacked and burned its buildings. On the Acropolis they 'plundered the temple and set fire to every part of the citadel' (Herodotus), ruining what had so far been prepared of a second Athena temple on the site of the later Parthenon. This building had not reached the stage of having sculpture cut for it, and of its architecture little beyond the foundations could be reused after the sack, and much went into the repaired north wall of the citadel rock.

Before the Battle of Plataea in 479, the decisive final defeat of the Persians in mainland Greece, the Greeks (it was said) swore an oath that 'I will not rebuild any holy shrine burned and destroyed by the barbarians, but I shall let them stand as a monument to future ages of the sacrilege of the barbarians' (so recorded by the fourth-century orator Lycurgus). The historicity of the Oath of Plataea was doubted even in antiquity (notably by Theopompus, as early as the fourth century), and it was certainly not observed to the letter by Greek states, among whom Athens and the East Greek cities had been the chief sufferers. After 479 Athens created a League, which became an Empire, to drive the Persians from all Greek lands, and by 450 (the 'Peace of Kallias', also doubted by some ancient and modern scholars) this had been achieved. Four years earlier the League's treasury had been moved to Athens from Delos and from then on one-sixtieth of the tribute was reserved 'for Athena'. Since 479 there had been much public building in Athens, notably the Theseion and the Painted Stoa, but nothing involving sculptural rather than pictorial embellishment, and no replacing of the ruined temples.

Plutarch says that Pericles, leading statesman of Athens in the mid-century, summoned a pan-Hellenic congress to discuss, among other things, 'the Greek shrines which the Persians had burned'. The Congress may never in fact have been conceived and certainly never took place,

but it is clear that Pericles decided that he could use League money to rebuild Athens, now that Greece was 'free', and ignore the protests at this apparent embezzlement which arose both within and outside Athens: funds 'wantonly lavished out by us on our own city, to gild her all over, and to adorn and set her forth, as it were some vain woman, hung round with precious stones and figures and temples, which cost a world of money'. The result was a spate of new temple building in the lower city of Athens and in Attica, generally on the sites of older temples and many of them the design of one architect. Most were completed before Pericles' death in 429 but on the Acropolis, which was entirely rebuilt, he lived to see only the new temple for Athena (the Parthenon) and the new Propylaea, not the replacement for Athena's old temple (the Erechtheion) or the temple of Athena Nike.

Apart from the sculpture and cult statues created for these buildings there were other public sculptural monuments to commemorate Athenian success against Persia, notably the Marathon Group at Delphi, and the Athena Promachos on the Acropolis. But it is the progress of the architectural sculpture on Athens' new buildings that provides our yardstick for the development of Greek sculpture in this, the High Classical period. Many of the buildings and even the progress of work on them can be closely dated by criteria which are not merely stylistic. Architectural sculpture does not, of course, always demonstrate the finest achievements of a period or a school. It is generally anonymous, unlike individual monuments and dedications, and when we are allowed a glimpse of these we can judge what we are missing. The best of the Parthenon sculptures are the most battered; the frieze has its longueurs; Roman copies are at best pedestrian translations; but the Riace bronzes [38–9] make the blood leap and their quality, we should remember, lurks disturbingly behind the blander products which will occupy many of the following pages. We have to judge the art of a period whose masterpieces were of bronze mainly through its surviving marble sculpture, most of which was not free-standing but subordinated to the needs of architecture. It was also thus distanced from its viewers, a shortcoming corrected by modern museum display, and which seems, in antiquity, not seriously to have discouraged the artist from lavishing care on the detail and finish of his works.

The burst of activity in an Athens long quiescent in the practice of the sculptors' arts presented some problems of personnel. Phidias, whom we might cast as Pericles' Minister of Arts, was an Athenian, already an established artist. His teachers were said to be Hegias (Hegesias) who worked in Athens, or the Argive Ageladas. The latter was also said to be teacher of Myron, who came from the borders of Attica (and, incidentally, of Polyclitus). That the Peloponnese had been the training

ground of the generation of sculptors who worked for Pericles comes as little surprise until we consider their style. But the completion of a major architectural and sculptural programme required also an army of apprentices and masons, at all levels of skill, and these must have been recruited from the islands or again from the Peloponnese. That a common style could be created, and, to some degree, imposed, and that it should differ so markedly from the 'Severe style' of the preceding generation says much for the genius and example of its creator or creators, foremost among whom must have been Phidias.

The sculptural style of Classical Athens was to prove the most influential of all antiquity. It must be judged and described with reference to what went before – mainly Peloponnesian and Olympia – as well as in terms of its positive achievements. At Olympia the nuances of expression in faces and age in bodies gave promise of a developing subtlety in depiction of emotion and action. This was not, however, the direction in which the Athenian school chose to move. The path to realism and deep psychological study was broad and easy, and later generations would travel it swiftly. The triumphant citizens who had withstood the Empire of the east had seemed to walk and fight beside their gods. So had they in the Golden Age of Heroes, in the light of which, in art and on the stage, they constantly set their own problems and achievements. Their war dead were assured immortality, and the annual oration for those who had died for Athens dwelt upon the divine character of the city's past (we would say mythical) and present successes. Greeks fashioned their gods in the likeness of men, and their men, their heroes, partook of the divine. This is implicit in much of their poetry and philosophy. The timeless quality which could be detected in even transient events, and especially in victory, required expression in an art which looked beyond the immediate reaction or emotion. If the results seem today passionless this is because comparable and familiar styles of the last century, themselves inspired by the Classical, had not the depth of conviction to sustain them. It requires a greater effort to appreciate the idealizing styles of Classical art, and the positive and novel qualities which they expressed in fifth-century Greece, than to respond to the more direct appeal of Archaic art or Olympia. The nineteenth century realized this – to them Classical Greece had been misread in the legacy of Hellenistic–Roman realism – although they could not recapture it. Now that the style has become more familiar it requires more thought to recapture its brilliance and not dismiss, for instance, the Parthenon Frieze as 'an impersonal pageant of heroic but utterly extrovert mimes . . . with nothing whatever in their heads' (Mortimer Wheeler), or observe in it merely a 'static, stunned quality' (Geoffrey Kirk). Not that the Parthenon sculptures were quite devoid of facial expression, although the most obvious examples,

some of the centaurs, owe more to the Archaic than the Early Classical. Nor is there lack of observation of different ages and physiques. The 'standard' head, with compactly rounded skull, large expressive eye (paint in the pupil!), small rather disdainful mouth, and generally patternless tousled hair, sets a model which was not modified until well into the fourth century – a long time in Greek art – and which was the natural model for later, classicizing periods of art.

The anatomy of male figures is generally unemphatic except in the most vigorous groups. So it had been in many figures at Olympia, but there the underlying skeletal structure was still not fully understood, while on the Parthenon (our inevitable model for the Classical style) there is a confidence of structure beneath slack, spare, or plump flesh which disarms all criticism of anatomical plausibility and makes the figures seem constructed from within, not carved from without, the enduring miracle of all stone carving. The women are now feminine, down to their Venus-ringed necks, not adjusted males. The Aphrodite of the east pediment is the first truly sensual figure in Greek art. In action groups the equilibrium, the frozen moment of arrested motion, is more nervous than in the more direct narrative of Archaic sculpture or the Olympia metopes. The effect may be more charged, but perhaps less satisfying. The new-found use of space, the way in which the sculptor can place his figures in the world and not in a frame, better suits free-standing works than architectural sculpture.

The Olympia Master had problems with dress, its natural fall and its relationship to the body beneath, while the peplophoroi offered pleasing linear patterns of little subtlety and almost no variety. The Classical treatment of dress is the most dramatic of the changes in sculptural style. The fabric is realistically draped, though probably impossible to reproduce in detail on a live model. The linear pattern of sharp arrises or folds is abetted by deeper troughs and shadows so that within the dress itself there is a play of depth, of light and shade, comparable to that sought in the representation of the human body, and even more varied. The folds emphasize and articulate the form of the body beneath, an important feature on works designed to be seen from a distance where modelled depth is less clearly apparent. This is not the effect of the precise linear patterns of earlier red-figure painting on vases, though it is an effect which the draughtsmen were to try to reproduce. The effect of light and shade and pattern is closer to that of the painter (of the generation *after* Polygnotos whose painting style was Severe, probably sub-Archaic). The detailing of dress is enhanced with whorls and crinkles, realistically disposed, but there are mannerisms too and repeated patterns – forked folds over broad stretched fabric, double folds, bellying folds, crimped selvages, most of them patterns which

derive from earlier sculptural practice but rendered in a novel manner. These mannerisms and deviations from the natural have to be looked for, however, since they are, at least at first, discreet. As the years pass a measure of flamboyance is added and dress can seem to take on a life of its own, dependent on its function, and can be used in new ways to balance or dramatically frame a moving figure. Here we have to remember what the effects and contrasts of colour might add.

On the Parthenon, dress, however skilfully composed, may still seem a carapace to the figure beneath, but there are already clear intimations of what is to become characteristic of the last quarter of the fifth century. Just as the bony structure of the body could be sensed beneath its marble skin, so the warmth and nakedness of flesh could be sensed beneath dress which clings so close that 'wet' or 'wind-blown' come naturally as epithets. This is not simply a matter of nudes with added vestiges of drapery, though it is an essentially plastic style, built on understanding of the underlying body and designed to demonstrate its forms. The dress would have been a different colour and the play of lighter or deeper folds upon it required even more subtle design. It is, however, a style which could lend itself too readily to mere prettiness.

In the subject matter of Classical sculpture we might expect an enhanced degree of humanity, however divinely inspired, and many claim to recognize it. The approach is simplistic. In their way the kouroi too were heroically or divinely human in their conception. The Parthenon Frieze, which sometimes seems to exercise an unhealthy dictatorship over our understanding of Classical art, is an uncharacteristic monument, and was the least conspicuous of the new sculpture on the Acropolis. It is in other methods of heroizing the present that the new and idealized view of the mortal is best expressed – already in commemorative statues for athletes and public figures, an interest which, with the help of a new approach to sculptural realism, will lead slowly to true portraiture; and after the Parthenon in the new series of grave reliefs in Athens.

Two further points must be made before we turn to the monuments themselves. First, Athens is not Greece. The architectural sculpture of fifth-century Athens has survived better than that of other parts of the Greek world. The picture is not altogether unjust, because Athens had more to rebuild than most and had acquired exceptional resources from which to undertake the rebuilding. But the Peloponnesian schools were still active, and even though original work was sparse compared with Attica, we know that Polyclitus of Argos was no less influential than the Phidian school, and that he expressed more consciously and clearly that preoccupation with proportion, that view of the human body as a virtually divine demonstration of mathematical principle, which had

characterized the sculpture of Greece from the days when its draughtsmen learned the Egyptians' ways of laying out colossal figures, and found how naturally they agreed with their own basically architectonic view of the forms, living or abstract, that they sought to realize in stone. These principles were no less influential in Athens, we may be sure, indeed their presence or some comparable canon seems the prerequisite of any idealizing Classical style, but we are less conscious of them, and more conscious of the new mood that they were harnessed to promote.

Secondly, the Athens of Pericles which built the Parthenon and the many temples of Attica was not the Athens which completed the Periclean programme. In 431, two years before Pericles' death, war was joined with the cities of the Peloponnese and Athens' empire began to crumble. The war dragged on, a succession of daring successes, crushing defeats, famine and pestilence with, for a while, annual invasion of Attica to devastate her crops. Yet these are the years of the building of the Erechtheion and of the temples for Athena Nike and on the Ilissos, of the casual elegance of the Nike balustrade and the new, almost saucy style of dress and undress for mortal and divine. In vase-painting the mood of escapist daydreaming is strong, and the continuing effort to complete the embellishment of Athens combined not only no little bravado, but a deeper self-confidence that the brilliance of Athens' past was more important than the setbacks of the present, and was a guarantee of a brighter future. The Athenians knew they were the best, their city the greatest, and even when it was no longer true it was an arrogant presumption that most other Greeks and barbarians acknowledged, and that the monuments of Classical Athens stood to affirm.

Chapter Ten

THE PARTHENON

Work started on the Parthenon in 447/6 BC. Much of the foundations of the temple begun after Marathon (490) and overthrown by the Persians could be reused, but they were enlarged because the new temple was to be differently proportioned, with a broad eight-column façade and not the usual six-column. The building, with its cult statue, was dedicated at the Great Panathenaea festival of 438 but accounts were still being rendered in 433/2, and all the sculpture may not have been ready in 438, indeed the pediments barely begun. It was dedicated to Athena Parthenos, Athena the Virgin. It did not replace the old Athena temple destroyed by the Persians. This had sheltered the sacred olive-wood statue of the goddess, to which the peplos robe was brought at the Great Panathenaea, and the image must have been kept in some temporary structure on the Acropolis until the Erechtheion was built for it. At first sight the Parthenon seems a temple without a cult and with no new altar to serve it: more a demonstration of civic pride and a memorial to Athens' achievements under the patronage of her goddess. To some degree this must be true but there had possibly once been an intention that the old statue should also be housed in the new temple, and it may be that a, or the, peplos, suitably enlarged, was offered to the Parthenos, though hardly draped on her. The unusual character of the building may help explain the unusual choice of subjects for the sculptural decoration, which will be discussed in Chapter 12.

Figure sculpture was placed on the building in the usual positions for a Doric structure – the pediments and the exterior metopes, but it is unusual in that all the metopes were filled, and that there was also a continuous frieze (an Ionic feature) running at the top of the wall within the colonnade – the level of the sculptured metopes at Olympia. For a major temple this was an altogether exceptionally ornate scheme, more acceptable on an Archaic treasury (as *GSAP* figs 210–12). The temple was in effect a treasury, the large rear chamber being reserved for Athena's wealth.

The state of survival of the sculpture is explained by the building's history. Conversion into a Christian church meant the construction of an apse at the east. This destroyed the centre of the pediment of which the

barest scraps survive. It then became a mosque and in 1674 'Jacques Carrey' drew the pediments, much of the frieze and all the south metopes. These drawings are a precious source. The other metopes were probably already too battered to be worth attention and had been unkindly treated by Christian hands. Thirteen years later a Turkish powder magazine in the building was ignited by a Venetian shell and the centre part of the temple was blown out, shattering parts of the frieze. Later drawings by visitors record the progressive loss and damage to the sculpture – Morosini smashed the horses of the west pediment attempting to remove them. The turn of the eighteenth and nineteenth centuries saw much scholarly interest in the building, drawings and the casting of its sculpture, and in 1812 Lord Elgin was able to rescue most of what lay on the ground or was easily removable from the building to the safety of London, where, in 1817 it was bought by the British Museum. On the building there remained some pedimental scraps (now replaced with copies) and all but two slabs of the west frieze. Other fallen pieces are in the Acropolis Museum, including substantial parts of the frieze, and museums elsewhere have oddments, including a good fragment of the frieze, a metope (s 10) and a pedimental head [84] in Paris. The nineteenth-century casts prove how much the sculpture that stayed in Athens has suffered, mainly from Athens' industrial climate, an attack now belatedly being answered. The marbles in London, and the casts rapidly spread through the universities and museums of the west, demonstrated to scholars and artists what Classical Greek sculpture was really about. They have been more influential on art and attitudes to ancient Greece in the last century and a half than they had been in the preceding two and a half millennia, and the country which has done so much to preserve and understand the Greek heritage is an appropriate setting in which they can continue to exercise their benign influence. Grounds for protest have ranged from sentiment (Byron would have preferred to let the building and its sculptures ruin naturally) to political expedience.

To a scholar the sculptures present dire problems. The battered frieze and metopes can with varying degrees of success be restored and studied, though of the metopes all but the majority of those on the south offer hardly more than ghosts. Of the pediments there are few near-complete figures and many fragments, new ones being identified and joined or tentatively placed in the composition annually. A notable programme of research in the Basel Cast Gallery has attempted to restore missing parts between the casts in light plastic so that it becomes possible to judge more accurately which figure or fragment might fit where, but the presence or absence of whole figures, even chariot groups, and the pose of the central figures, can still be argued. In antiquity the sculptures seem

never to have been accurately copied in paint or stone and echoes of them can only be identified faintly where the originals are themselves well enough preserved. We shall observe examples of this.

Marble for the temple was quarried on Mount Pentelikos, and the sculptures were roughly blocked out before removal to be finished on the Acropolis itself. The columns were still being worked on in 442/1 so the metopes could only have been placed later but were surely being worked upon before. The frieze might have been in position by 438 but it may have been worked *in situ*. The pedimental figures could be hauled into position at the end, down to 432, when we have the latest record for payment. Within fifteen years the whole task was accomplished, and this was not the only sculptural and architectural project being worked upon in Athens and Attica in these years.

Something has been said about the style of the sculptures in the last chapter, their subjects are treated in Chapter 12 and the figure captions discuss the restorations and identity of figures. Pausanias, the second-century AD traveller, is our only ancient source for the Parthenon sculptures. He ignored the metopes and frieze, and described only the subjects of the pediments – the dispute between Poseidon and Athena for Attica at the west: the birth of Athena at the east – which we might barely have guessed from the surviving fragments. So we are left with the record of the stones themselves and what visitors saw and drew.

The Pediments

The cuttings in the floors of each pediment give remarkably little information about the figures they supported. Rectangular sinkings in the outer corners probably supported a lifting device, not sculpture, and towards the pediment centres are cuttings for iron bars to support the extra weight of overhanging figures. The sculptures were worked wholly in the round and finished at the back, a demonstration of artistic integrity or an indication that they were on display for a while before installation, or both. Yet some parts, invisible from ground level, were left unfinished; others, equally invisible, were detailed. Though each figure must have been planned to fit the pediment, deviation in execution meant that some needed trimming – e.g., West A [79.1]. The depth of the pediment floor meant that some figures, even those reclining, could be angled out, and this, with the variety of body angles, even for seated figures, and the readiness to let figures even overlap the frontal plane of the gable, mitigated the four-square frontality which is almost unavoidable in a shallower or less well designed pediment. Most of the figures survived for Carrey to draw, and substantial pieces of some are still extant.

The composition is crowded and the constraints of the awkward field were as sore a challenge to the designer as they must often be to the credence of the modern viewer. Removed from the pediments the figures lose little by being judged independently, and when a sequence is preserved, as with East A–G and K–O, we can begin to appreciate the genius of design and expect that little of this was lost when the sculpture was skied 16 metres above the ground. But no earlier pediments were so cluttered.

WEST [77].

The centrepiece was a great cross of the two gods, Athena and Poseidon, sweeping away from each other, yet closed by their glance, their enmity and the direction of their weapons. The rearing chariots behind them answer and check the outburst of the duel, and the charioteers and attendant deities are also swept to and fro by the motion and conflict. Beyond them matters are calmer and the forceful symmetry of the central group is not as emphatically carried through to the wings. Seated, reclining and kneeling figures of both sexes and all ages attend rather than watch the outcome of the struggle. They must be the early kings and heroes of Attica and their families, and identification of individuals is not easy. They are there because they ought to be, not to convey any sense of apprehension over the future of their country. Athena had promised the olive tree, which must have been shown somewhere near the centre. Poseidon threatened inundation, and the sea monster which attends his consort-charioteer Amphitrite recalls this, and answers the land-bound snake coiled beside B who is surely the Attic king Kekrops, often himself shown with serpent legs in Classical Athens. Snakes are important in Athenian pre-history and attend Athena herself as Promachos and Parthenos.

Of individual figures the reclining A [79.1] invites contrast with the river gods of Olympia. C seems to cower away from the central action to the protection of her father [79.2]. Restless, deep-cut and bunched folds swirl across her breasts and over her right thigh. Of the protagonists there are substantial pieces only of their torsos [79.4], but the upper part of the Poseidon (M) seems to have been copied for Tritons on the façade of the second-century AD Odeion of Agrippa in the Agora [81]. The Iris (N) is the most vigorous of the pediment figures [79.5] and the charioteer (O) beside her is dully executed by comparison. Carrey's drawings and original fragments show that some of the west pediment figures (B, C, L, Q, W?) were copied (and others adjusted) at a much reduced scale for a second-century AD pediment at Eleusis devoted to a different subject (the rape of Persephone) [82]. A recent suggestion that Zeus' thunderbolt divided the quarrelling gods seems supported by a late fifth-century vase

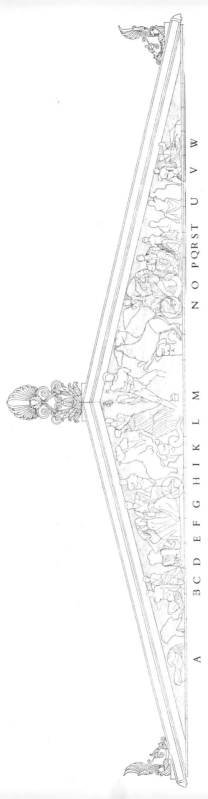

A B C D E F G H I K L M N O P Q R S T U V W

77 Parthenon. West Pediment. Drawing combining extant fragments with Carrey's drawings. After Berger. (The originals are in London unless otherwise stated). The figures drawn by Carrey are left plain

A – reclining hero (or river god, 'Ilissos'; cf. 18.A,P). B, C – King Kekrops and daughter, coiled snake between them. D–F – perhaps Kekrops' other daughter and between them his son Erysichthon. G – Athena's charioteer, probably Nike. H – Hermes. I, K – the horses' belly may have been supported by a Triton. L – Athena (London and part of head in Acr.). M – Poseidon, cf. 8'. Between L and M many place an olive tree (of which there are scraps which might belong); or Zeus' thunderbolt (Simon). N – winged attendant of Poseidon's chariot, probably Iris. O – Poseidon's charioteer, his consort Amphitrite; a sea-serpent (ketos) with porcine snout below. P, Q, R – woman with 2 children, probably Oreithyia, the Attic princess with Kalais and Zetes. S, T, U – a youth on a woman's lap and another woman. V – kneeling male. W – reclining woman. 'Kephalos and Prokris' for V and W are implausible. Local river or fountain (Kallirhoe) deities are suggested (cf. A, and Olympia east, according to Paus.). Probably all (A–F, P–W) are Attic royalty or heroes

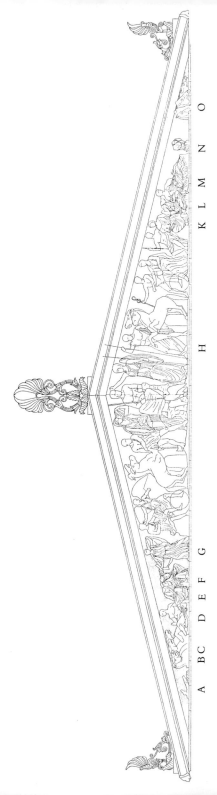

A B C D E F G H K L M N O

78 Parthenon. East Pediment. The Basel reconstruction (by Berger).

A–C – The Sun (Helios) and his chariot. D – reclining on an animal skin; almost certainly Dionysos. Other candidates are Heracles (also an Olympian 'outsider' but implausibly attending the birth of the goddess who introduced him there), less probably Ares, and impossibly Theseus (the usual earlier identification). E, F – seated on boxes, not much like Eleusinian cistae but these may be Demeter and Kore. Otherwise Horai (Seasons), not commonly shown in pairs or on Olympus. G – perhaps Artemis. K, L, M – probably Hestia, and Aphrodite in the lap of her mother Dione. N (Acr.Mus.), O – The Moon (Selene) or Night (Nyx) and her chariot. There is also a torso (H) usually taken for Hephaistos (or Poseidon); pieces of a peplos figure (Acr.Mus.) perhaps Hera; part of a lyre (Acr.Mus.) for Apollo.
(Berger's identifications: A–C – Helios; D – Dionysos; E, F – Kore, Demeter; G – Eileithyia (goddess of birth); Ares (chariot), Iris, Hephaistos, Hera, Zeus, Athena, Poseidon, Hermes, Amphitrite (chariot), Apollo; K, L, M – Leto, Artemis, Aphrodite; N – Nyx)

in Pella Museum. Otherwise few vase scenes only vaguely reflect the centrepiece. The pediment is the first evidence for this contest and in later literature we are told that Zeus intervened, or that it was judged by the gods or by the early king-heroes of Attica.

EAST [78].
Of this pediment we know more of the wings, far less of the centrepiece. The latter was more of an epiphany than an action group (compare Olympia) with Athena, fully grown and armed, standing before her father Zeus from whose head she has sprung. Hephaistos, starting back from the extraordinary birth that he had assisted (striking Zeus with his axe: cf. the earlier treatment *ABFH* figs 62, 123.1, 175, and *ARFH* fig. 355), would have lent an element of bustle and action and his torso is generally recognized in H (where the Basel restoration sees Poseidon). Basel restores Zeus seated near-frontal on a rock, his eagle below him [78]. Most have put him on a throne in profile or three-quarter view, which is how he appears in this scene elsewhere. The centrepiece must have comprised Zeus and Athena with Hephaistos and probably Hera (to whom pieces of a stately peplophoros may belong), at the very least. Basel also restores chariots at either side, which would serve to frame the centre group (as in the west pediment) but have no narrative function in this scene, and there are chariots already, in the corners. Later art does nothing to help us to a reconstruction. A Roman well-head in Madrid shows a Zeus, Athena and Hephaistos, with a Nike crowning Athena and accompanied by the Three Fates [83]. If the main group owes anything to the Parthenon it is via a fourth-century relief which included the Fates.

The spectators of this event must be Olympian deities. They react in very different ways: most, not at all. Enough that they are there and this is Olympus. There is no more glorious statement of the Olympian family in art or literature, even on the Parthenon frieze [94], where individuals are more easily recognized. Since the occasion is the birth of Athens' goddess, the city was claiming for herself a very special patronage. In her market place the Twelve Gods had, for the first time in Greece, been worshipped as a family at an altar built in the late sixth century. On the Parthenon their service to the city was unique, as we shall see.

Of the attendant gods and goddesses the beautiful G sweeps away from the centre to the protection of the seated E and F [80.2]. The decreasing tension carries through to D [80.1], who faces away from the centre to the corner, where a rising chariot, the Sun's, leaps from the pediment floor. Behind the Moon's (or Night's) chariot, sinking in the other corner, is another calm group (L, M) with K edging away from them

towards a missing figure at her side [*80.3*]. The carving of the extant figures is brilliant and varied. D is the only near-complete figure with a head, a massively confident reclining nude. The dress of the peplos-figures E and F is disposed in hard, sharp folds with deep-cut troughs between to catch the shadow, and the figures are firmly reassuring. G, also in peplos, has her dress similarly cut but the flow across the leg accentuates her movement with delicacy yet strength, and the movement is carried up her body to her head, turned back to the centre. Contrast the chiton-clad threesome, K, L, M (long understandably miscalled the Three Fates) where the himation over the legs (cut like the peploi of E–G) contrasts with the crinkly, clinging folds of the dress beneath, which barely conceals the forms of the body and slips away from polished bare neck and shoulders. This looks forward to styles of later in the century. On then to the taut athleticism of Selene the charioteer (N) and the stunning majesty of her team (O) [*80.4, 5*].

The Metopes

The metopes are 1.2 metres high, with a broad flat fillet at the top. There were 32 on north and south, 14 at east and west; 92 in all [*85–91*]. The figures upon them are cut almost in the round, some only lightly attached to the background (carved, of course, in one piece with it), which seems to have been painted red. Many compositions within the rectangular field are brilliantly composed, but many are less satisfying than the best of the Archaic or Olympia. Some figures burst from their frame, and overhanging limbs are not uncommon, especially in the vigorous groups of the south metopes, which are the better preserved. Others seem rather extracts from a frieze, almost casually excerpted. The Classical command of space is poorly served by metopes, and scarcely better by pediments.

These may be the earliest sculpture carved for the building, and it has been suggested that some had been made for an earlier 'Kimonian' Parthenon, never completed (Carpenter). This now seems highly improbable. The interesting suggestion that some had been cut to be set over a porch, as at Olympia, but never installed once the decision was taken to place the frieze there, seems unlikely to be upheld, though it might help explain some problems of the south metopes.

All the metopes at east and west are still on the building, but severely battered. Less than one-half of those on the north survive, in as bad condition (and two of them 'loose'), except for N32 at the west [*88*] which was spared by the Christians because the figures resemble an Annunciation scene. The south metopes were also spared, but nearly half (at the centre) were shattered by the explosion of 1687 and nearly all the

rest are in London (s1 is on the building; s12 in the Acropolis Museum, and s10 in Paris). Several heads and fragments are dispersed in other museums. Fortunately, Carrey drew all the south metopes.

WEST [85–6].
w1 has a horseman, the rest duels, alternately on foot and with a rider, making a simple rhythmic composition. The contestants are Greeks, mainly near-naked it seems, and Amazons, in oriental tunics and hats. Brommer has pointed out that the latter might be Persians, since no clear indication of their sex has survived, but Persian horsemen in such duels are uncharacteristic for the period, and the honours are roughly even, as often in Amazonomachies. The fighting groups offer no originality in composition and most can be matched on earlier Athenian works.

NORTH [87–8].
At the right (west) three metopes show deities who seem to attend rather than watch or judge the action on the other metopes. On these some scenes are undeniably of the sack of Troy, which is likely to be the theme for all, but several groups are not readily paralleled elsewhere although the subject was a very popular one. Only n32 [88] can be judged stylistically. The chiton-clad goddess seated on a rock presents an extraordinary pattern of wavy folds across the centre of her body and her left side, not matched on pediment or frieze, and contrasting with the comparative severity of the peplophoros before her. The latter's severity is mitigated by the cloak she holds as a backdrop to her body. Since she is Athena we may assume that this eye-catching style and pose (and the fact that this is the first metope figure faced by anyone approaching the Parthenon) is deliberate. The main series of metopes are framed by a chariot (n1) and rider (n29), probably Helios and Selene/Nyx, as on the east pediment.

EAST [89]
The subject is clearly the battle of Gods and Giants, though unorthodox in its treatment of some duels, and, in the poor state of the metopes, there is room still for discussion about identities. Of the four chariot metopes e14 may be Helios again and the others attendant on adjacent deities rather than carrying Olympian protagonists. This should leave room for 9 Olympians, Heracles, and extras (Nike, Eros) sharing metopes with gods, the less active goddesses being omitted.

SOUTH [90–1].
Metopes 1–12 and 22–32 show centaurs fighting Greeks or carrying off their women. s21 may also belong with this sequence, with two women taking refuge at a cult statue. This cannot be other than the fight with

Lapiths, which occupied the west pediment at Olympia [*19*], but with some weapons as well as domestic furniture (water jars, spits). It does not exactly conflate the two phases of the fight – at the feast and a pitched battle – since the odd shields are scant indication of the latter (they could have been picked up in the house) and the Kaineus episode is missing. The prime figures of Theseus and Peirithoos are no easier to identify here than they are in many another centauromachy of the fifth century, but we might look for Theseus in the tyrannicidal Greek on s32 [*91.11*]. This cannot be some hypothetical Attic centauromachy, for which there is no other evidence. Metopes 13–20 have, at first (and second) sight, no common theme or action, and have accordingly offered good scope for speculation and uncertainty, since we know them only from Carrey's drawings and the merest scraps have survived – enough to show that the drawings can interpret details wrongly. The chariot on s15 recalls the chariots in the corners of the east pediment and in the north metopes (and cf. E14). If these slabs have been remaindered from a different project the sequence need not be complete and need not be in order. There is no echo of subject in the prolific minor arts, as vase-painting, but there is seldom much iconographic correspondence between the major and minor arts. Nevertheless, if the subject was important and presumably recognizable (in this or another form) we would expect some evidence for it in other art or literature, however differently expressed.

The centaur metopes are the best preserved and show the greatest originality of composition, including some quite ungainly (s31) [*91.10*], some tensely poised or exuberantly bursting from their frames. We miss much of the narrative detail through loss of fragments, especially heads, and loss of metal accessories. Thus, the hapless youth on s1 [*91.1*] has in fact driven home a spit in the centaur's belly. The range of quality and style in execution is considerable. Two of the metopes with women (s10, 29) [*91.8*] are very weak. Some carving is hesitant and much overworked – on s9 the hair had eventually to be attached separately, in drilled holes. Dress can play an important part in some compositions: on s27 [*91.6*] the slipping cloak that frames the youth's body (the cloak would have been painted, the body not), and wisps of dress or the centaurs' animal skins flying into the blank background. The weighty equine bodies and taut, almost archaically patterned musculature of the young men heighten the tension no less than the contrast between the comparative calm of the Greeks' expressions and the centaur's grimaces. They help to lift the mood of the conflict above that of a drunken wedding brawl to something more timeless, a struggle between civilized and barbarian, good and evil. It was probably for this quality that the south metopes were spared by the Christians. But there are on them too some centaurs with near-Olympian features, and some sorely troubled youths.

The Frieze

The frieze is 160 metres long, continuous around the central block (cella) of the building [92–6]. From within the colonnade the view of it is too oblique to make it easily intelligible, although its upper part is cut in slightly higher relief. From outside the colonnade the best view, but interrupted by the columns, is at least 20 metres from the frieze, and since the frieze is only one metre high this means that little detail was readily visible, although the indirect light upon it was probably quite strong. From the extant remains, including many fragments, and drawings, it is possible to be certain of most of its figures, except in parts of the cavalcade and for some details of equipment. It was richly provided with metal accessories, now lost, and, of course, colour may have defined objects which were not carved.

It depicts a procession running in two streams on the long sides of the building, starting at the south-west corner, not the centre-west, but culminating at the centre-east, over the main door of the temple [95]. Seventy per cent of its length is devoted to a cavalcade, led by chariots. In front go ministrants of the procession and sacrificial animals, and on the east they are met by groups of Heroes and Gods, while at the centre-east a small group perform an act with a robe. The procession is clearly a version of the Panathenaic procession which, at the Great Panathenaea every four years, escorted the new peplos robe to the Acropolis for dedication to the statue of Athena. We have considered at the start of this chapter the place and role of this statue, and in Chapter 12 must face the interpretation of the whole frieze in context.

The blocks on which the frieze is carved are of uniform width, aligning with wall blocks along the north and south sides, but rather wider than the norm on the west. Here the carved figures respect the block divisions and seem individually composed, almost like metopes. Perhaps the placing, immediately over the Doric columns of the porch, suggested this Doric rhythm rather than Ionic flow. At least it is achieved by the massed verticals of the more static figures (51 standing plus 12 seated; against 13 men with 23 horses at the west), though here too the block divisions are observed without dictating the composition. East and west could well therefore have been carved on the ground. On north and south, however, there is considerable overlapping of figures between blocks. This does not, of course, mean that they could not have been carved on the ground, but it is equally possible that they were carved *in situ*; although, I imagine, as a last resort, dictated by the building programme (and this does not look a rushed job despite the remarkably short time in which the Parthenon was completed).

The compositions on the west frieze blocks are free, and ingenious

106

[92]. Even those devoted to pairs of riders [96.1] are varied in the pose, dress or gesture of each figure. With them are some superb studies of youths, standing, tending their horses, or dressing [96.5]. And the horses themselves show their mettle, nowhere better than on one of the central slabs where a bearded man (and there is only one other with a beard in the cavalcade, also on the west [96.2]) restrains the beast, bracing a foot against a rocky outcrop [96.3]. These minor details, barely deserving the title 'landscape', appear here and there throughout the frieze: sometimes they are functional, as here or where youths raise a foot to tie a sandal (twice on the west), and elsewhere they denote some roughness of ground, even where the gods are seated on the east. It has been suggested (Fehl) that they denote the Panathenaic Way for most of the frieze, and Olympus, where the gods sit, but it is unlikely that they would denote two separate areas, or even any specific area. Even less probably do the blocks serving the sandal-binders denote the Acropolis and Eleusis (Harrison). The more open composition of the west frieze also gives examples of the compositional use of flying dress (figures 14, 15). Of this there were some examples on the south metopes, and it will become an important compositional device on later friezes.

With the cavalcades on north and south we find a skill in the suggestion of depth by overlapping figures yet with the slightest recession in planes [96.7], given the shallowness of the relief, such as was attested in the finer relief friezes of the sixth century (cf. *GSAP* fig. 212.1, Siphnian Treasury). The riders are bunched in ranks, roughly ten on north and south (more clearly though on the south), and in less competent hands this would have been a composition either of total confusion or of wooden repetition. Instead it flows with controlled freedom, with the rarest dull passages (on the north). The view of the frieze on the building, intermittently between the columns, would have lent it something of the character of a film-strip. Variety is achieved by spacing, by the intervention of standing marshals [96.10], by the different set of human heads (some turned), of horse heads and legs, and by the variety of dress in the riders. On the south each rank is dressed in a different manner. This emphasis may well be an indication that the ten tribes of democratic Athens are represented here, but since all the dress is Athenian (even the Thracian details of the fur caps [96.9, cf. 2, 3], long before affected by Athenian cavaliers) we need not believe that there was a special dress associated with each tribe. This could hardly be the case when it varied from full armour [96.6] for one, to near nakedness for another, and the head-gear from fur hats to sun hats to nothing. The different dress is an artistic device further to differentiate the ranks.

Before the horsemen are four-horse chariots. Ten on the south carry charioteer and warrior, each, it seems, with an attendant before or beside

the horses. Some gallop [96.7], some, at the front, stand or have drawn up. Twelve (or eleven) on the north are similarly composed but most are more active, and show the warrior mounting or dismounting from the moving chariot. The excitement is heightened by a marshal (figure 58) whose useless cloak serves only to set off and frame his splendid nudity [96.11]. The exercise, jumping on and off a moving chariot, was inspired by heroic practice, such as Homeric warfare, and was not a realistic military exercise in the fifth century. It was an event in the Panathenaic Games, and from the frieze and a relief found in the Agora, seems to have been a feature also of the Panathenaic procession on that part of the Panathenaic Way across the Agora which was relatively flat, and called the *dromos* (race course). Here too, in the procession, there were horse-racing displays. The movement of the riders and chariots is brought to an abrupt halt, on north and south, by a group of standing old men, and from here on to the corners we see attendants of the procession and sacrificial animals. These are described and detailed in the figure captions [93].

On the east frieze [94], at the front of the temple, the procession continues from either corner, with a number of women, who shuffle forward [96.15]. With them the procession as such is completed. Before them stand a group of men, ten altogether, who are generally taken to be the Eponymous Heroes of the ten tribes of Athens [96.16]. They are at ease, talking to each other, as it were awaiting the arrival of the main procession. Behind them are twelve major Olympian gods, six at each side, seated, with two attendant deities [96.17, 18]. They are more obviously awaiting the procession but the group is enhanced by having one figure with his body turned away, and by pairs who are linked by pose (23 + 24) or the directions of their heads (29 + 30; 36 + 37; 38 + 39). They are on stools, with Zeus (30) on a throne. They slightly overlap, with the nearest figures (Zeus and Athena) being those nearest the centre of the frieze. Seated, but with their heads to the top of the frieze, they are clearly and appropriately at a greater scale than the other figures on the frieze. The heroes (18–23; 43–6), are not appreciably taller than other males, for instance the immediately adjacent marshals (47–9), the first of whom signals across the Heroes and Gods to the other stream of the procession. (This clearly links them and is a grave objection to those who believe each stream of the procession to be for a different sacrifice [Deubner, Simon] or even of a different period [Harrison].) But with most of the other figures on the east frieze female and decidedly shorter, the Heroes do stand out, and their relaxed, plump poses also make them marginally bulkier than the upright marshals, at least on the side where marshals and Heroes are side by side. The centrepiece, on which the gods turn their backs (there have been ingenious attempts to suggest that they

are in fact facing the centre!), is a five-figure group [96.19] with no explicit relationship to the gods or the procession. For details and identity of these figures the reader is again referred to the captions, and for their function to Chapter 12.

Akroteria

Large florals have been restored as akroteria, and substantial fragments remain, but the question has been posed whether figure akroteria might also be sought, as on other Attic temples, completed later.

Planning and execution

There is nothing haphazard about the Parthenon. Architecture and sculpture are related more subtly than on any other Greek temple – the pedimental figures are related to the spacing of the colonnades beneath them, and the long-side frieze blocks to the walls they crown. There is much thematic unity and cross-reference too, as we shall see. Even in the long and involved composition of the frieze numbers are observed closely, and not merely of Gods and Heroes. It is impossible to escape the conclusion that there was an overall plan which dictated the number and placing of all figures. Whether this also dictated their poses is another matter. The pediments certainly required a single designer in all details. On the metopes, especially where no special narrative was involved (most of the south and west), more individual freedom might have been allowed to sculptors to devise a centauromachy, or an Amazonomachy with or without riders. For the frieze general instructions might have been given about numbers and groupings in parts of the cavalcade or for the identity or function of other figures, without precision about their pose, but there must have been close supervision of the execution or the unity of composition and mood would not have been achieved.

Plutarch said that Phidias was the director and supervisor of the whole Periclean plan for Athens and Attica. There can be no doubt that he was the principal designer of the sculptural scheme for the Parthenon, and perhaps for other temples. We cannot say to what degree we may detect his design or hand in individual figures, but it is likely that his supervision of execution was closest for the pediments. We cannot name other master sculptors involved, although it is likely that some who are known from other recorded works were employed, with their teams: Myron, perhaps, and younger sculptors said to be Phidias' pupils. Correspondences in the execution of some figures have been detected by scholars, but not unanimously, and even where quite unusual details of carving are observed we are not entitled to regard them as the signature

of one artist in the way we do the details of drawings by vase-painters. The latter are valuable in determining hands because they are unconscious, but there is nothing unconscious in the carving of marble, and mannerisms could readily be copied within a studio or outside it. It was, indeed, this juxtaposition of many masons and the pressure, almost fever, of sculptural activity in Athens over a generation that must have contributed to the extraordinary unity of style.

Cult statue

We can be certain of Phidias' authorship of the chryselephantine cult statue of the Parthenos. Of the original nothing survived, and even its fate in late antiquity is uncertain, though it may have been taken to Constantinople and there destroyed. It stood in the Parthenon cella, facing the east door, screened at side and back with super-imposed colonnades of Doric columns. Before it was a shallow basin of water, covering the whole floor area before the door. This provided a healthily humid atmosphere for the ivory and would have reflected light from the doorway. Evidence has recently been offered for windows at either side of the door and light from these would have filtered through the colonnades directly on to the statue.

It was completed in time for the dedication of the temple in 438 since surplus gold and ivory from it were being sold in the years before and after. We know its appearance [106] from ancient descriptions, from reduced copies of it and copies of parts of it in other media and settings [97–105]. Pliny says the statue was 26 cubits tall, probably around 11.5 metres. Pausanias describes the helmet, with a sphinx at the centre and griffins in relief at either side; there was an ivory head of Medusa on her breast (on the aegis, clearly); she held a Nike (victory) about 4 cubits high and a spear; at her feet a shield and by her spear a snake; on the base a relief showing the birth of Pandora. For the last Pliny adds the detail that twenty gods attend, and he says that the fight of Lapiths and centaurs appears on (the edge of) the soles of her sandals. For the shield, see below.

Copies indicate that the helmet was triple-crested and that the side crest-holders were perhaps winged horses. Horse protomes edged the peak and there were relief griffins on the upturned cheek-pieces. The hand supporting the Nike was supported by a column on one of the more detailed copies [97], but by a tree on some coins, and it has been argued that originally there need have been no support at all. At some stage it seems that the statue was damaged but the degree of repair is not known (even complete replacement has been suggested) nor when, which or whether a support for the hand was added. She wore a small,

bib-like aegis with gorgoneion (Medusa) and a peplos with long overfall, tucked into the belt in a manner peculiar to the goddess. The pose of the left leg is between that of Early Classical figures and the Polyclitan. She holds the shield upright at her left side, with the snake coiled within it. The Nike seems to have been shown just alighting on the goddess' hand, holding a wreath or fillet. It is possible that the figure was copied, or more probably echoed in the golden Nikai dedicated on the Acropolis shortly afterwards, of which copies have been identified. And there are copies of similar Nikai elsewhere which might derive from these, or the Phidian. The Nike's head is more confidently now identified in copies found in the Agora and Rome [105]. For the composition with Pandora on the base of the statue we have nothing but a few sketchy figures on [98, 101] and for the centauromachy on the sandals nothing at all.

It is difficult, no, impossible, to assess the effect of such a colossal figure, the strong verticals of dress and support, the dazzle of gold caught in indirect or reflected light, the crisp detail of cast and chased metal, and the ivory flesh; the contrast of fine narrative detail on sandals, shield and base, with the opulent simplicity of the golden dress. Although the technique had been anticipated in Archaic Greece the volume and display of precious materials must have seemed a forthright statement of sheer wealth, bestowed in gratitude by the city on its goddess, but not without thought of those other resources for more mundane purposes stored in the room behind her. The point must have been well taken, and the displays by later colossal chryselephantines perhaps lost a little by comparison. The message of a Greek work of art is often a compound of religion, myth-narrative, politics and propaganda, the 'artistic' quality being determined by its successful answer to these functions, and not by any demonstration of 'art for art's sake'. We can only dismiss the Parthenos as a gaudy and extravagant display by a hubristic City Council if we abandon all attempt to judge Classical art on the terms of its creators and sponsors.

The one part of the statue that can be reconstructed most successfully is the shield. Abridged versions of its exterior decoration appear on some copies of the whole statue [98, 99, 107], but there are more detailed copies, still somewhat abridged, of the shield alone [108], while single and pairs of figures from it were copied at life-size for reliefs found in a Piraeus shipwreck [109]. Pliny says that it showed the battle of the Amazons on the exterior, and a gigantomachy inside. Of the latter we know nothing, but for two giants painted in one of the shield copies (the Strangford [108]). An Attic vase of the late fifth century gives a gigantomachy in a manner suitable to a shield, but if it is an accurate copy from the shield it is unique. The exterior of the shield, which we can reconstruct in some detail [110], is never copied on vases, or at best

sometimes echoed in particular figures or groups. Its figures were probably of metal, perhaps gilt silver or bronze, affixed to a background which might also have borne decoration.

The composition is in a circle of figures, roughly two deep around a central gorgoneion, and it shows some thirty Greeks and Amazons. The battle is that in which the Amazons were repulsed from Athens by Theseus, and the disposition of the figures, partly dictated by the unusual hoop-shaped field, suggests the repulse of an uphill assault, with separate duels in the foreground. Some of the Piraeus slabs include architectural and landscape detail in the background. This may have been rendered on the shield in two dimensions or very low relief, with the high relief figures added, which explains why it does not appear on all copies, where it would logically have been painted upon the marble. This presents the possibility of a reconstruction, such as that by Harrison [110], which gives a detailed topography for the battle. It may not in fact have been so detailed or coherent, but it does seem likely that this was the general scheme. There are some variations even between versions of the same figures on the Piraeus reliefs, but no more than we might expect from a copyist's studio, even one located so close to the original. The style is 'Parthenonian' and in the pose if not carving of some figures we can glimpse something of the power of a composition which, of all those on the Parthenon, most excited the attention of copyists and collectors.

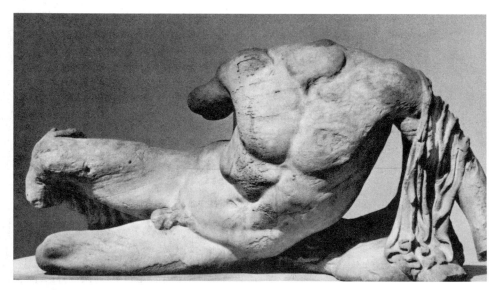

79.1 Parthenon. West ped. A

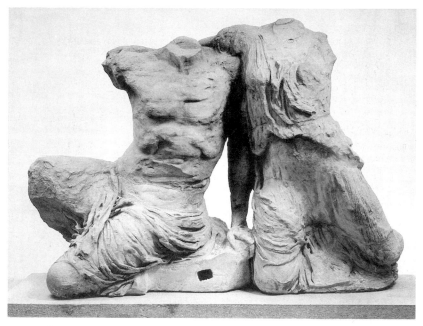

79.2 Parthenon. West ped. B, C

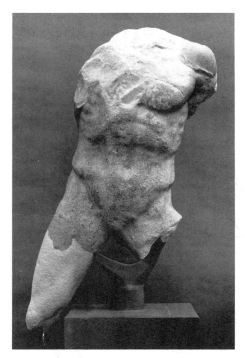

79.3 Parthenon. West ped. H (Cast in Basel, with new fragment)

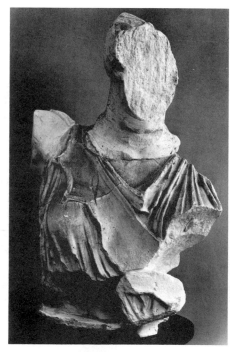

79.4 Parthenon. West ped. L

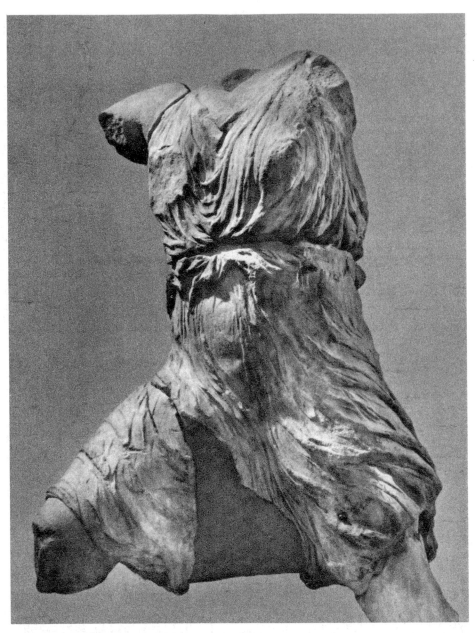

79.5 Parthenon. West ped. N

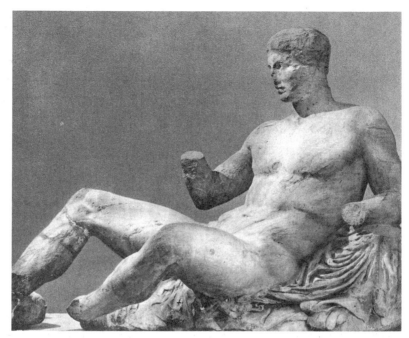

80.1 Parthenon. East ped. D

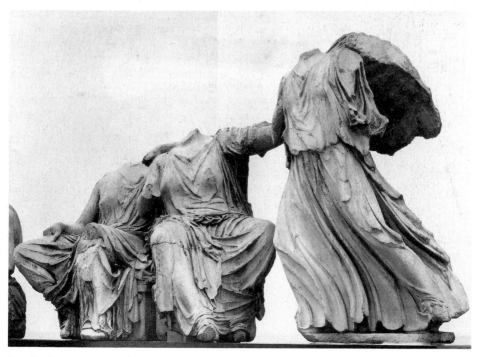

80.2 Parthenon. East ped. E, F, G

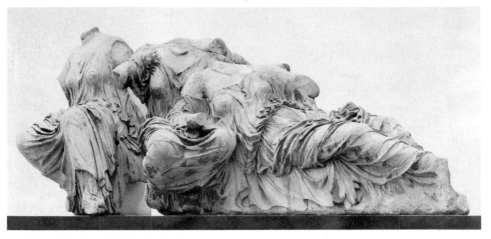

80.3 Parthenon. East ped. K, L, M

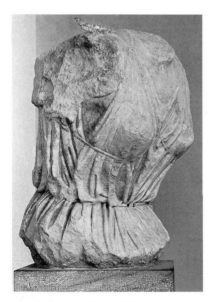

80.4 Parthenon. East ped. N

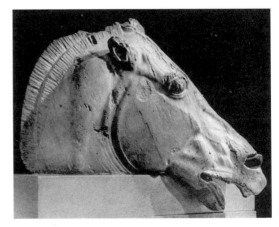

80.5 Parthenon. East ped. O

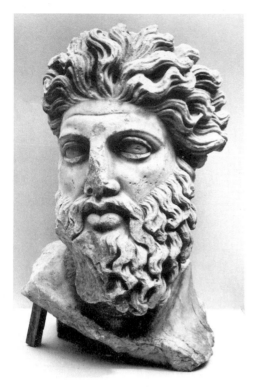

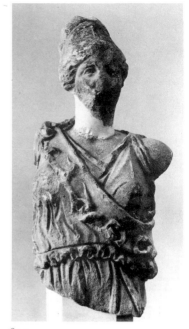

81 Head of Triton from 2nd cent. AD. Odeion in
the Agora, probably copying the W. pediment
Poseidon. (Athens Agora S1214. H. 0.57)

82.2

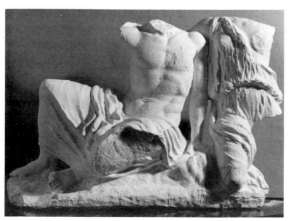

82.1

82.3

82 Pedimental groups from 2nd cent. AD temple at Eleusis inspired by W. pediment figures.
1. cf. B+C (Athens 200. H. 0.41. Cast in Oxford). 2. cf. L (Eleusis 5073. H. 0.85). 3. cf. Q ?
(Athens 201 + Eleusis. H. 0.58)

83 Relief figures on cylindrical well-head (puteal), 2nd cent. AD, probably copying a 4th cent.
BC original. Birth of Athena with Three Fates. (Madrid 2.691. H. 0.99)

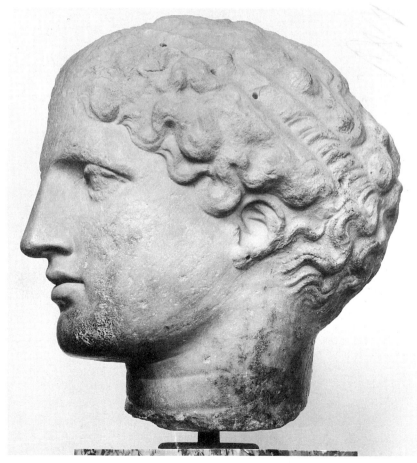

84 'Laborde head' of a woman, probably from a Parthenon pediment. Somewhat restored
(nose, lips, chin). (Paris. H. 0.41)

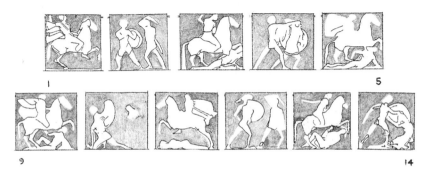

85 Parthenon. West metopes. Amazons (mounted and on foot) fight Greeks. The figures somewhat restored in the drawings. 6–8 hopelessly worn. The Greeks are (expectedly) defeated on the rider metopes, victorious or undetermined on the rest. In situ. H. of metopes 1.20

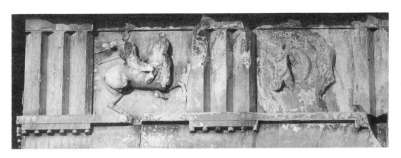

86 Parthenon. West metopes 1, 2 (in situ)

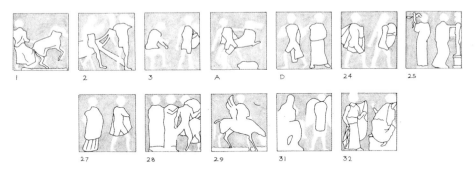

87 Parthenon. North metopes. Troy. 1–3, 24, 25, 27–32 are in situ; A and D are loose (Acr.Mus.). 1. Probably chariot of Helios, but sex of charioteer not certain. 2. Men disembark from stern of ship; either Greeks arriving at Troy (cf. A) or returning from Tenedos before the sack. 3. Greeks arm, stringing a bow at the left. A. Man with horse. Troilos (Dorig: an early episode at Troy, cf. 2 and *ARFH* fig. 232) is unlikely since Achilles, pulling him from his horse, could not be on a separate metope. D. Rescue of Aithra by one of her grandsons (cf. *ARFH* fig. 172.2) or Polyxena led to sacrifice at Achilles' tomb (cf. *ARFH* fig. 245.2 left). 24. A Greek, and Menelaos with drawn sword, menace, on 25. Helen who takes refuge at a statue of Athena, with Aphrodite, Eros standing on her shoulder, behind her and persuading Menelaos to spare her (cf. *ARFH* fig. 158). 27. Woman and man. 28. A woman, Anchises, Aeneas and his son escape from Troy. The woman is unexpected and Aeneas usually carries his father (cf. *ARFH* fig. 135 top left). 29. Woman rider, with flying cloak, her horse descending into waves: perhaps Selene or Nyx. 30–32 are gods (the pro-Trojan are perhaps not to be expected): 30. 2 gods, Poseidon and Hermes ? 31. Zeus and Iris. 32. Athena and Hera or Themis

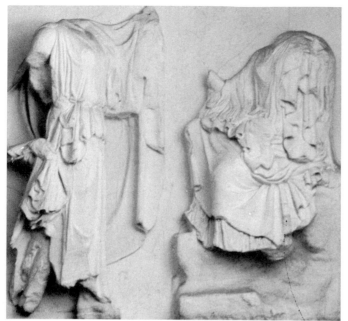
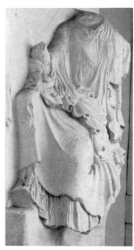

88 Parthenon. North metope 32 (Cast in Oxford)

89 Parthenon. East metopes. Gods fight Giants. Most identifications of the gods are uncertain and not all follow schemes met in other arts. In situ. 1. Hermes. 2. Dionysos aided by lion and snake. 3. Ares (the only god with shield) or Hephaistos. 4. Athena with Nike flying beside her. 5. Chariot (Amphitrite, consort of 6 ?). 6. Poseidon with rock, crushing giant. 7. Chariot with winged horses on rocky ground (Hera ?). 8. Zeus ? pulling at giant's shield. 9. Heracles with lionskin defending himself (the only non-god fighting the Giants, though vital to the issue, is the only one apparently having difficulty; he is necessarily next to Zeus). 10. Chariot (probably woman). 11. Eros with bow and a god (Apollo ? – if so 10 or 12 may be Artemis; or Ares ? if so 10 or 12 may be Aphrodite). 12. Goddess. 13. Hephaistos wielding fire brands. 14. Chariot rising from sea (fish beside wheel) with male driver, probably Helios. Cf. *ARFH* figs. 187 (for 4, 8), 196 (for 4, 6), 280.1 (for 6), 337.2 and 359 (for 2's lion and snake)

90 Parthenon. South metopes. The drawings conflate remains (plain) and Carrey. On 1–9, 11, 23–4, 26–8, 30–2 Lapiths fight centaurs; on 10, 12, 22, 25, 29 centaurs attack Lapith women; 21, Lapith women take sanctuary at statue of goddess. The youths are naked or wear a cloak, two have shields, one perhaps a helmet (32); water jars (for the wedding feast) appear in 4, 9, 23. 13–20: Robertson's solution sees a theme involving Daidalos who was both a divine craftsman and of the Attic royal house: 13. Daidalos' sister and son (whom he killed, then had to flee Athens), 14. Amazement at Daidalos' gifts to Athens: wheel-made pottery. 15, 16. Helios' chariot and Daidalos with collapsing Ikaros; an impressive identification. 17, 18. Daidalic dance: chorus of statues (the figures look very Archaic) activated by a musician. 19, 20. Women at loom or bed (Carrey's scroll is wrong). Simon gives 13 + 14 to the centauromachy and sees the Ixion (related to centaurs) story in 15–20. Others look for stories of Attic kings.
(1 in situ; 2–9, 26–32 in London; 10 in Paris; 12 in Acr.Mus.; 11, 13–25 drawings only)

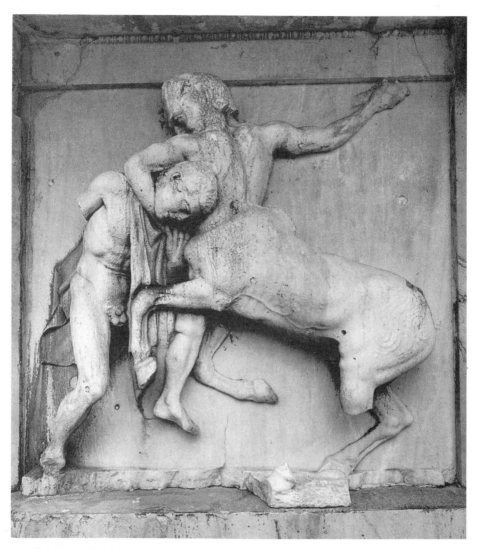

91.1 Parthenon. South metope 1

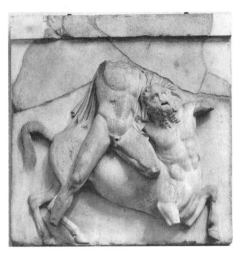

91.2 Parthenon. South metope 2

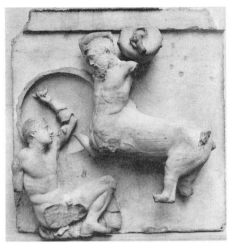

91.3 Parthenon. South metope 4. Heads in Copenhagen

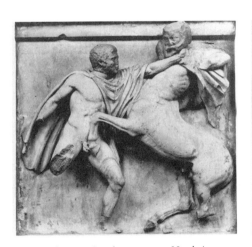

91.4 Parthenon. South metope 7. Heads in Athens

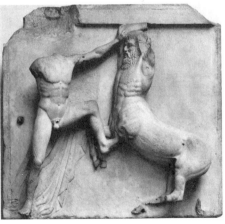

91.5 Parthenon. South metope 26

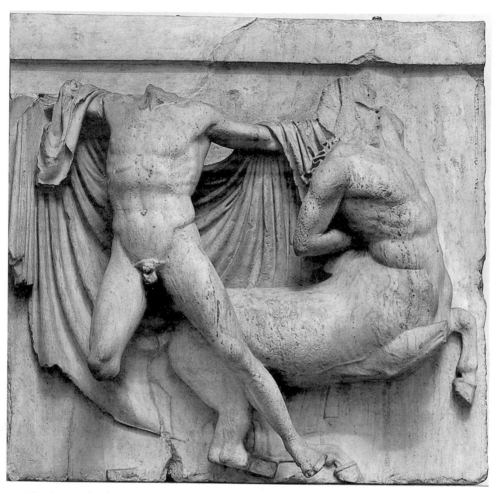

91.6 Parthenon. South metope 27

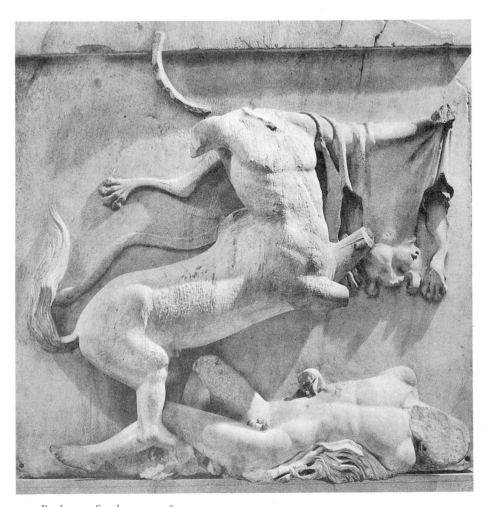

91.7 Parthenon. South metope 28

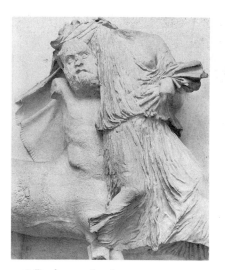

91.8 Parthenon. South metope 29

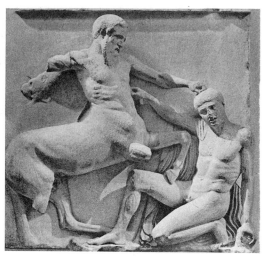

91.9 Parthenon. South metope 30

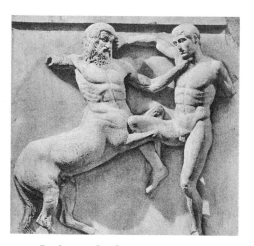

91.10 Parthenon. South metope 31

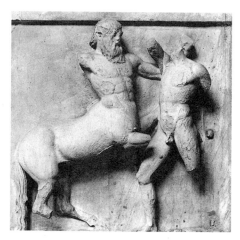

91.11 Parthenon. South metope 32

92 Parthenon. Frieze. West

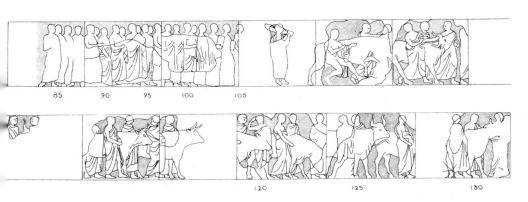

93a Parthenon. Frieze. South, east end. (Figures from Carrey drawings – not beyond 105 – outlined.) 84–101 – elders, often taken to be the thallophoroi 'branch-carriers', but the branches are not shown or easily restored; 102–5 – men carrying lyres ? (Brommer suggests tablets); 106 – a tray-carrier; thereafter, men with sacrificial cattle

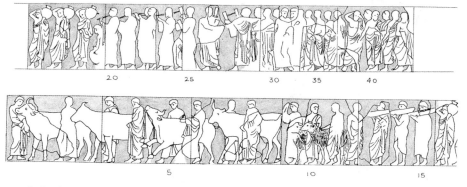

93b Parthenon. Frieze. North, east end. (Figures from Carrey drawings outlined.) Reading west to east: 43–28 – cf. South 84–101; 27–24 – kithara players; 23–20 – pipers; 19–16 – youths with water jars (necessary for sacrifices); 15–13 – skaphephoroi ('tray-carriers': resident foreigners, 'metics'); 12–10 – men with horned sheep; 9–1 – men with cattle

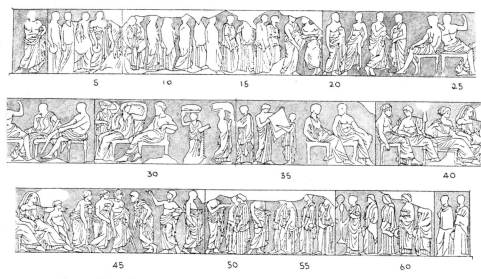

94 Parthenon. Frieze. East

Mortals and heroes: 1 – marshal gesturing round corner to south frieze; 2–11 – women with phialai or oinochoai (for libations); 12–15 – pairs of women carry between them two heavy stands (for a loom ?); 16–7 – women, empty-handed (12–7 are perhaps the peplos-weavers); 18–23, 43–6 – eponymous heroes of the 10 Attic tribes; 47–9, 52 – marshals, 47 gesturing to the other half of the procession, 49 holding a dish (hardly the ritual kanoun which was carried by girls and must have been larger); 50–1, 53–7 – women, 55 with phiale, 57 with incense-burner; 58–63 – as 2–11.
Gods: 24 – Hermes, travelling hat in lap; 25 – Dionysos, holding staff or thyrsos (Robertson suggests Heracles); 26 – Demeter, holding long torch (Kenner suggests Hecate); 27 – Ares with spear (mainly painted ?); 28 – Nike (or Iris) stands beside 29 – Hera, unveiling in the ritual gesture to 30 – Zeus, on a throne, not stool; 36 – Athena; 37 Hephaistos; 38 – Poseidon; 39 – Apollo; 40 – his sister Artemis; 41 – Aphrodite, with 42, Eros standing at her knee holding a parasol (from a 19th cent. cast, the figure now destroyed)
Centre piece: 31 – girl carrying stool and footstool; 32 – girl carrying stool, being lifted down by 33 – a woman, probably the priestess of Athena. 34 – a man, probably the Royal Archon, receives the peplos from 35 – a small girl, an arrhephoros, charged with responsibility for the peplos. 35 has generally been regarded as a boy but has clear Venus-rings (as do many Parthenon women) and is historically appropriate

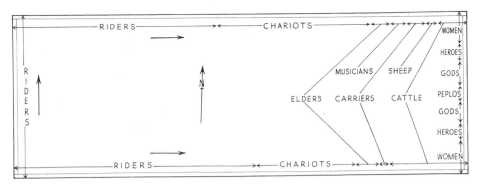

95 Plan of Parthenon Frieze

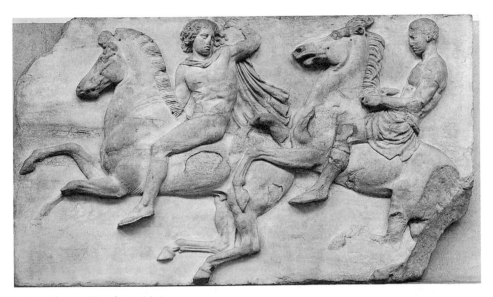

96.1 Parthenon. West frieze slab II

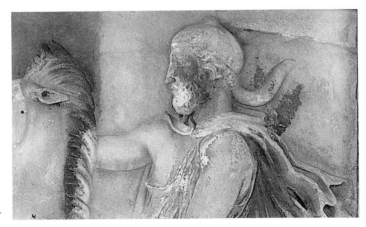

96.2 Parthenon.
West frieze slab IV

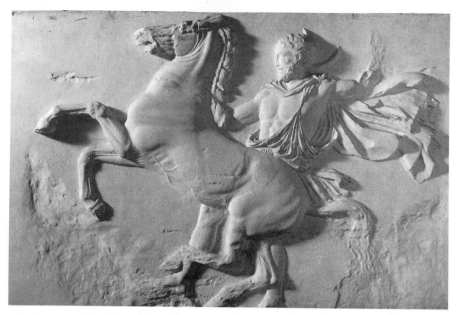

96.3 Parthenon. West frieze slab VIII (Cast in Oxford. The head is now mainly destroyed)

96.4 Parthenon. West frieze slab XI

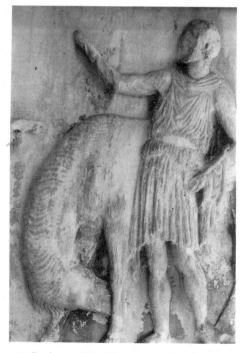

96.5 Parthenon. West frieze slab XII

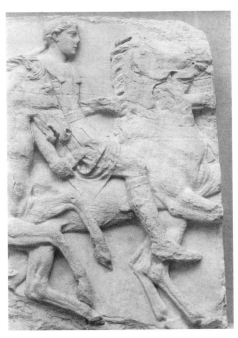

96.6 Parthenon.
South frieze slab XIII

96.7 Parthenon.
South frieze slab XXX

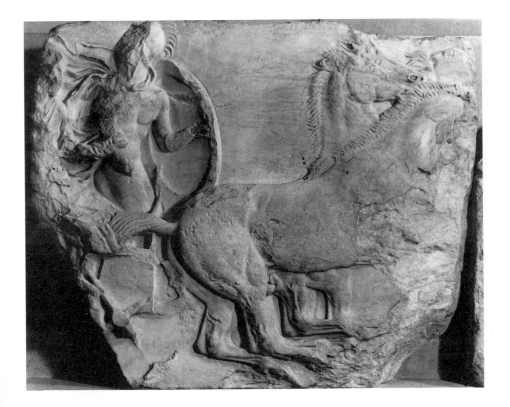

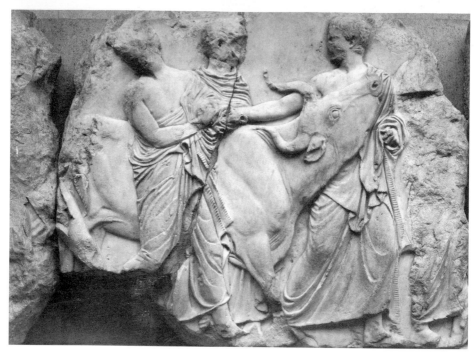

96.8 South frieze slab XL (112–5)

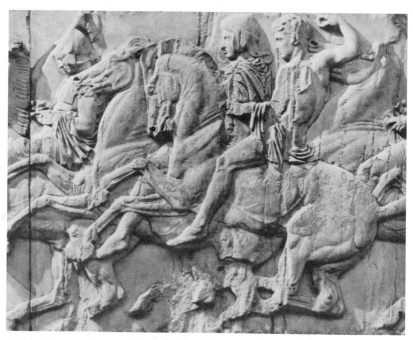

96.9 Parthenon. North frieze slab XXXVIII

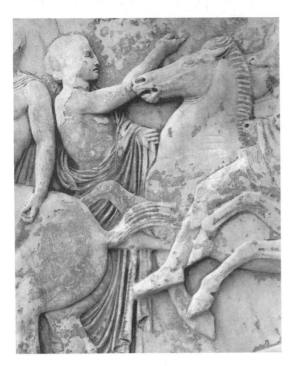

96.10 Parthenon.
North frieze slab XXIX

96.11 Parthenon.
North frieze slab XVII

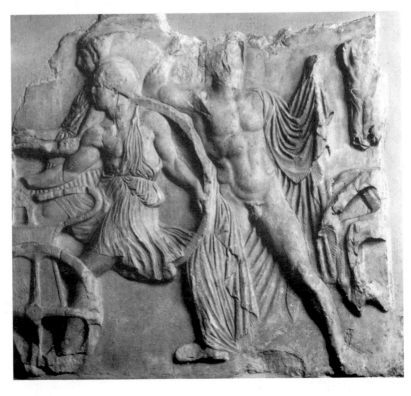

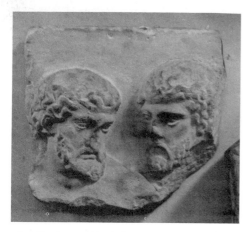

96.12 Parthenon. North frieze slab IX
(31–2; Vienna. Cast in Oxford)

96.13 Parthenon. North frieze
slab VIII (27–8; Acr.)

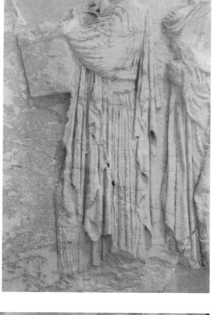

96.14 Parthenon. North frieze
slab VI (16–19; Acr.)

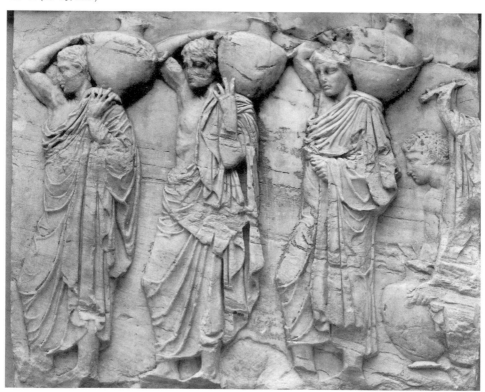

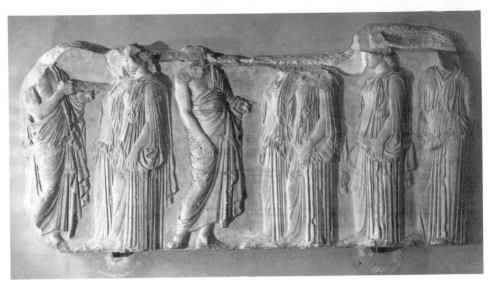

96.15 Parthenon. East frieze slab VII (49–56; Louvre)

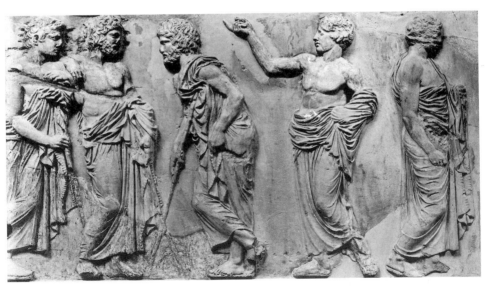

96.16 Parthenon. East frieze slab VI (44–8; mainly Acr., now mainly battered and dispersed. Early cast in London)

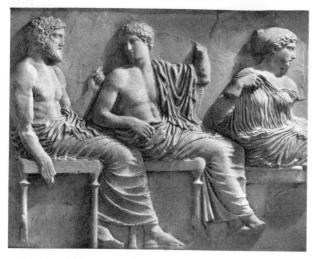

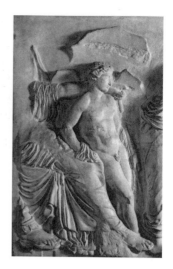

96.17 (*above*) Parthenon. East frieze slab VI (38–40; Acr.)

96.18 (*above right*) Parthenon. East frieze slab VI (41–2; Acr.;
Eros (42) now mainly destroyed. Early cast in Oxford)

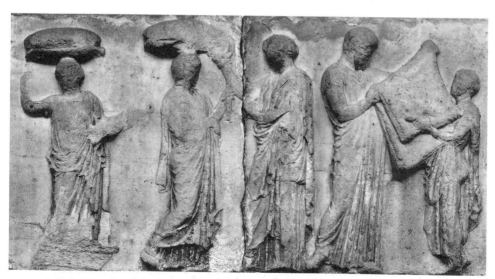

96.19 Parthenon. East frieze slab V (31–5)

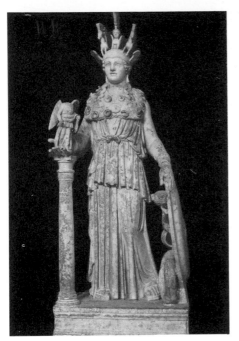
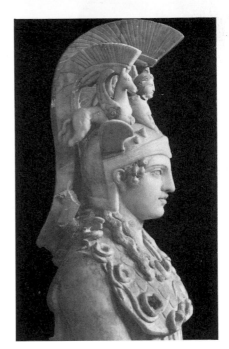

97 'Varvakeion statuette' from Athens. 2nd cent. AD version of the Parthenos. Helmet and crest-holders are sphinx and pegasi. (Athens 129. H. 1.05 with base)

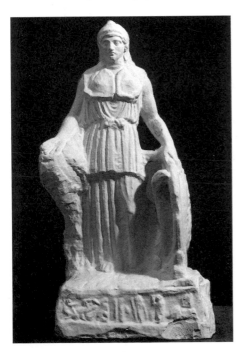

98 'Lenormant statuette' from Athens. 2nd/3rd cent. AD version of the Parthenos. Summary figures on base and shield. (Athens 128. H. 0.42 with base)

99 'Patras statuette'. 2nd cent. AD version of the
Parthenos. (Patras. H. 0.86)

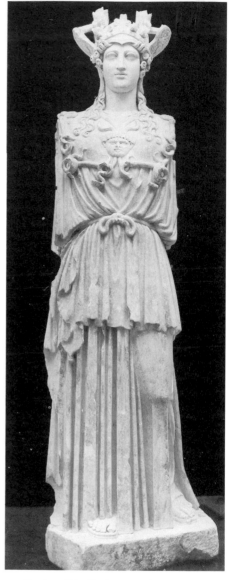

100 Version of the Parthenos, 2nd cent. AD.
(Boston 1980. 196. H. 1.54)

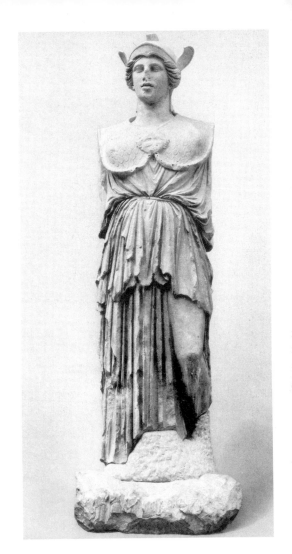

101 Hellenistic version of the Parthenos, with base, from Pergamum. The helmet had cuttings for three crests. The base preserves parts of 6 out of 10 figures (the Parthenos had 21) shown in a manner that does not betray either their identities or actions. (Berlin (E). H. of statue 3.105; face of base 0.405 × 1.85. Base, Oxford Cast Gallery)

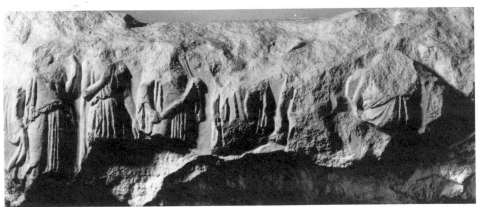

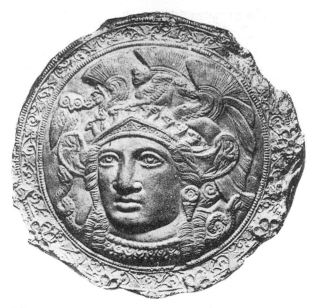

102 Gold medallion from Kerch (S. Russia), 4th cent. BC. Head of the Parthenos. Crest-holders are sphinx and pegasi, griffins on cheekpieces, deer and griffins over helmet peak, owl on left cheekpiece. (Leningrad. Diam. 0.072)

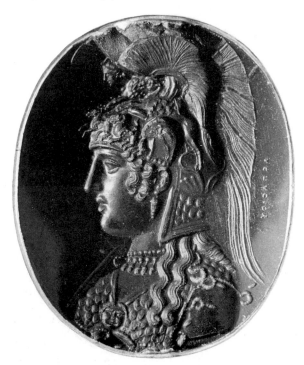

103 Red jasper intaglio signed by Aspasios (1st cent. BC) with the head of the Parthenos. As 102 but horses over the helmet peak. (Rome, Terme. H. 0.03)

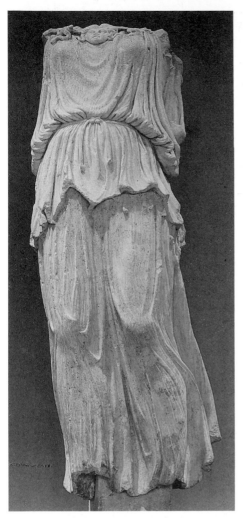

104 Nike from Cyrene, possibly a full-size copy of
the Nike on the Parthenos' hand. The aegis, mainly
at her back, is surprising. (Philadelphia L-65-1. H.
1.12)

105 Head, possibly a copy of the Parthenos' Nike.
Other copies (the 'Hertz head') were once
associated with the Nike of Paionios 139. (Athens,
Agora S2354. H. 0.42)

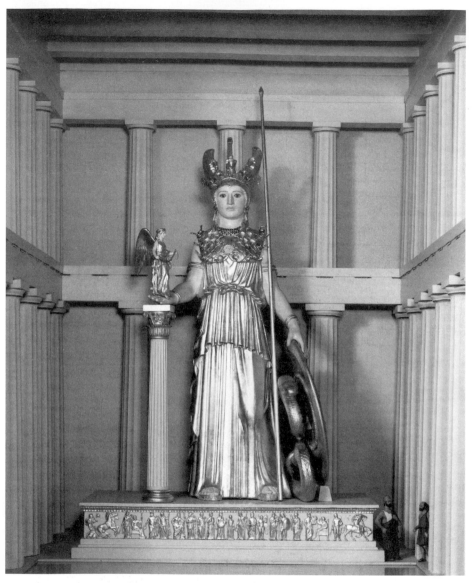

106 Model of the Parthenos within the Parthenon, reconstruction by N. Leipen in Toronto,
Royal Ontario Museum. About one-tenth full size

107 Shield from 99 with Amazonomachy.
(Diam. 0.45)

108 (below) 'Strangford shield' from
Athens. 3rd cent. AD copy of the
Parthenos shield with Amazonomachy.
The detail shows part of a gigantomachy
painted within the shield. (London 302.
Diam. 0.50)

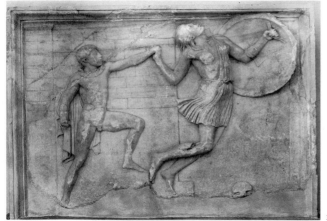

109.1

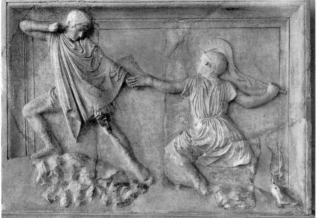

109.2

109 Reliefs from a Piraeus wreck and in Rome.
2nd cent. AD copies at full size of excerpts from the
Parthenos shield. Pieces of 20 such reliefs,
including copies of the monument also represented
on the puteal *83* and the Charites *76* were recovered
from the wreck. 1. Piraeus. 0.92 × 1.30. Another
version in Piraeus lacks the architectural setting. 2.
Piraeus. 0.92 × 1.31. Archer and Amazon. 3.
Rome, Villa Albani 20. H. 0.60. Greek struck in
the back, popularly called Kapaneus or Erechtheus.
The slab was completed by an Amazon attacking,
uphill

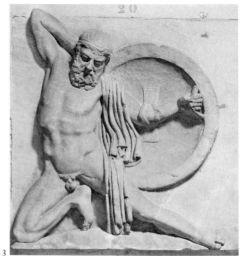

109.3

110 Reconstruction of the shield of the Parthenos, after E. B. Harrison. The 'Phidias' is top centre (with stone), 'Pericles' right of centre, below (arm across face). In the group bottom left it is not clear whether the Amazon is being helped by a Greek (in which case, the friendly Antiope) or stabbed. (Original diam. about 4.8)

Chapter Eleven

OTHER ATTIC ARCHITECTURAL SCULPTURE

The rest of the Periclean plan for rebuilding on the Acropolis, in Athens and Attica resulted in the construction of several other temples, less ambitious in scale than the Parthenon but no less innovatory in detail. We start with Doric temples which appear to have been planned, although not all completed, while the Parthenon was being built, and which seem likely to have been designed by one architect; with these an Athenian Doric temple on Delos; then the Ionic buildings which belong to the last third of the century.

Doric Temples

(a) Temple of Hephaestus and Athena, overlooking the Agora in Athens. This is the best preserved of the temples but hapless in that it was long known by the wrong name (Theseum) and now has its identity again threatened (Harrison: for Artemis Eukleia). Work started on it in 449/8 and the metopes, still rather Severe [111], were carved, and perhaps a pedimental centauromachy. Then there was a break and the friezes [112–14] were cut in the 430's or a little later. The second pediment is of the later phase, if the two-girl group (which used to be taken for an akroterion) belongs to it [115], and with it may go a 'Nereid' akroterion [116]. All this in Parian marble. (A second pediment had been restored from Pentelic marble pieces, but this is generally now disregarded.) The remains of pediments and akroteria are very scrappy and attributions disputed. Cult statues were added in 421/20 and dedicated in 416/15 (see [226]).

(b) Temple of Poseidon at Sunium, on the cape at the southern-most tip of Attica; much visited today. Pieces of frieze and pediment seem to be of the 430's [120–1].

(c) Temple of Ares and Athena, moved into the Agora in the late first century BC, having stood at Acharnae, eleven kilometres north of Athens. (This is almost certainly the correct explanation of its history.) Sculptural fragments of Pentelic marble [117–19] attributed to it may be from other Agora buildings, including those listed here. All seems decidedly post-Parthenonian.

(d) Temple of Nemesis at Rhamnus, on the east coast of Attica, five kilometres north of the Marathon Plain. We have part of an akroterion, enough of the cult statue to recognize it in copies, and much of its base (of about 425) [122–3].

(e) Temple of Demeter and Kore at Thorikos, on the east coast of Attica, near Laurium. This was incomplete and parts were moved, with its cult statue (of about 420–10) into the Agora in the first century AD.

The scraps of sculpture from the pediments of the Hephaisteion and perhaps the Temple of Ares tell us nothing very reliable about the compositions or even subjects. (In these circumstances pieces of centaurs or Amazons are a godsend since they give the subject immediately.) And we know something of the cult-statues for Nemesis [122] and Demeter. More interesting is the disposition of the frieze decoration which three of these buildings share with the Parthenon, although none in quite the same manner. For the Hephaisteion the friezes are at each end of the cella (central block), not along the sides, but at the east the frieze runs on over the aisles to within the outer colonnade. And on the outside of the building at this end there are relief metopes across the front and returning down the sides to the point where the frieze, inside, abuts. So, from the ground outside, you look up at a sort of sculptural box with all figures facing out, metopes outside, a frieze inside. This box-like scheme is found at Sunium but without metopes, and with the frieze apparently all within the front porch, one side of it therefore visible only from within the colonnade, which shows that such a steep angle of view was tolerated, however unsatisfactory it must have been. Ares too may have had a frieze. 'Experimental' seems quite the word for these schemes, including the Parthenon. It is generally assumed that all were inspired by the Parthenon, but the earliest to accommodate them, the Hephaisteion, appears to have been designed from the start for its east frieze to align with the colonnade and the end of the series of decorated metopes. So was this the experiment which led to the Parthenon? The decision must have been taken at least as early as that for the Parthenon frieze. The style of the Hephaisteion frieze seems later than the Parthenon's, but perhaps sculpted slabs need not have been installed for the experiment to be judged. The placing of the certainly early metopes and the groundplan imply a frieze in this position. Its composition echoes the Parthenon, whether designed before it or not, with two groups of gods observing an apparently heroic battle [112], but here facing the action groups between them and with subsidiary figures in the wings behind them. Other scraps of frieze from the Agora are variously attributed to temples or a balustrade; they may never find a secure home. The Sunium frieze is too

147

battered to judge [*120*]; the figures do not overlap blocks, as they do on the Parthenon north and south.

Probable akroteria, attributable to one or other of the Agora temples, are female figures, often in motion, and since most of them seem the latest additions to the buildings their style happily exploits the new fashion of clinging drapery [*116, 118–19*]. The use of such figures, perhaps, came too late for consideration of comparable figures for the Parthenon, already equipped with fine marble anthemia. A statue of Nike [*118*], now tentatively given to Ares, had previously been placed on the nearby Stoa of Zeus Basileios. This was the official residence and office of the Archon Basileus, the magistrate in charge of the religious affairs of Athens. On its roof Pausanias saw terracotta groups of Theseus with Skiron and Eos with Kephalos, pieces of which have been found. There are scraps of other Doric architectural sculpture in Athens, not certainly placed on any of the temples named here, and a metope of Pentelic marble in Rome has been thought Attic, and associated with Rhamnus, though its style looks rather provincial.

Between 425 and 417 the Athenians built a temple for Apollo on Delos, marking Athens' purification of the island and inauguration of a new festival. It sheltered seven bronze statues from what had been probably another Athenian temple for the god, of the Archaic period. Akroteria of Pentelic marble are two-figure groups with Boreas and Oreithyia at the east [*124*], Eos and Kephalos at the west, and girls at the corners.

Ionic Temples

The Erechtheion on the Acropolis was the real replacement for the old Athena temple destroyed by the Persians. The new temple was unorthodox in plan, probably because of its multi-functional character. It housed, we assume, the old cult image, but also served cults of Erechtheus and Poseidon, while in or around it were assembled other cult places or objects to do with Athens' earliest history. The building was begun in 421 but most of the work was completed between 409 and 406. The six Caryatids [*125*], the statues of women supporting the roof of the false south porch, may be slightly earlier than this last phase of work, since they have a structural function (though not a vital one for the main block of the building). The frieze [*126*], which ran around the outside of the building, is certainly late. Its figures were cut in Pentelic marble and fastened on to a dark marble (Eleusinian) backing – an effect achieved in monolithic reliefs by painting the background. Accounts record the payments for figures on the frieze – the going rate was sixty drachmas per figure, human or animal, less for children. They imply a

considerable spread of competence in marble-carving in Athens' population, and name no artist known to us from any other source. The Caryatids are massive figures as befits their function, recalling the latest of the Parthenon, but with the clinging drapery and emphatic set of hips and legs that look forward to the yet richer styles of the later century. Of the frieze we have only a mass of fragments with very few near-complete figures. Most are women and the only figure certainly identifiable by pose or attribute is an Apollo with omphalos, which is a Roman replacement [126.5]. The subjects of the frieze are not, it seems, any ordinary narratives, but may have been devoted to explaining the origins and functions of the many girl-attended cults of the area.

The small Ionic temple to Athena Nike (Athena as Victory) on the bastion to the south side of the approach to the Propylaea of the Acropolis, was built in the later 420's. Its external frieze, almost all preserved though in a poor state except for three slabs in London, has gods at the front, battles at back and sides [127–8]. The style is almost flamboyant with areas between the well-spaced figures filled with swirling dress. This feature had appeared on the Parthenon metopes and here it is established as a compositional device which will dominate frieze composition for the following century. The vigour of the battle scenes is particularly impressive with the long-limbed, sweeping figures, twisting and turning their backs to the viewers, giving a sense of depth which overcomes the unnaturally mannered composition imposed by any frieze. The temple had bronze akroteria, perhaps a Bellerophon with Chimaera and Nikai; their material is judged from an inscription and the bases; their subjects from an inscription not certainly related to this building.

A comparable spirit to that of the Athena Nike friezes, at a slightly later stage and expressed in quieter figures, can be discerned on the other frieze associated with the temple of Athena Nike. This was on a balustrade around the top of the bastion on which the temple stood, running along its south, west and north sides (here with a short return beside steps up on to the temple platform). The subject is figures of Nike (Victory) erecting trophies or leading bulls to sacrifice, with a seated Athena on each main side [129, 130]. Substantial pieces of roughly a third of the figures survive and can be fairly accurately placed. This reveals the hands of six masters, each working half of one long side (probably eight figures each, dividing the work on one slab, with master A working the extra two slabs by the steps, but the length of the frieze on the south remains uncertain). The relief is not particularly high but the figures are only lightly foreshortened, and as it were pressed against the background. The clinging drapery style is expressed at its very best here, revealing strong, active, but essentially feminine bodies, lacking the soft

near-sensuality that the following generations were to add, and the better without it. The carving is probably of the 410's.

In lower Athens, by the river Ilissos, stood another Ionic temple, very like that of Athena Nike, built and decorated at about the same time (dating has been lowered some twenty-five years by recent studies). Pausanias mentions the temple to Artemis Agrotera near the Ilissos, and the Metroon for Demeter in Agrai must have been hereabouts. The temples's frieze [131–2], placed as on Athena Nike, is puzzling and does not assist identification of the building. Stuart and Revett drew the building (since destroyed) in the eighteenth century, but it had already lost its frieze, of which fragments have been excavated near the site, enabling others to be identified in Vienna and Berlin museums. It is worth noting that there exist Roman copies of the frieze. Otherwise, late copying seems largely confined to the subsidiary narrative compositions of Periclean sculpture – the Parthenos shield, Rhamnus base.

The sculpture on these buildings, combined with that from the Parthenon which offers us more in the round or of colossal size, presents a sequence through the second half of the fifth century by which we judge the unity and development of the Athenian sculptural style. Fortunately there are often apparent cross-references in execution, composition or motif between works on different buildings, to help suggest contemporaneity or succession. The development is determined with some confidence, given that some dates can also be assigned on non-stylistic grounds, but not with total confidence. A misunderstood decree about Athena Nike had caused dating of the Ilissos sculpture twenty-five years too early until recently. Several buildings appear, on stylistic grounds, to have had sculptural additions at quite different periods. The combination of inscriptions about the buildings and knowledge of Athens' troubled history in these years encourages speculation about the reason for delays or suspension of work, especially, for instance, at the outbreak of the Peloponnesian War in 432/1 and for years in which Attica was annually invaded. It all seems to fit pretty well, but it is not in the nature of the art, or of sculptors' behaviour, that stylistic dating can ever be very close, and errors of up to twenty years are possible.

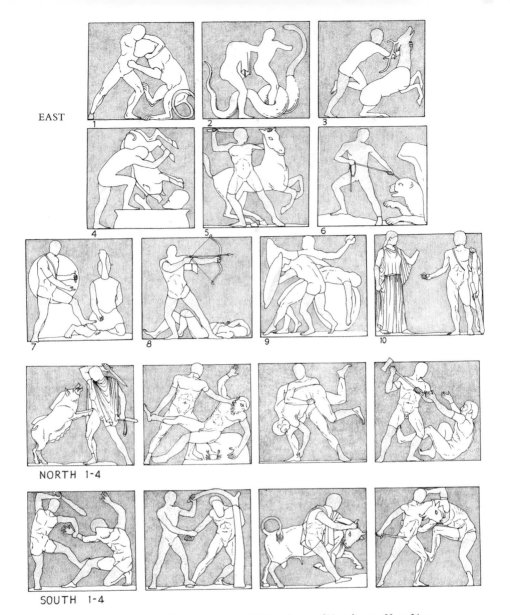

EAST

NORTH 1-4

SOUTH 1-4

111 Hephaisteion. Metopes. In situ. H. 0.63. EAST. Labours of Heracles. 1 – H. v. Lion.
2 – H. with Iolaos v. Hydra. 3 – H. v. Stag. 4 – H. delivers Erymanthian boar on Eurystheus.
5 – H. v. horse of Diomedes. 6 – H. drags Cerberus from Hades. 7 – H. v. Amazon.
8 + 9 – H. over body of herdsman Eurytion v. Geryon. 10 – H. with apples of Hesperides
and Athena. Compared with Olympia *22* the Birds and Augeas are omitted; 1 is treated in
the old Archaic scheme (cf. Athenian Treasury, *GSAP* fig. 213(15)); 2 adds Iolaos and 8
Eurytion, as often; the presentation of the apples to Athena on 10 is novel (cf. the Birds
metope at Olympia).

NORTH/SOUTH. Adventures of Theseus. North (from east): 1 – with sow of Krommyon. 2
– with Skiron. 3 – with Kerkyon. 4 – with Periphetes ? South (from east): 1 – with Prokrustes ?
2 – with Sinis. 3 – with Marathonian bull. 4 – with Minotaur. The schemes of South 2, 4
resemble the Athenian Treasury (*GSAP* fig. 213 (1, 7) and cf. (4) with South 1); others are
matched on vases

EAST

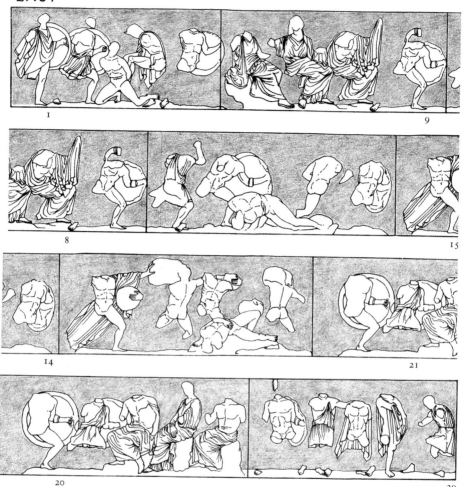

112 Hephaisteion. East frieze. In situ. H. 0.85.
1–5 – Warriors bind a prisoner (3), the last (5) moving right but looking back. 6–8 – Gods seated on rocks, observing 9–21: 6 – Athena holding spear in right hand (?), drilled holes for attachment of aegis; 7 – probably Hera, in view of – 8 – probably Zeus, sceptre in left hand. 9–14 – Warriors fight, with spears, swords, shield, probably 9, 11 and the fallen 12 against 10, 13, 14. 15–19 – Men fight with boulders; the slipping mantle of 15 is heroic (cf. Olympia *19M*) and might be Theseus, but his weapon is missing; the fallen 18 might be his companion. 20, 21 – Two warriors make off right. 22–24 – Gods seated on rocks, observing 9–21: 22 – Poseidon or Hephaistos, and if the former – 23 – Amphitrite; 24 – a god. 25–29 – Warriors prepare for battle, 26 and 27 are paired, 29 is stringing his bow. The heroic boulder-fight (15–19) seems the core of a more conventional battle with preparation to the right (25–29) and action still contemplated but a prisoner taken (3, an unusual motif and so presumably significant) at left (1–5). The gods are on a different plane, perhaps Olympus, but set within the range of the action, not to one side as on the Siphnian Treasury (*GSAP* fig. 212.2)

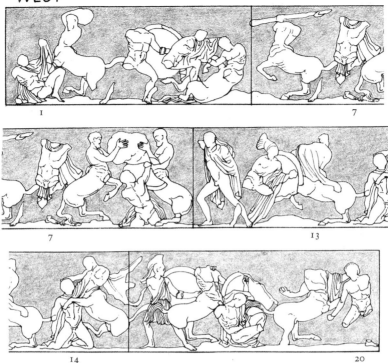

WEST

1

7

7

13

14

20

113 Hephaisteion. West frieze. Lapiths fight Centaurs; after the wedding, unlike Olympia *19*
and, probably, the Parthenon south metopes *90*. Notice the centaur (5) collapsing on to his
back. For the pose of 7 (probably with axe) and 11 (tyrannicidal, cf. *3*) compare the heroes at
Olympia *19 K, M*. These should then be Theseus and Peirithoos. 8–10 – two centaurs beat the
invulnerable Kaineus into the ground (cf. *ARFH* fig. 326)

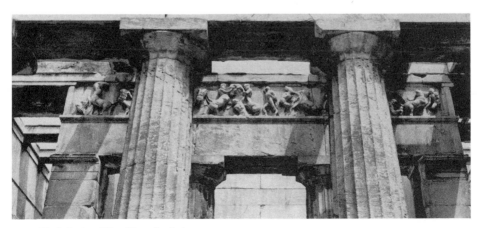

114.1 Hephaisteion. West frieze (in situ)

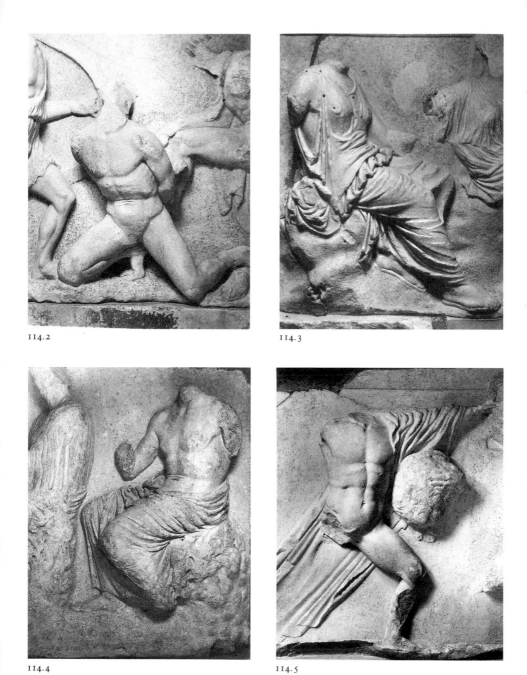

114.2

114.3

114.4

114.5

114 Hephaisteion. East frieze. 2 (fig. 3). 3 (6). 4 (24). 5 (15)

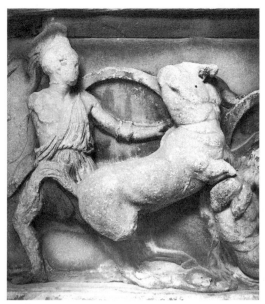

114.6

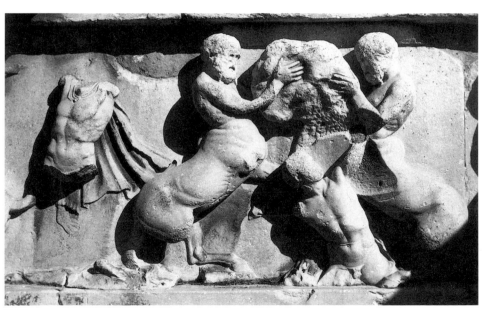

114.7

114 Hephaisteion. West frieze. 6 (16–7). 7 (7–10)

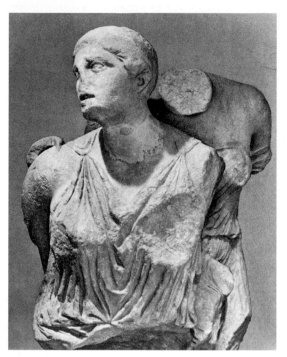

115 'Ephedrismos' group (Parian marble). One girl carries
another pickaback. Commonly ascribed to the
Hephaisteion, akroterion or pediment. (Athens, Agora
S429. H. 0.65)

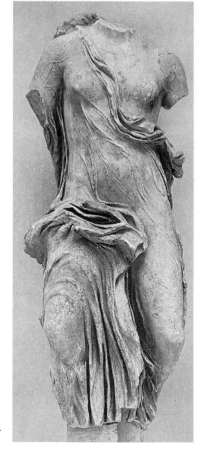

116 Woman (Parian marble), akroterion commonly
ascribed to the Hephaisteion and described as a 'Nereid'.
(Athens, Agora S182. H. 1.25)

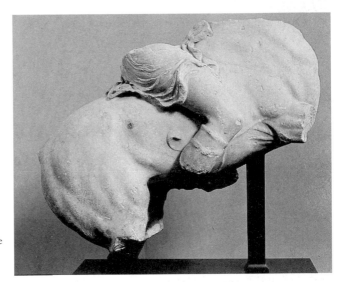

117 Amazon rider (Pentelic marble) of unknown provenience but commonly ascribed to a pediment of an Agora temple. (Boston 03.751. L. 0.91)

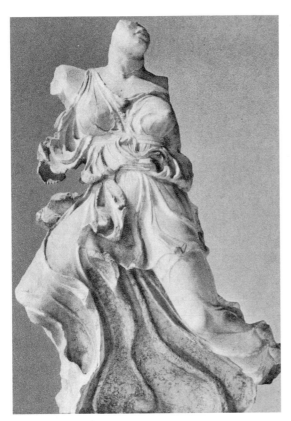

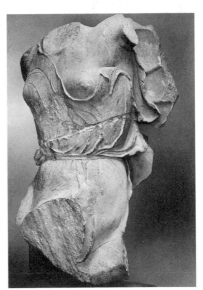

119 Nereid riding a dolphin (Pentelic marble), commonly taken for an akroterion of the Temple of Ares. (Athens 3397. H. 0.57)

118 Nike (Pentelic marble) commonly taken for an akroterion of the Temple of Ares (once ascribed to the Stoa of Zeus). (Athens, Agora S312. H. 1.29)

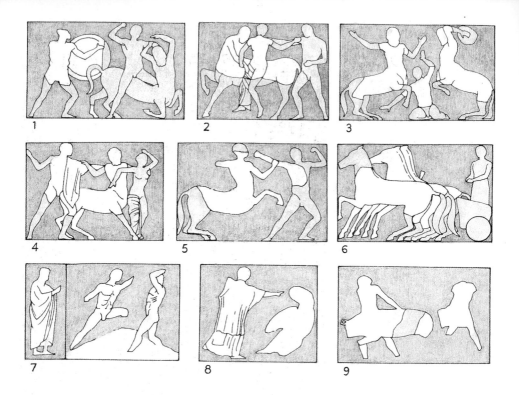

1 2 3
4 5 6
7 8 9

120 (*above*) Frieze slabs from the pronaos of the
Temple of Poseidon at Sunium. The subjects are
Lapiths and centaurs (1–5), including the rape of
the Lapith women (2, 4) and the battering of
Kaineus (3; cf. *113. 8–10*); a chariot (6);
gigantomachy (7 ?, 8 Athena); Theseus with sow
(9) and Skiron. About 430. (Sunium. H. 0.825)

121 Seated woman from the pediment of the
Temple of Poseidon at Sunium. (Athens 3410.
H. 0.58)

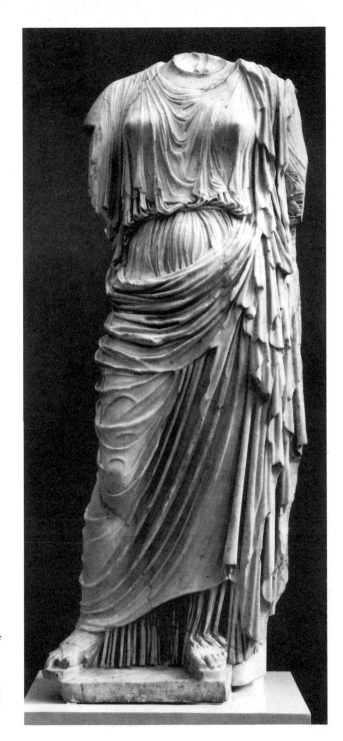

122 Copy of the cult statue of
Nemesis at Rhamnus, by
Agorakritos, identified by
Despinis from fragments of the
marble original. Paus. says the
marble had been brought to
Marathon by the Persians to make
a trophy – an unlikely story. He
saw it with a crown decorated
with deer and Nikai, an apple
branch in one hand, in the other a
phiale decorated with negro heads
('Ethiopians' – familiar decoration
for the shape). (Copenhagen, Ny
Carlsberg 304a. H. 1.85)

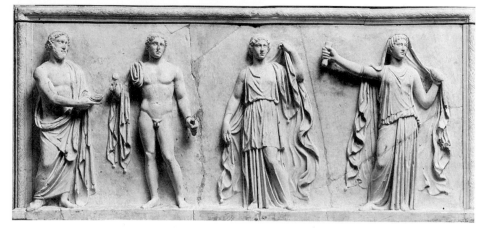

123 Relief inspired by the base of Nemesis at Rhamnus *122*. Restored (notably the right forearm of the right figure). Paus. saw Helen brought from Nemesis to Leda, with, among others, family figures (Tyndareus, Agamemnon, Menelaos) and local heroes. On this relief may be Tyndareus, Menelaos ?, Helen, Leda. Pieces of the original base have been found. It had four figures on each of three sides, cut in very high relief (H. 0.50). (Stockholm 150. H. 0.51)

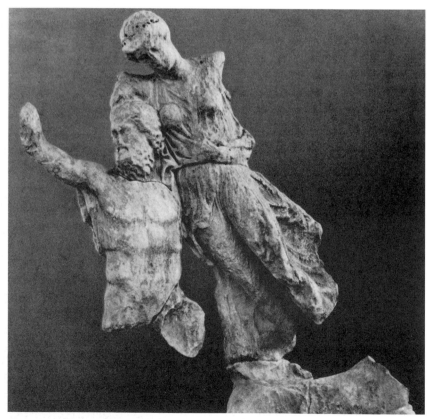

124 Akroterion from the Temple of Apollo on Delos. Boreas and Oreithyia. About 410. (Delos. H. 1.70)

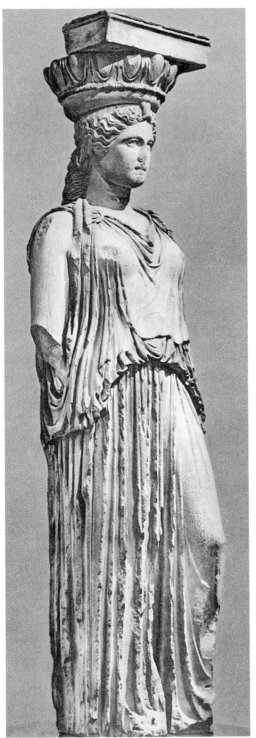

125 Caryatid from the south porch of the Erechtheion. Copies in Rome and Hadrian's villa at Tivoli show that these figures (6 in all) held phialai in their right hands (cf. Parthenon frieze *94*). Their inner (in the architectural setting) legs are flexed. For Archaic Caryatids see *GSAP* figs. 209, 210. The name 'Caryatid' is given by Vitruvius, from Karyai in Laconia, where the women danced with baskets on their heads. His further allegations, that the name was applied to architectural supports to commemorate Karyai's wicked defection to the Persians, is absurd. The term appears first in the 4th cent. Archaic Laconian female support-figures are known (cf. *GSAP* 25–6). (London 407. H. 2.31)

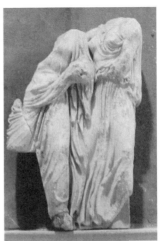

126.1

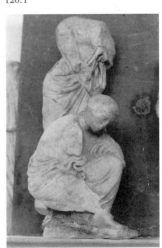

126.2

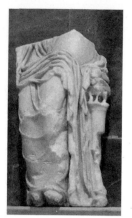
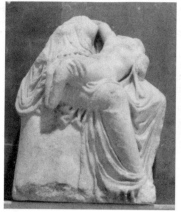
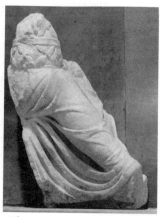

126.3 126.4 126.5

126 Erechtheion frieze fragments. 1 – two women; 2 – man and youth; 3 – woman (?) rising from throne with sphinx-armrest; 4 – woman with child; 5 – seated figure (Apollo ?) holding omphalos (Roman replacement). (Acr. Mus. 1071 (H. 0.49), 1073 (H. 0.49), 1239 (H. 0.37), 1075 (H. 0.38), 1293 (H. 0.32)

NORTH

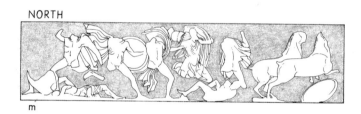

m

h

127.1 Temple of Athena Nike. NORTH frieze. Battle between Greeks including cavalry. Slab m (and other frs.)

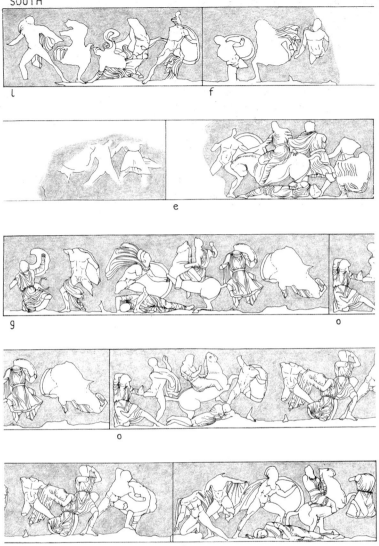

127.2 Temple of Athena Nike. SOUTH frieze. Marathon (?). Battle between Greeks and Persian cavalry and archers in oriental dress (trousered, sleeved). Note the 'heroic' pose of the second figure on slab g. Slabs l, f + e, g, o, a

EAST

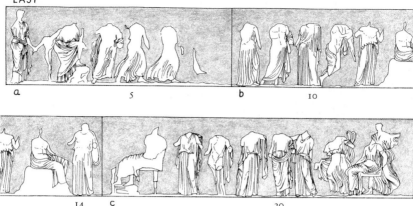

127.3 Temple of Athena Nike. EAST frieze. The right slab is missing. Olympian gods. All identifications are speculative except for Athena (14) and Zeus (16) with a figure between (Nike ?), Eros (2), therefore, probably Aphrodite (3). The prominent 13 may be Poseidon, the 'lame' 11 Hephaistos. Notice the hurrying figures 4–6, 22, 24. Slabs a, b, c

WEST

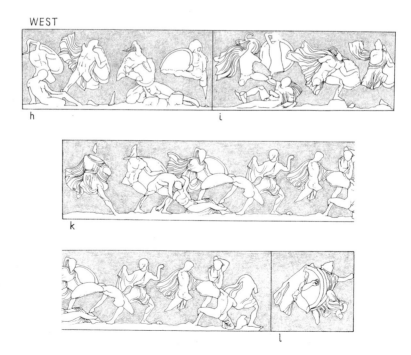

127.4 Temple of Athena Nike. WEST frieze. Battle between Greeks. Slabs h, i, k, l. (Acr. in situ; and slabs g, o, i, k are London 424, 423, 421, 422. H. 0.49)

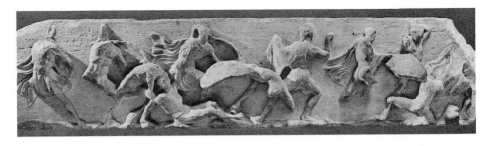

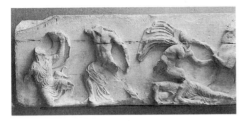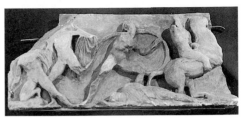

128 Athena Nike temple frieze, slabs k (1), g (2), a (3)

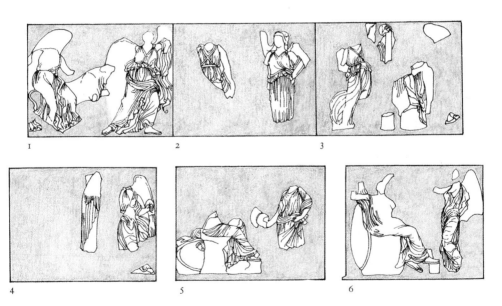

129 Frieze on the balustrade of the Temple of Athena Nike, Athens. Selection of restored blocks. 1–3 – from north side: two Nikai bring cattle for sacrifice; two Nikai, one holding a greave; two Nikai dress a trophy with a 'Greek' helmet and shield (?). 4, 5 – from west side: Nike with shield; Athena and Nike, holding 'Attic' helmet. 6 – from south side: Athena and Nike, a trophy between them; the association of the two figures on one slab is questioned. (Acr. Mus. H. 1.40)

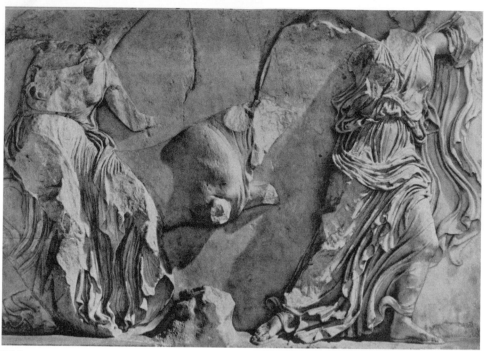

130.1

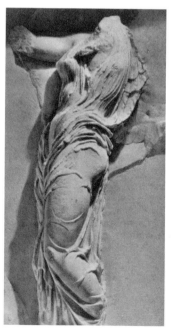

130.2

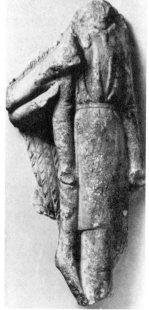

130.3

130 Athena Nike temple balustrade, details. 3 shows a trophy with Persian spoils. The sleeved coat is Persian. Arm of a Nike holding a quiver to deck the trophy, at the left. Trophies on the balustrade are Persian (as this), hoplite (shield, helmet, cf. *129.2–5*), apparently naval (a steering oar). Just possibly they correspond, on each side, with the battles on the temple frieze (the *certain* Persian trophies are on the south)

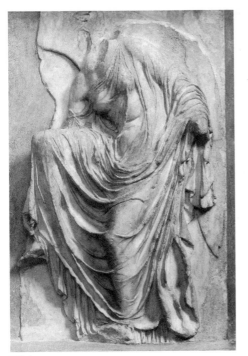

130.4

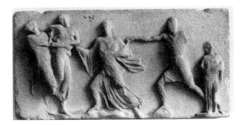

132 Ilissos temple frieze. Slab D. See *131*. (Berlin 1483a)

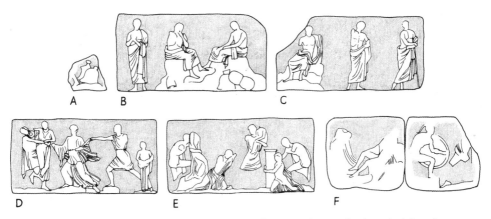

A B C

D E F

131 Frieze slabs from the Temple by the Ilissos. Subjects are obscure. On the rocks below the seated thinkers on B appear a bucket, a tied bag (cf. A) and a bundle, as for travellers. D and E show the rape of women, one (on E) from a sanctuary at a pillar. F is a very worn corner block with taller, slimmer figures. (A, F – Athens 1780, 3941; B, C.2, D – Berlin 1483b, c, a; C.1, E – Vienna 1094, 1093. H. 0.47)

Chapter Twelve

THEMES IN ATTIC SCULPTURE

An important part of the effect of the architectural sculptures of the new Attic temples on the contemporary viewer must have been what we would call their aesthetic appeal – quality of execution, composition and style. They exercise an aesthetic appeal also today, but this has changed in character since the sculptures were recovered for western eyes, and cannot have been the same as it was in fifth-century Athens, partly because we are not fifth-century Athenians, partly because we cannot see them in their original state (freshly carved and coloured) or in their original setting. Such aesthetic appeal, at any rate, is dependent on subjective criteria dictated by the culture in which the viewer lives, his education and sensitivity. Another element of their appeal, however, was their content. Greeks saw and interpreted their present through their past – think of the subjects of Attic drama – and since, objectively, something can be known about the myths and something can reasonably be surmised about their use as parables, we have here some hope of approaching the fifth century's own view of these remarkable works. I discount, however, speculation about subsidiary messages that may or may not be present and are at any rate not provable. Many have been proposed for these monuments – subtle topographical or personal allusions, the glorification of women or the family, multi-dimensional (time and space) cross-references.

The Attic temple programme was inspired by the historical fact of the city's recent leadership and military successes against Persia, and we might reasonably expect some relevant thematic unity in the choice of subjects both for individual buildings (in part determined by their deity) and for the whole complex of new buildings, especially if, as our sources imply, there was some element of central planning. What follows is a survey of the themes of Attic architectural sculpture, closing with special consideration of an unusual monument, the Parthenon frieze, and of the whole thematic programme of that building. The grounds for ident-ifying subjects or figures, which are by no means secure in many cases, are given in the previous two chapters or the figure captions.

Divine Olympian themes are unusually prominent. That the Parth-enon pediments should present the birth of the city goddess and her

defeat of Poseidon for control of the city is only remarkable when compared with the more oblique references on other Greek temples to the deity worshipped. The Athena and Poseidon theme may have been taken up also at Sunium (pediment) in Poseidon's own temple, with less emphasis on defeat; and on the east frieze of Athena Nike (reception of Athena after the contest). It was a new story, first recorded on the Parthenon. A comparable tale, of uncertain antiquity, was told of Troezen, which was Theseus' birth-place. Theseus had been a prominent hero in the earlier years of the young Athenian democracy, but he does not dominate the heroic themes of the Parthenon, as we might have expected, and Pericles may have deliberately played down the role of the hero of his predecessor and rival Kimon (who was almost an *alter Theseus*). The defeat of Theseus' father Poseidon by Athena; the military importance attached to land rather than sea at the time the Parthenon was being planned and the resources of Athens' maritime empire were becoming centred on the land of Attica: many interconnected motives could have led to the choice of subjects.

The Olympian family of gods was worshipped first, as such (a literary rather than religious concept), in Athens from the end of the sixth century. In the minor arts they assembled for a few appropriate Olympian occasions, often with a heavy literary flavour (as the Homeric group on the Archaic Siphnian Treasury, *GSAP* fig. 212.2), or to fight Giants (see below). On the Parthenon they attend Athena's birth in the east pediment, they attend the procession on the east frieze, and they attend the birth of Pandora on the Parthenos base; and on the Athena Nike temple they attend Athena on the east frieze. Where other Greek cities laid claim to hardly more than the patronage of their principal deity on their temples, Athens, self-appointed leader of Greece, claims the attention of the whole Olympian family for what are probably all Athenian occasions: thus, the gods bless and endow a newly-created Pandora, the 'all-bestower', as they bless and endow Athens and her people with qualities in which they too can school Greece. These divine births are another recurrent theme in Attic sculpture. The birth of Athena had been celebrated in major art before, but not Pandora, nor Helen (Rhamnus base) – hatched by Leda from the egg laid by Nemesis, sired by Zeus. The last story appears to have been a local one, but Helen too had gifts for mankind, dire ones, having provoked the Trojan War and taught mortals the inevitability of Zeus' will and Nemesis. A Birth of Erichthonios has been suspected on the base of the statues in the Hephaisteion (see [*240*]; he was her foster-child). At Olympia Phidias put a birth of Aphrodite on the base of the Zeus. At a slightly lower and more patriotic level the hero-kings of Attica are accommodated on the west pediment, and the eponymous Heroes of the ten tribes (a political

confection, just as the Olympian family was a literary confection) on the east frieze. The mysterious central south metopes of the Parthenon may also depict Athens' early kings and heroes.

Of the major heroes adopted by Attica Heracles had been dominant before the democratic reforms of 510, and Theseus thereafter. They roughly share the honours on the Hephaisteion, just as they had on the Athenian Treasury at Delphi at the beginning of the century (*GSAP* fig. 213). This is another indication of the archaizing character of part of this building's decoration. It is as though the myth programme for Periclean Athens had yet to be established. Thereafter, Heracles is nowhere except in gigantomachies. Theseus has a role to play fighting Amazons and centaurs (see below) though he is not always easily identified, and he may be on the Hephaisteion east frieze in another episode (otherwise ignored in art) from Attica's early history. He is present at Sunium (his father's temple) at Rhamnus (an akroterion of Theseus with Helen is suggested), and on Athena Nike (a possible introduction to Olympus on the east frieze), but perhaps not correctly. Only on the roof of the Stoa of Zeus he is confidently identified (at least by Pausanias) in one of his old duels, with Skiron. These stories, born with the democracy, were still popular in Athens' minor arts. Skiron was a good choice for the period since the fight happened near Megara with whom Athens had recently been in bitter conflict.

The new fashion for akroterial groups required struggling pairs as subjects. We have alluded to Theseus with Skiron on the Stoa of Zeus, and with him there (and on the Delos temple) were Eos carrying off Kephalos. The latter was, in one version, an Attic prince carried east by Eos (Dawn). Another Delos akroterion was Boreas (North Wind) seizing Oreithyia; the latter, an Athenian princess: the former worshipped by Athenians since his help to them in scattering the Persian fleet at Athos and Artemisium (cf. *ARFH* 224). The Bellerophon and Chimaera perhaps on Athena Nike are more difficult to explain since Bellerophon was a Corinthian hero and there was no more hated city in Athens in these years than Corinth. Moreover, the building's west frieze has been thought to show a Corinthian defeat. But Bellerophon too had enjoyed Athena's patronage, and he slew the Chimaera in Lycia close to the scene of Athens' final crushing defeats of the Persians (at Eurymedon in 467). Peleus seizing Thetis are guessed on the temple of Ares and would explain the Nereids (Thetis' sisters) given to the same temple. Their struggle was the proem to the story of the Trojan War; their child Achilles. The other single figure akroteria are often Nikai, Victories, whose presence needs no explanation: perhaps on Athena Nike, Ares and the Hephaisteion, as well as their appearance on the Parthenos' and perhaps Promachos' (see below) hand and the Athena Nike balustrade.

The other major and popular themes are of conflict (with Giants, centaurs, Amazons) and its aftermath (Sack of Troy). The Greek victory at Troy was a victory over easterners, and Herodotus says that the Persians traced their conflict with Greece back to it. It had long been a popular subject in Greek art, as in literature, and appeared on the Parthenon north metopes (doubtfully also a Hephaisteion pediment). The Greek view of the Troy story was ambivalent and they respected the Trojans. The destruction of Troy seems presented as punishment for wrong-doing (the rape of Helen) wreaked upon those who may have been innocent of the crime but who had to share in the just punishment. It has been suggested that the only sack of a great city in the Persian War, that of Athens, could have been equated with Troy.

The centauromachy was seen on the Parthenon south metopes and Parthenos' sandals, on the Hephaisteion west frieze and a pediment, and at Sunium. (Also on the Promachos shield, see below, p. 203.) It involved Theseus, who may not, however, have been the main reason for its popularity. Its role at Olympia has been mentioned (pp. 36–7). It was an Athenian-aided victory, with Theseus. At a more general level it represented a triumph of the civilized over the bestial (the Persians, like all invaders, had a bad reputation) and it happened in North Greece which had been generally welcoming to the Persian invaders.

Amazons are easterners and come to be dressed like Persians in Classical art, but they enjoyed respect and even worship in some Greek towns, and were allegedly founders of some East Greek cities. Amazonomachies are seen on the Parthenon west metopes and Parthenos shield, and perhaps for Ares, Athena Nike and the Hephaisteion. It may have been the invasion of Amazonland, and perhaps jointly by Theseus and Heracles, that appeared on the Athenian Treasury at Delphi (*GSAP* fig. 213), an event which could have celebrated the Athenian-aided attack by the Ionians on the Persian capital at Sardis in 499 (the Ionian Revolt). But a new conflict was soon invented to reflect the Persian invasion of Attica at Marathon, in an Amazon invasion repulsed by Theseus in Athens itself. Which fight is being shown in Classical Athens is not always clear, but it is surely the fight for Athens that appeared on the Parthenos shield, and at any rate, the general message *is* always clear.

The battle of Gods and Giants (on the Parthenon east metopes, the Parthenos shield, perhaps Sunium, and an Athena Nike pediment) was long associated with Athens and Athena. It seems often, if not always, to have been embroidered on the peplos dedicated to her, and she, with her protégé Heracles, normally figured in the central group beside Zeus, from the Archaic period on (cf. *GSAP* figs 199, 212.1, 215; *ABFH* 220; *ARFH* fig. 187). The special role of the Olympian gods in Athenian sculpture has been remarked. Their triumph over what could be taken as

'powers of darkness' would naturally appeal quite apart from the special role of Athena. The story of Theseus' defeat of Pallas and his fifty sons at Pallene in Attica might seem a modest local version of the defeat of the giants at Pallene in North Greece. This lends some colour to the identification of Theseus and the Pallantidai in the Hephaisteion east frieze, where boulders are used as weapons, as in gigantomachies.

Other battles, yet farther removed from the Olympian, are seen on three friezes of Athena Nike. That on the south is against easterners (and not Amazons, as on the Parthenon metopes). Details suggest that the battle of Marathon is intended. On the other friezes the combatants are dressed as Greeks. The north may show Plataea, where the Athenians defeated the medizing Boeotians. Mortal battles are not normal themes for Greek temples but the Athenians who had defeated the Persians had been heroized by their countrymen, and accorded semi-divine status. Twenty years after their success had been alluded to through the Amazonomachies on the Parthenon, it may well have seemed proper to show them in the action itself, and few if any who had fought were still alive. That the west frieze could show an Athenian victory over other Greeks without the connotation of the Persian Wars (which carries Plataea and the Boeotians) is difficult to believe, although while embroiled in a new war the Athenian attitude to the divine qualities of their war dead was considerably heightened, and the identification of the defeat of the Corinthians at Megara by Myronides in 458 is attractive.

The Parthenon frieze is mainly devoted to mortals too, but not heroically occupied in fighting enemies who threatened Greece's liberty, and so a different explanation for the subject has to be sought. That it depicts a Panathenaic procession is as clear as the fact that it is no ordinary procession, since it lacks the citizen body and hoplite army, and instead is dominated by a cavalcade. To say that it is contemporary or generic ignores these omissions and many other problems. That it is the first Panathenaea is improbable, since this should be attended by identifiable Attic heroes or kings and not an undifferentiated civilian body, and the ten tribal Heroes belong to Athens' recent political history, not to its remote past (when there were four tribes). Their presence suggests something closer in date to the Parthenon itself.

Many would assign different parts of the frieze to different periods and places but we look for the unities in Classical work, and the apparent progress in the frieze from preparation to completion is illusory. I make no apologies for presenting my own view of the frieze. The reader may judge how well it suits what is suggested in the rest of this chapter.

The unities of time and place are definable: the opening stages of the Panathenaic procession on the northern outskirts and within the Agora. The culminating scene is the handing over by an *arrhephoros* of the new

peplos to the Royal Archon before the Royal Stoa. The workshop for the peplos was in the Agora and its delivery to the Acropolis (though not to the Parthenon at this date) was the reason for the procession. Its production may also be alluded to in the east frieze, and Athena's gift to Pandora (on the Parthenos base) was the art of weaving. The Panathenaic way across the Agora was known as the race-course (the *dromos*) and on it were performed the riding and chariot events illustrated in the cavalcade. At the start of the *dromos* was the Altar of the Twelve Gods and nearby (probably) the place of worship for the tribal Heroes, who are together on the east frieze receiving the procession. But what is there so special about this procession that it should be greeted by Gods and Heroes? Why only the cavalcade? Can an answer absolve us from having to accept this unique instance of a placid mortal event in such a divine setting? The scheme of presentation and reception is one familiar in Greek art for the promotion of a hero (as Heracles) to divinity. The cavalcade is, in its way, heroic, in that horses in Greek art commonly denote heroes. Moreover, horsy hero-cults in the Agora are thought to have been the reason for the cavalry events held there in the procession. We do not need to look far for Athenians recently promoted to heroic status – those that died at Marathon, Athens' first stand against Persia. And the number of males in the cavalcade (excepting only the charioteers who are no more important than the horses) seems exactly or close to that of the Athenian dead at Marathon – 192. The four-yearly Great Panathenaea had been celebrated less than a month before the battle, so the two were readily associated in the minds of the Athenians. The choice of the cavalcade rather than a real procession with citizens and foot soldiers becomes clear from its heroic connotations and behaviour. Athens was declaring the divinity of the men who had fallen in defence of the city; declaring it before the gods of Greece and the tribal Heroes of the city; on the building which was gratefully dedicated to the city goddess and which commemorated the final success against her eastern enemies. It was achieved on a monument, the frieze, which with genius conveyed the whole message in the framework of the depiction of one stage in the progress of the sacred procession, with all its apposite allusions of religious and civic topography. To the fifth-century Athenians and visitors to their city the statement could not have been clearer.

Reconsider now the whole programme of the Parthenon sculpture. There is a physical declension – the divine in the pediments, heroic in metopes, both meeting the mortals in the frieze. At the west, the delivery of Athens – to her goddess in the pediment, from the Amazons in the metopes, in a parable of that mortal success alluded to so subtly in the frieze. At the east the theme is gods and men. In the pediments the gods greet the newborn city goddess; on the metopes they demonstrate their

superiority over the earth-born giants; on the frieze they greet a mortal procession that has won heroic status. On the north metopes the greatest city of myth-history is sacked, but in scenes of human encounters, not mere carnage; on the south metopes the bestial is repulsed. Within stands the gold and ivory virgin goddess. Her shield and sandals pick up again the themes of defeated Amazons, giants and centaurs, and on the base Pandora, like an Athena or Athens, is created by the Olympians to bring her gifts to mankind: a poignant footnote, for she was a deceiver too. Athena's own gift to her was weaving, perhaps another allusion to the peplos.

This nexus of myth and parable in architectural sculpture is remarkable, yet it is only one aspect of a closely interconnected whole, created by the artists, playwrights and historians of Classical Athens in a mood, at first, of self-confidence and pride, which had to carry the city through darker years of defeat and self-questioning, when the Greece that she had sought to lead and instruct turned against her, and her proud Long Walls were brought as low as Troy's.

Chapter Thirteen

OTHER CLASSICAL SCULPTURE

The remarkable dearth of architectural sculpture outside Attica may be primarily a matter of the accident of survival, but the rest of Greece had not Athens' need to replace ruined temples. (The sculptures from the temples at Bassae and the Argive Heraeum fall just beyond the limits set for this book.) A pedimental group representing the slaying of the Niobids by Apollo and Artemis was taken to Rome in antiquity, and of various figures attributed to it three match so well in scale and style that their association is certain [133], while there are others at a slightly smaller scale. It is far less certain which temple they once adorned – Bassae and the Doric temples in Attica have been suggested but Bassae has proved to have no pediments, and the style is not noticeably Attic. It is not even certain, though highly probable, that they came from Greece rather than some Greek city in southern Italy. The figures seem kin to those from the Olympia temple, yet dressed as for the Parthenon. The style is weak, but flowing, and in the stumbling girl [133.2] we have our first example in sculpture of the pathetic appeal of nudity: at Olympia there was an erotic element as well. But the body is only superficially feminine; the hips and legs could be a boy's.

An Apollo of about the same date [134], apparently a bowman, has in the past been associated with the Niobids, as their slayer. It was also found in Rome, near the temple of Apollo Sosianus, a known setting for imported, stolen Greek statuary. It had been repaired in antiquity with bronze forelocks (not shown here) and copied. It has recently been reidentified as a probable Theseus from an Amazonomachy – perhaps another pedimental group.

Apart from architectural sculpture Attica has yielded a number of other original pieces, generally votive, of some merit. Pausanias saw a group of Prokne and Itys on the Acropolis, dedicated by Alkamenes. The name is that of a famous sculptor, and the preserved group [135] is likely, therefore, to be from his hand, since it would be churlish to ignore the coincidence simply because to some the work does not seem superlative.

From the Agora there are battered pieces of a colossal marble which we would dearly have complete [136]. The dress style is the transparent

one of the late century and the rather luscious quality of the body which this conveys is enhanced by the almost lazy swirl of the chiton. The figure seems in a pose which implies motion. She has been called Aphrodite, but whatever her identity the role of such a figure at this date is not easily guessed: hardly a cult statue, yet massive and anonymous for a dedication, and to whom?

Another pupil of Phidias, Agorakritos, has been associated with a statue of Demeter from Eleusis [137] – on poorer grounds, through similarity to figures on the Rhamnus base, and again to the dissatisfaction of experts who find it inadequate.

Another Agora piece, earlier, is the half life-size bronze head commonly described as a Nike [138]. The name was prompted by the grooves at neck and hair-line which were cut to allow insertion of plates of silver overlaid with gold (of which traces were found). Some such technique may have been employed for the gold Nikai (reported in 407/6 on the Acropolis) whose precious material could be removed, melted down, and later replaced, as economic necessity demanded, but it is no longer certain that this was the intention on our bronze. The head was meant for insertion in a body, not necessarily also of bronze. It is a coolly Classical piece, of superb quality, the first original bronze we have had occasion to admire in this part of our study.

An unquestionable Nike is the dedication of the Messenians and Naupaktians at Olympia, celebrating success over the Athenians at Sphakteria in 425, and signed by Paionios of Mende [139]. The way the material is pressed against her body, baring one leg and breast, anticipates the dramatic 'wet' look of the figures later in the century. It would have been the more dramatic if we could view it with the figure's wings spread and the rest of her dress billowing in deep folds at either side of her body. This is something of a tour de force.

The Boston Leda [140] bares her body provocatively and innocently embraces the insidious swan. Many place this in the later fifth century, anticipating the more familiar, rather vulgar group which is the creation of the following century. It has also been tentatively assigned to Attic temples, in pediments or as an akroterion, but was probably an independent offering.

An original male bronze head also deserves consideration here [141]. It has been taken for a portrait, but we cannot be too sure that the traits of individuality – the tight lips and weak beard on an otherwise normal idealized Classical head – are more than generic indications such as we may look for more readily in superior works, and not in marble, especially the architectural ones we have been studying, bearing in mind their message and purpose. The diadem makes him a king, but this need be no likeness. There will be more to say on portraiture in Chapter 17.

We end with marble. One, a herm from the many in Athens which served as wayside shrines, marked sacred places or were dedicated for public good (Kimon gave Athens three to commemorate his success at Eurymedon; for the Archaic type see *GSAP* 87, fig. 169). [*142*] is a good Classical example from the Agora, a little under life-size, and its good surface condition combined with its damaged features have suggested that it was one of the herms desecrated by Alcibiades' companions on the eve of the fated expedition to Syracuse in 415. And a marble youth dedicated at Rhamnus, cut in an unassuming style of the end of the century [*143*].

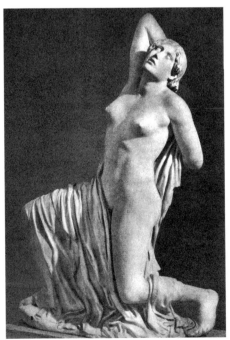

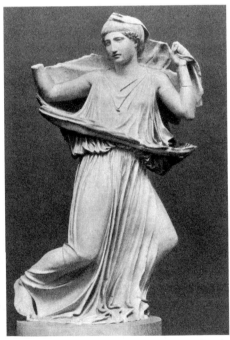

133.1

133.2

133 Niobids. Found in the Gardens of Sallust, Rome. They had been overworked in antiquity. About 430. 1. Stumbling Niobid, struck in the back (Rome, Terme 72274. H. 1.49) 2. Fleeing Niobid, protecting herself with the upturned back-overfall of her peplos. (Copenhagen, Ny Carlsberg 398. H. 1.42) 3. Fallen, wounded Niobid. (Copenhagen, Ny Carlsberg 399. L. 1.65)

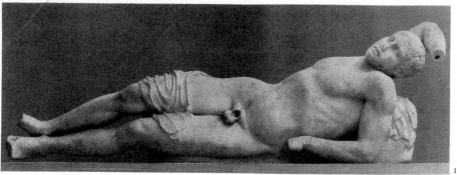

133.3

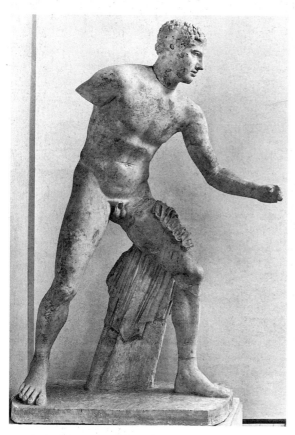

134 Archer, formerly 'Apollo', possibly Theseus from an
Amazonomachy group. Found near the Temple of Apollo
Sosianus, Rome. About 440–430. (Rome, Conservatori 2768.
H. 1.52)

135 Prokne and Itys. From the Acropolis. She is
contemplating the murder of her infant son, who nestles
against her. About 430–20. (Acr.Mus. 1358. H. 1.63)

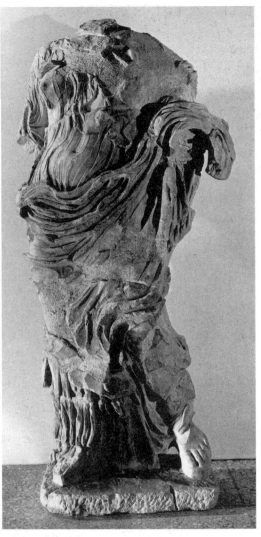

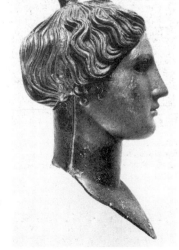

136 'Aphrodite', from the Agora. Athens. About 420.
(Agora S1882. H. 1.83)

137 (*above right*) 'Demeter' from Eleusis. The belted
overfall of the peplos is as Athena's, e.g. *41*. About 410.
(Eleusis 64. H. 1.80).

138 Bronze head of 'Nike', from the Agora, Athens, to
be coated with gold and silver plates. The projecion on
the crown is for fastening a hairpiece, cast separately
(perhaps the flame-shaped lampadion). About 420.
(Agora B31. H. 0.20)

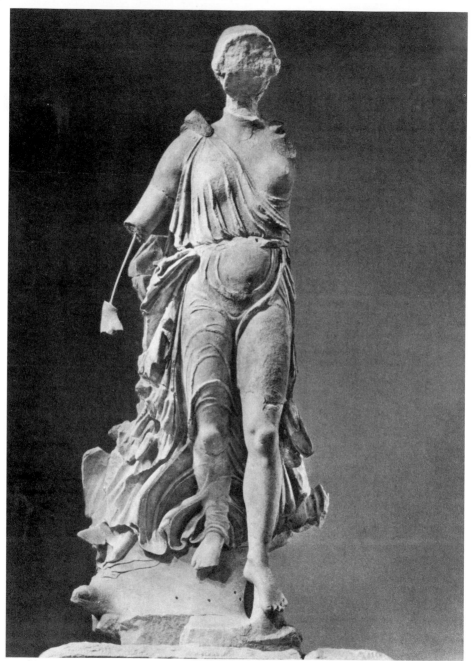

139

MEΣΣANIOIKAINAYПAKTIOIANEΘENΔII
OΛYMПIΔIΔEKATANAПOTΩMПOΛEMIΩN
ПAIΩNIOΣEПOIHΣEMENΔAIOΣ
KAIГAKPΩTHPIAПOIΩNEПITONNAONENIKA

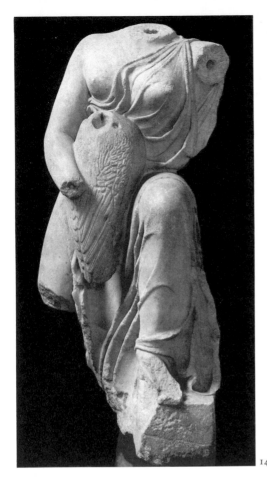

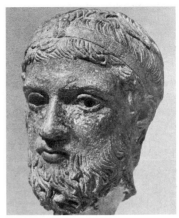

141

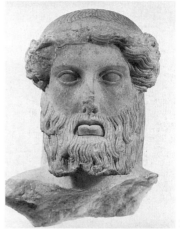

142

140

139 (*opposite*) Nike of Paionios at Olympia. She is shown
alighting but still airborne, an eagle with spread wings at her
feet. She stood on a tapering triangular pillar some 10m high.
About 420. (Olympia 46–8. H. 1.95). The inscription reads:
'The Messenians and Naupactians dedicated this to Olympian
Zeus, a tithe from the spoils of war. Paionios of Mende made
this, and was victor (in the competition) to make the akroteria
for the Temple'. (Cast in Cambridge)

140 Leda with the swan. The figure has been recut and
mutilated to serve as a fountain. (Boston 04.14. H. 0.88)

141 Bronze head from Cyrene, diademed. This has been
thought a portrait of Arkesilaos IV of Cyrene. About 440.
(Cyrene. H. 0.10)

142 Head of a marble herm from the Agora, Athens. The lower
lip is inserted as a separate piece, probably a repair by the artist
of a fault in the stone, or a mistake. About 440. (Agora S2452.
H. 0.23)

143 Youth from Rhamnus. He held perhaps a staff and a phiale.
The base records the dedication by Lysikleides. About 420–10.
(Athens 199. H. 0.98)

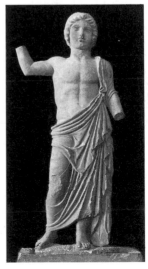

143

Chapter Fourteen

OTHER CLASSICAL RELIEF SCULPTURE

The few pieces of temple relief sculpture outside Athens in the second half of the fifth century need not detain us: the next major complex is the frieze from Bassae, too late for this volume. There is some other architectural sculpture, however, and some large or not readily definable reliefs which deserve attention before we turn to the major categories – the grave, votive and record reliefs.

Thasos has already offered some unusual relief decoration in the Archaic (*GSAP* figs 223, 263) and Early Classical periods. Towards the end of the fifth century more city-gate reliefs were cut including a rather Archaic looking Hera with Iris, and Zeus with Hermes from a corresponding slab.

The famous three-figure relief from Eleusis [*144*] is hardly architectural but must have been placed in a position of prominence since it was copied in antiquity, like the three-figure reliefs from Athens ([*239*]: known only from copies). There is much still Severe in its style though details of dress are already Parthenonian. The very shallow relief perhaps gives it a misleadingly provincial air. Its role, whatever that may have been (even a form of cult group for a small shrine) perhaps dictated its robust, old-fashioned appearance. Some find it positively non-Attic in style.

Another large relief is in Rome [*145*], and had been taken to Italy in antiquity, almost certainly from Attica. It is probably votive but exceeds considerably in size the normal Attic votives and may have been more permanently installed in a heroon. Its interest lies in the multi-level composition which we know to have been practised on wall paintings earlier in the century. Any landscape effect in sculpture had hitherto been confined to discreet rocky excrescenses, rarely more. Add, in the mind's eye, paint and we have virtually a panel-picture in relief, but no true perspective since the differing scales of the figures probably denote their relative importance and not their distance – this is obviously true of the small mortal worshipper in the left foreground.

Finally, a handsome Athena in Basel seems to fly like the Nikai (from Zeus' hand?) and her flat back suggests that she had been fastened to a background slab [*146*]. The inlaid eyes are unexpected in a marble and it is difficult to imagine its original setting and context.

Attic grave reliefs

Early in the century the production of decorated gravestones in Attica ceased, for whatever reason (*GSAP* 163). It re-starts around 430, to the relief, no doubt, of the numerous masons whose employment on the architectural sculpture of the Parthenon and other Attic temples had almost disappeared. It represents a new concern for the decoration of tombs of the private dead to match the concern devoted to the public dead who had fallen in defence of their country, and comes at a time when the outbreak of the Peloponnesian War must have heightened Athenian sensitivity in such matters. We cannot tell whether any ban on decorated gravestones was formally lifted, or if the new series was prompted by consideration of employment, or wealth, or sentiment, or any combination of these. In Athens' main cemetery family plots are laid out and there is an air of deliberate display in the assemblage of monuments with their frequent and sometimes lengthy epitaphs. Close by, immediately outside the city walls, state graves for the war dead had already been built in the fifth century and their decoration – fighting scenes – will have contributed to the inception of the new private monuments and eventually contributed to their iconography.

In the Early Classical period, as we have seen, the tradition of figure-decorated gravestones was upheld by other studios in Greece, notably in the Islands and Ionia. To the Archaic, slim, anthemion-crowned, one-figure stelai were added broader types accommodating more figures, especially seated ones, and architectural features could also be added to frame the figure or figures, which themselves offer greater variety in age and activity. The new Attic series depends on this tradition wholly and as time passes it especially develops the architectural setting for stelai. Much of this is apparent already in the fifth century but its fullest expression comes in the fourth, and the turn of the century has no significance at all in the gravestone series, though it does in Athenian politics, and in architectural sculpture we saw that it represented roughly the end of Athens' programme of rebuilding.

To our eyes, the idealized, Classical style in sculpture exemplified in the Parthenon is well suited to funerary subjects – a touch of sublime, otherworldliness combined with heroic calm in the face of the unknown and inevitable, and the absence of violent expression of emotion. The subject matter is basically the representation of the dead in life, but now sometimes combined with figures which we naturally regard as living, in scenes of what appear to be farewell, or admiration of the departed, or togetherness indicated by the handshake (*dexiosis*). The identity of living and dead is not at all clear, however, nor is it always made the clearer by inscriptions. Many of the stock scenes must have come to convey a

generic message of departure or loss or family unity without the necessity of identifying individuals in the relief. Sometimes the scene is made specifically appropriate by the epitaph; sometimes an extra name is added to commemorate a later burial in the same plot regardless of the theme on the stone. Full consideration of the subjects of the reliefs would need to embrace the far more numerous fourth-century series. The dead are not usually characterized very closely, but shown in everyday dress. Warriors appear in working dress, under arms, but we do not know whether this always means that they died in battle. There are the obvious indications of age or relationship – the youthful athlete, old man with stick, spinning woman, wife and husband, mother and child, child with toy etc., and occasionally an indication of profession.

The pieces illustrated [147–58] exemplify the principal types in the first generation of Classical Attic stelai. One of the earliest is of Eupheros [147], a slim, one-figure slab like the Archaic, the youth characterized as an athlete, but the stone is given a pedimental finial which is carved on the slab rather than standing free. The 'Cat stele' from Aegina [148] (fairly taken with the Attic) includes a subsidiary figure but is unorthodox in showing also what seems to be a stele with cat (?) atop and in its patterned upper border. Mnesagora's [149] is another wide stone but with only a broad lintel above, to carry a lengthy epitaph. Ampharete and Hegeso [150–1] typify the broad stele with its full pediment and antae, giving the appearance of an entrance or doorway before which the figures sit or stand, overlapping the doorposts.

Individual warrior gravestones are surprisingly few in the later fifth century, given Athens' warlike preoccupation. The dead were honoured communally in the state graves, but Lykeas and Chairedemos [152] had a memorial for themselves, on Salamis, and there come to be other examples of warriors commemorated in their family plot though probably buried in state graves. These were furnished with stelai naming the dead by their tribes and decorated with reliefs of battle scenes. It is possible too that some carried major reliefs in an architectural setting, like the Albani relief [153] which was taken to Rome. This is the Parthenon style translated for vigorous action, with the swirl of clinging dress of the succeeding generation and some rare landscape details which, at this date, are generally referred to the influence of new realistic styles in panel painting.

Towards the end of the century marble vases carrying relief decoration may also serve as grave markers: either lekythoi or loutrophoroi, both shapes familiar in clay and having funerary associations in Athens. The subjects of the relief often go beyond the repertory shown on stelai and the one shown here [154] introduces Hermes as Psychopompos, leader of souls, with the dead Myrrhine, who may well be the famous first

priestess of Athena Nike. Three members of the family, at a slightly smaller scale than Hermes and Myrrhine, observe them. Hermes is a more familiar figure on the clay lekythoi which serve as grave offerings.

Non-Attic grave reliefs

The anthemion stelai and broader gravestones made in the rest of Greece, while Athens went without, continued in production after the mid-century, but seem gradually to become assimilated to the Attic series in style and subject, although there is still room for considerable individuality.

The distinguished East Greek series of gravestones which runs from the Late Archaic through the Early Classical falters later in the century though there are individual pieces of considerable merit and interest. The fragmentary stone from Samos [159] has a supple grace in its surviving figure of a youth, which recalls Archaic work in Ionia and stands in clear contrast with the harder, more architectonic styles of Attica and the Peloponnese. The strange stele of Krito and Timarista from Rhodes [160] is slightly later and far more atticizing in style though not in subject or shape. From Euboea comes part of a fine, highly Parthenonian slim stele with a bearded man [161] whose pensive gesture is elsewhere taken to indicate the living contemplating the dead.

In Boeotia there are stelai, mainly from the area of Thespiae, which are carved in a fine atticizing style, though some seem earlier than the Attic series. The horseman is a characteristic motif [162], while the frontal girl on [163] is somewhat surprising in her combination of Caryatid pose and clinging drapery.

In Thessaly the quality of the Early Classical is barely maintained on stelai, and subjects move closer to the Attic range, although there are still some unusual themes, such as a woman suckling a baby. The youth in his sun hat is a recurrent figure – in a good mid-century style on [165] but provincialized in the family group on [166]. The Peloponnese offers little [167].

Votive reliefs

The record of Classical votive reliefs is rather monopolized by Attica, and the only non-Attic example chosen for illustration here [172] has been taken for part of a gravestone, and neither it nor other non-Attic work reveal any startling new developments in the composition of such monuments.

In Attica the interest in stone votive reliefs, rather than ones in wood or in some other medium or shape, may have been stimulated in much

the same way as was the new series of relief gravestones, since both start at about the same time. For votive reliefs the low rectangular shape is generally preferred (but they were regularly set on top of pillars) and the upper edge is commonly carved as the edge of a roof or gutter, with palmette antefixes, and not with the pediment seen on so many gravestones. The fifth century sees the gradual adoption of schemes which become stereotyped in Attica and then in the rest of Greece in the fourth century and later, but the general scheme can be traced back to the Archaic period. The presence of the dedicator, sometimes with his family, and sometimes, it seems, not as an unseen onlooker but more closely involved with the divine, becomes increasingly common. These mortals are shown at a reduced size, sometimes much reduced, and may carry offerings or lead animals for sacrifice. The gods stand or, less often, sit to receive them, and the principal deity may be accompanied by a consort or other gods, perhaps to be thought of as from neighbouring shrines. Heroes recline at banquets (as may Dionysos also [170]) and this scheme is one which, as the 'Totenmahl' or death feast, is adopted as a motif for gravestones in the fourth century, with the implied heroization of the dead. A growing interest in the local heroes of Athens and Attica yields some interesting and puzzling reliefs, including mythological scenes which are otherwise not recorded [168]. River deities were popular recipients, and on their reliefs their senior representative and sire of nymphs, Acheloos, is often also admitted as a man-headed bull, either in forepart or mask [169, cf. 176]. Pan is another common intruder in votives for the more rustic deities. Sometimes groups of gods alone are depicted [175], recalling Olympian family groups on the architectural sculpture of contemporary Athens. Not surprisingly, style and pose often seem to echo the larger sculpture of the day: sometimes the quality is as exquisite as its models, sometimes pedestrian. Some exceptional reliefs like [173] carry what must be regarded as near-contemporary battle scenes and are directly comparable with the subjects of some gravestones; and, in this case, comparable with the big Torlonia relief in the unusual depiction of landscape detail. There had been a long tradition of painted panel votives, and the translation of new pictorial schemes on to the votives came even more naturally than on to the gravestones. The blank backgrounds of some reliefs, not only votives, may often have carried other painted subjects or figures integrated with the relief figures.

Record reliefs

Record reliefs appear in Athens on the upper parts of inscribed stelai recording treaties and decrees from about 425 on [177–9]. They usually show two figures, symbolizing the parties to a treaty or agreement – thus

an Athenian decree honouring Samians for their support carries a relief of Samos' goddess Hera clasping Athena's hand [*177*]. Moreover, the reliefs can be dated to a year, if the inscription survives – in this case 405. This might seem a valuable chronological yardstick for Attic relief sculpture, and to a minor degree it becomes so later, but in a period when stylistic change is slow or subtle these small figures can tell little. Sometimes they seem to reflect a major sculptural type, perhaps a cult statue, and at the best they can demonstrate a date by which a particular pose or pattern of drapery won its way into the sculptor's repertoire.

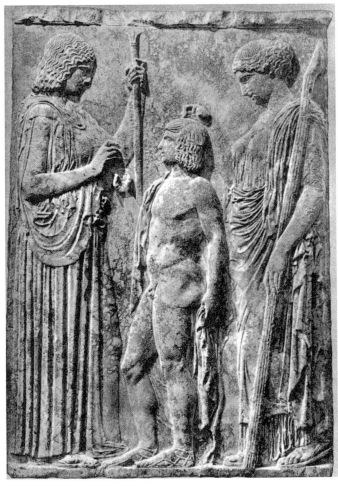

144 Relief from Eleusis. Demeter, with a sceptre, gives ears of corn (probably; they would have been added in bronze or gold) to the young Triptolemos, to bestow on mankind. Behind him Kore/Persephone with a torch. Triptolemos is only slightly older on Attic vases (*ARFH* figs. 154, 189, 309). About 440–30. (Athens 126. H. 2.20). The detail (*overleaf*) shows a fragmentary copy in New York (14.130.9)

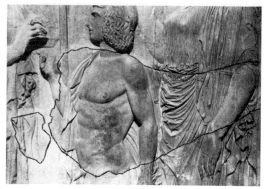

144b

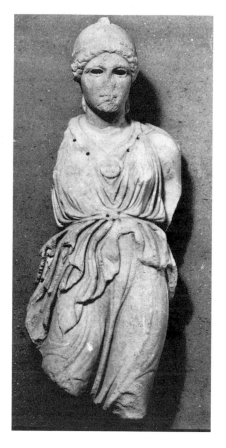

145 (below) Relief found in Rome, probably from Attica originally. A hero with horse and dog is approached by a worshipper, beyond a block altar. Above, at either side, two deities are seated on rocks, and between them is a columned shrine in which we see the lower part of a figure, probably a cult statue. Perhaps from a heroon associated with a major sanctuary: Asklepios in Athens has been suggested. About 420–10. (Rome, Torlonia 433. H. 0.40)

146 (right) Athena. The eyes were inlaid, the aegis snakes and belt ornament added in metal. About 420–00. (Basel BS228. H. 0.53)

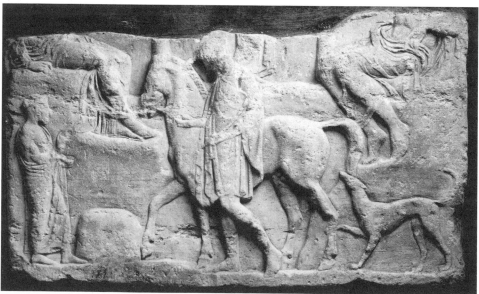

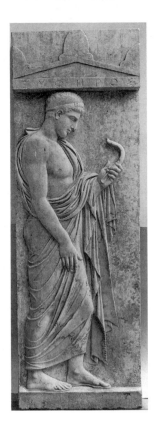

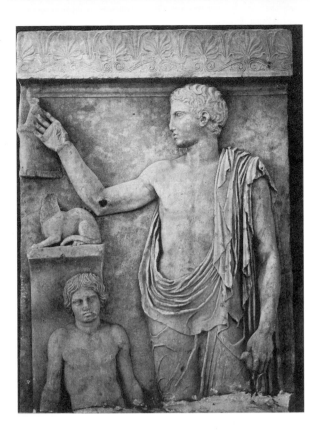

147 Gravestone of Eupheros, from Athens. He wears
himation and sandals, contemplating his strigil, a basic
piece of athlete equipment. This was found near the
grave of a boy of about 15. About 430 (that he was a
victim of the plague of 430–27 is pure conjecture).
(Athens, Ker. P1169. H. 1.47)

148 'Cat stele' from Aegina. A youth holds a bird in
one hand, raises his other towards a lantern or
birdcage. A young attendant beside him, before a stele
with a crouching cat (?) upon it. The youth's head and
dress are very 'Parthenonian'. The flame palmettes at
the top are an early example of the type. About 430.
(Athens 715. H. 1.04)

149 Gravestone of Mnesagora and Nikochares, from
Vari in Attica. A girl holds out a bird to a baby. The
epitaph suggests that this marked a cenotaph for a
brother and sister. The age difference in the figures
shown, whom we would take for mother and child,
suggests that the stele was not bespoke (or referred to
the boy with his mother) but chosen for being roughly
apposite. The baby has the proportions (especially the
head) of a mini-adult. About 420–10. (Athens 3845. H.
1.19)

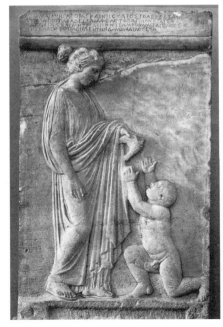

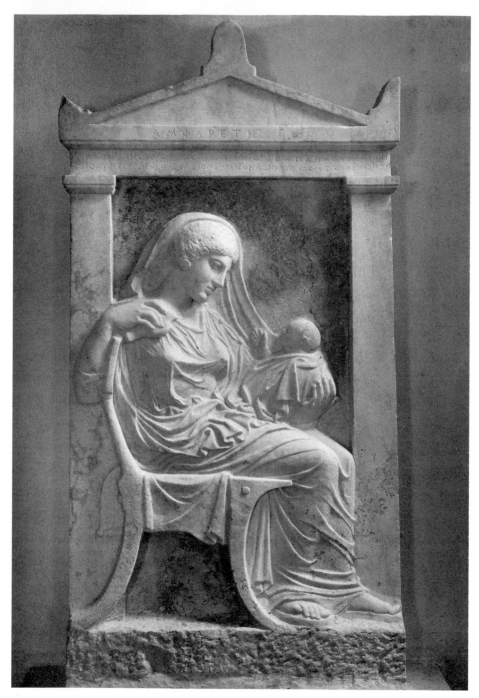

150 Gravestone of Ampharete, from Athens. A seated woman holds a bird in her right hand, a baby in her left. The epitaph indicates that the stele is for Ampharete and her grandchild, but she seems very young and this may be a mother-and-child stele adopted for this unusual joint memorial. Prime work. About 410. (Athens, Ker. H. 1.20)

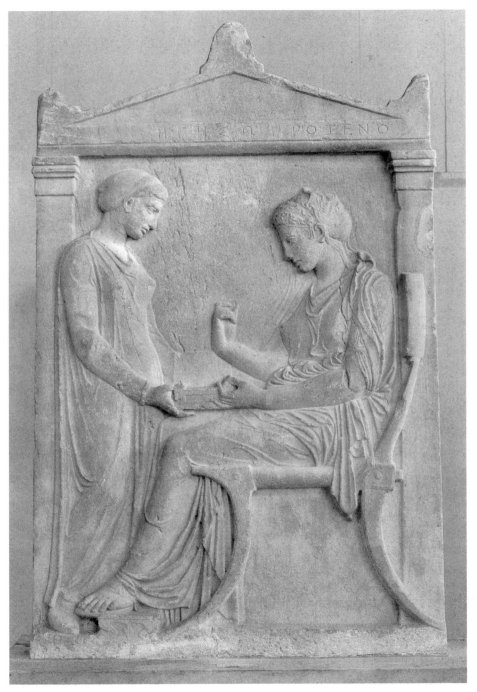

151 Gravestone of Hegeso, from Athens. A woman, well dressed and coiffed, picks jewellery from a box held for her by a girl (servant ?) wearing an ungirt chiton. Finest 'transparent' style of about 400. (Athens 3624. H. 1.58)

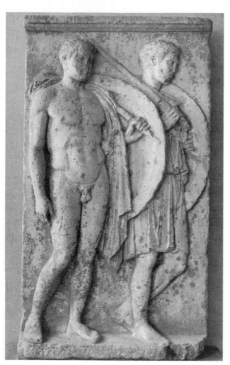

152 Gravestone of Lykeas and Chairedemos, from Salamis. They carry shields and shoulder their spears – the basic hoplite equipment. About 400. (Piraeus 385. H. 1.81)

153 'Albani relief'. A dismounted warrior strikes down another. To the left a hill (and river, recut in Roman times as the horse's tail?). About 420–10. (Rome, Villa Albani 985. H. 1.80)

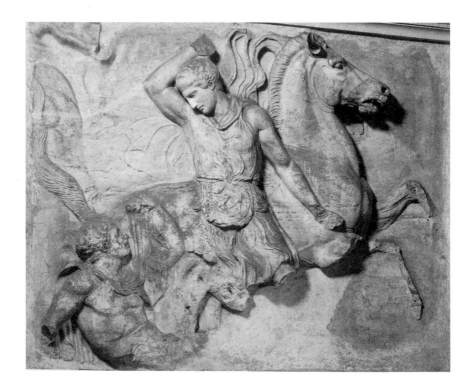

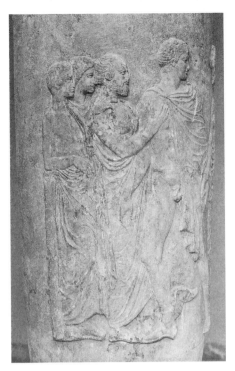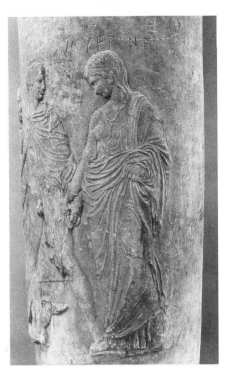

154 Grave lekythos of Myrrhine, who is at the right, led by Hermes (cf. 239.1) past three onlookers. From Athens. About 420–10. (Athens 4485. H. 1.38)

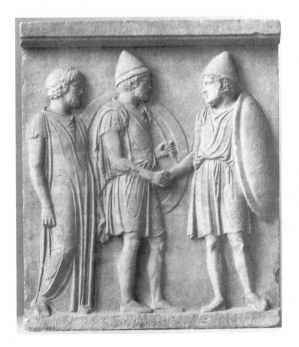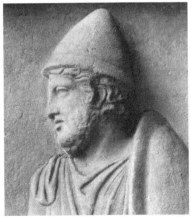

155 Gravestone of Sosias and Kephisodoros, from Athens. The warriors, with pilos helmets and shields, shake hands. The central warrior and the man at the left, in the priestly loose chiton, are presumably the dead. There is no architectural elaboration to the stele. About 410. (Berlin (E) 1708. H. 1.05)

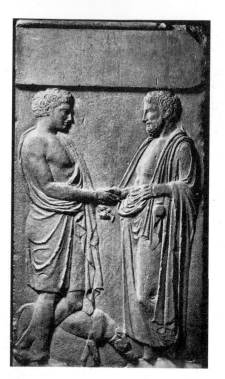

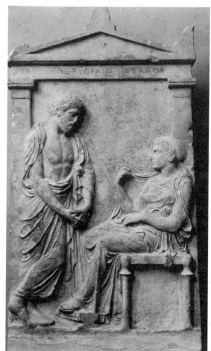

156 Gravestone from Athens. Surprisingly, the older man carries an aryballos – athlete equipment. About 410. (Athens 2894. H. 1.03)

157 Gravestone of Ktesilaos and Theano, from Athens. The woman's gesture with her cloak is often associated in Greek art with brides, and is a gesture of modesty or partial veiling. About 400. (Athens 3472. H. 0.93)

158 Gravestone of Sosinos, from Athens. The inscription describes Sosinos of Gortyn (Crete) as a chalkoptes – copper-smelter, and the disc in his hand must be an ingot. The upper border of the relief is carved as the edge of a tiled roof. About 400. (Louvre 769. H. 1.0)

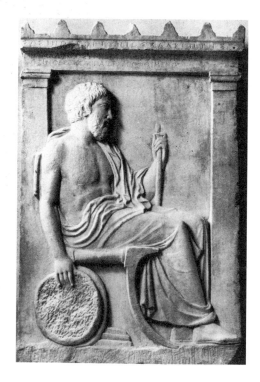

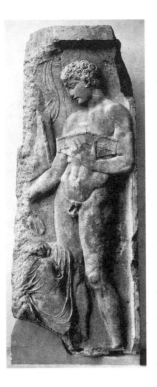

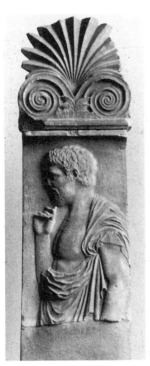

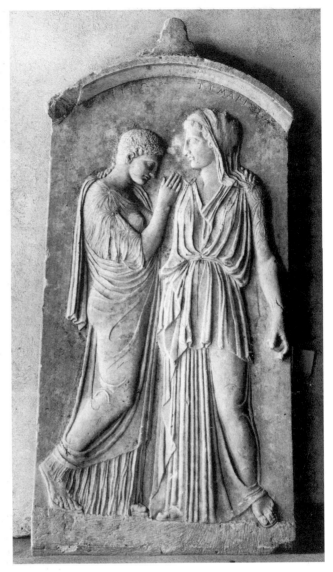

159 Gravestone from Samos. The youth was facing a seated figure, handing her a fillet or ribbon from a box. About 420. (Samos, Vathy. H. 1.72)

160 Gravestone of Krito and Timarista, from Rhodes. There is ancient recutting around the head of Krito. The rounded top of the stele is most unusual. About 410. (Rhodes 13638. H. 2.0)

161 Gravestone from Karystos (Euboea). About 440. (Berlin (E) 736. H. 1.49)

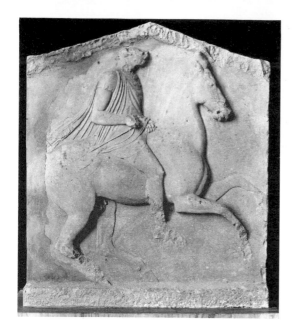

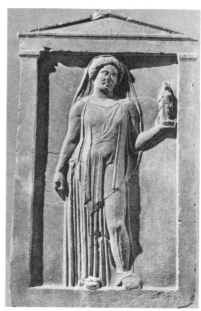

162 Gravestone from Thespiae (Boeotia). Horseman. The pedimental top of the stele embraces the figure field. About 440–30. (Athens 828. H. 1.20)

163 Gravestone of Polyxena, from Boeotia. She is veiled and holds the figurine of a goddess in her raised hand – perhaps indicating an unrealized ambition to be a priestess, or simply a plaything. She seems young to be a priestess herself (some restore a temple key in her right hand) and the ungirt dress suits a girl. About 400. (Berlin (E) 1504. H. 1.12)

164 Gravestone from Thespiae (Boeotia). The style and subject are very close to Attic. The stele was reused for Diodora, and at that time a child standing before her and a bird she was holding were chiselled away. About 410. (Athens 818. H. 1.50)

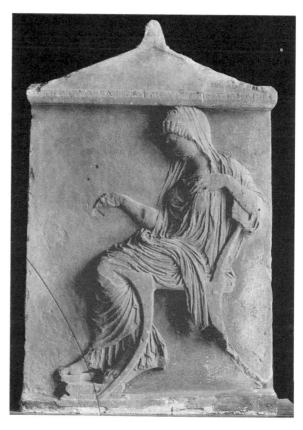

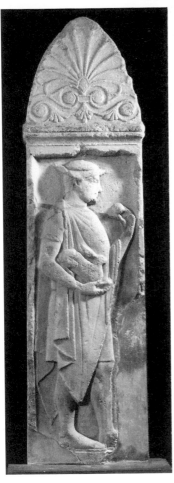

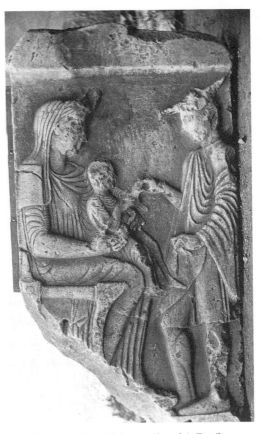

166 Gravestone from Phalanna (Thessaly). Family
group. The man holds a bird out to the child. About
430. (Volos 376. H. 1.25)

165 Gravestone from Konda
(Thessaly). Youth holding a hare
and a ball (or fruit). About 450.
(Athens 741. H. 2.40)

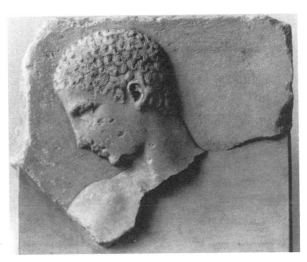

167 Gravestone fragment from
Megara. About 450. (Berlin (E)
735. H. 0.43)

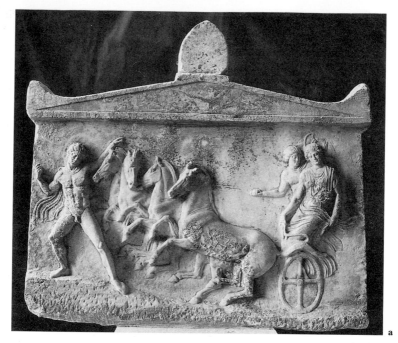

a

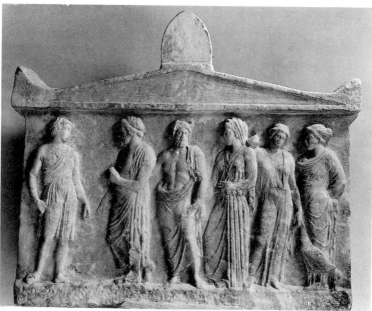

b

168 Votive relief, two-sided, from New Phalerum (Athens). (a) The hero Echelos abducts the nymph Basile, led by Hermes. (b) A god and goddess, the horned river god Kephisos, three nymphs. Dedicated by Kephisodotos. About 410. (Athens 1783. H. 0.75)

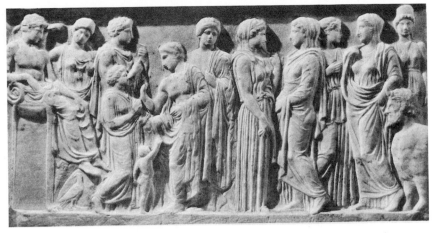

169 Votive relief to the river god Kephisos, from the same sanctuary as *168*. Apollo on his tripod at the left. Before him the small figure of a woman is the dedicator (Xenokrateia) with a child. Before them, perhaps, Kephisos. Other gods at the larger scale, not identified, and at the right a statue (?) and the forepart of a man-headed bull, the river god Acheloos. About 410. (Athens 2756. H. 0.57)

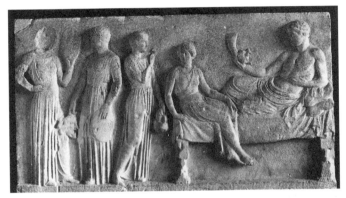

170 Votive relief to Dionysos, from the Piraeus. The god is reclining holding a rhyton (horn-pourer with animal forepart) and phiale, with a girl companion. At the left three actors, the dedicators, holding masks and tambourines. Reclining figures are generally heroes, but Dionysos (and Heracles) may also be shown thus. About 410. (Athens 1500. H. 0.55)

171 Votive relief. Perhaps Triptolemos, Kore/Persephone and Demeter with a god; a small worshipper at the left (but broken away, frontal). The subject would then be Attic but the boy is 'Polyclitan' and the work looks more Peloponnesian. About 430–20. (Copenhagen, Ny Carlsberg 197. H. 0.72)

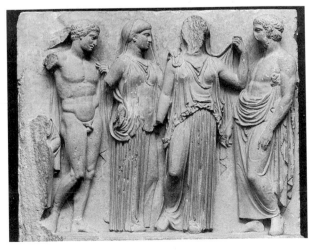

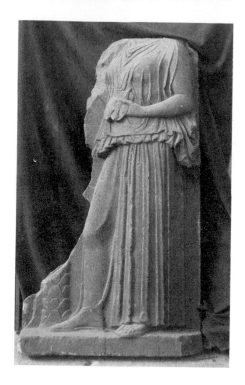

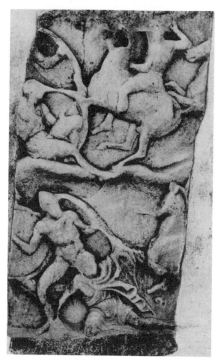

172 Votive (? or funerary) relief from
Mantinea (Peloponnese). A woman holding
a liver (for divination) before a palm tree
(for Apollo). Diotima, priestess of
Mantinea, in Plato's Symposium, comes to
mind. About 400. (Athens 226. H. 1.48)

173 Votive relief from Eleusis, given by
Pythodoros (a general in 414/3). Battle
between cavalry and hoplites on hilly
ground, the scene diposed in two registers.
About 420–10. (Eleusis 51)

174 Votive relief from Athens. Artemis,
seated on rocks, a dog beside her, a deer (?)
beyond her. About 410. (Berlin (E) 941. H.
0.59)

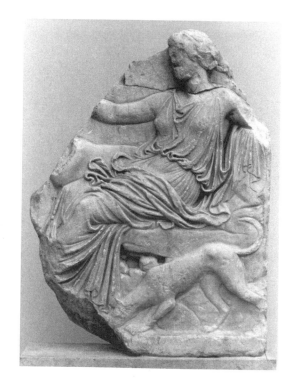

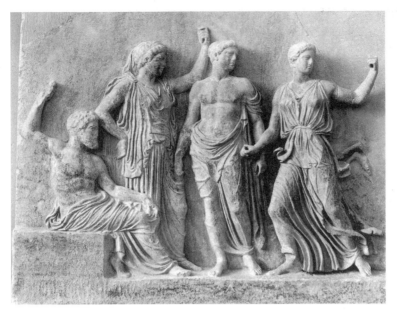

175 Votive relief from Brauron (sanctuary of Artemis on the east Attica coast). Zeus seated, Leto and her children Apollo and Artemis (with a deer, mostly lost). About 410. (Brauron 1180)

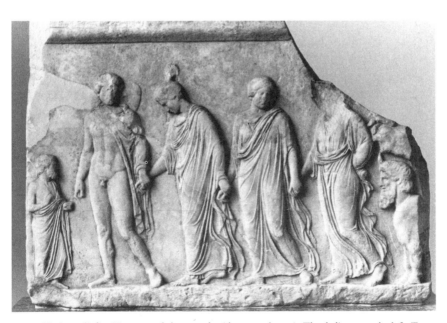

176 Votive relief to Hermes and the nymphs (three are shown). The dedicator at the left. To the right the forepart of Acheloos (cf. *169*) and above him Pan seated on rocks (mostly lost). About 400. (Berlin (E) 709A. H. 0.32)

177 Record relief from the Acropolis. Hera and Athena, for a decree honouring Samos in 405. (Acr. 1333. W. 0.56)

178 Record relief from Eleusis. Athena with an Eleusinian king or hero, watched by Demeter and Persephone. The decree concerns local bridge-building. 422/1. (Eleusis. W. 0.57)

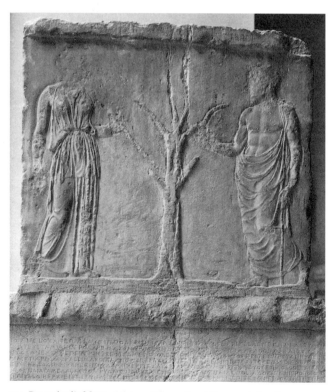

179 Record relief from Athens. Athena, Erechtheus and the olive tree. The inscription records treasure kept in the Parthenon. 410/09. (Louvre 831. H. 0.70)

Chapter Fifteen

NAMES AND ATTRIBUTIONS

Phidias

signed his statue of Zeus at Olympia as son of the Athenian Charmides. His role as overseer of Pericles' plans for the rebuilding and embellishment of the temples of Attica has been discussed in Chapters 10 and 11. This must have occupied much of his time, from about 449 to 438, when the Athena Parthenos was dedicated. He set his stamp on those sculptures by which we are obliged to judge the Classical style, and its expression in architectural and especially in cult and dedicatory statues set standards which later generations were to covet and emulate. Yet not, interestingly enough, the immediately following generations of sculptors, who seemed more moved by the work of his contemporary Polyclitus. Both were said to be pupils of Ageladas.

His earliest recorded works are Early Classical in date and probably were so also in style: bronzes commemorating Athens' success against Persia. At Delphi was a group paid for from the spoils of Marathon with Apollo, Artemis, Attic kings and heroes and the general Miltiades (who fought at Marathon but died a year later). To this group some attribute the Riace bronzes [38-9], which seem from different hands though the same studio. Copies which have been associated with the same group are the Apollo [69] and even the Athena [183], discussed below. On the Acropolis was another memorial to Marathon, a colossal bronze Athena, popularly called the Promachos though not in a striding, striking pose but at ease. It was erected just within the gateway (the new Propylaea had yet to be built). From tiny representations on Roman coins [180] she seems to have been standing, perhaps with her shield at her side and with something on her outstretched right hand (an owl or Nike) – a prototype for the Parthenos. The shield was decorated with a centauromachy which, Pausanias says, was designed by the painter Parrhasios and executed by the metal worker Mys. If so it was in appliqué figures added to the shield later in the century, perhaps in emulation of the Parthenos. There was also an Athena (Areia – war-like) for Athens' ally at Marathon, Plataea, her body of gilt wood, her face, hands and feet of marble – a reduced-rate version of a chryselephantine figure.

Phidias' most famous chryselephantine cult statue was the Zeus at Olympia. The discovery of its workshop (see p. 12) dates it securely after the Parthenos. A seated figure, bigger therefore than his Parthenos, it was an awe-inspiring work, long admired. It 'added something to received religion' (Quintilian), and was deliberately, we are told (Strabo), Homeric in concept. Pausanias describes the figure, holding a Nike on his right hand, a sceptre with eagle in his left; the throne decorated at the top with Graces and Seasons, below with Nikai, sphinxes with Theban youths, and the Niobids struck down by Apollo and Artemis; on its crossbars, athletes, Amazonomachy (Theseus with Heracles, it was alleged); on the footstool, Theseus' Amazonomachy; on the base the birth of Aphrodite attended by gods, recalling the Parthenos' Pandora. Before the statue was a shallow area of oil (or oily water), similar to the scheme in the Parthenon. Roman-period coins of Elis show the whole figure, though of course in no detail, and its wreathed head [181–2]. It must have inspired also many of the Classicizing Zeus heads of later works.

Groups in Ephesus may reflect the sphinxes with youths on the throne. Various relief friezes of Niobids seem relevant, and a vase of about 400 had such a frieze on the arm-rest of a throne for a Zeus (not resembling the Olympia statue, otherwise, however). So we know less of the Zeus than of the Parthenos.

Phidias made a bronze Athena for the Athenian colonists of Lemnos to dedicate on the Acropolis (they left Athens in the mid-century). Its beauty was often remarked and a very late source (Himerios) allowed the sculptor an Athena whose beauty was preferred to her helmet. The combination of copies of a head in Bologna and body in Dresden give a fine, bare-headed Athena, holding her helmet and spear, and may give us the Lemnia [183]. I give it the benefit of the doubt here, but see above, and p. 84.

Not surprisingly, scholars have sought to identify copies of many other works assigned to Phidias in antiquity, some of which, together with his Amazon, are considered in the next chapter.

He was a man of affairs as well as the creator of the Athenian Classical style. His work for Pericles guaranteed his fame, and the combination of power and fame created jealousy. We cannot be sure whether any of the stories told against him have any truth in them – that he embezzled gold (answered by weighing the gold plating of the Parthenos, which he had made removable) or ivory; that he insinuated his and Pericles' portraits on to the shield; that he stood trial; that he died in prison or was poisoned or killed by the Eleans. He was certainly able to work in Olympia after Athens. We are left with the impression of a man who was something more than a great artist.

Polyclitus

was of Argos, pupil of the Argive Ageladas. Phidias was assigned to the same master and there was a natural tendency for later writers to compare and contrast the two greatest sculptors of the Classical period. He was at work as soon as Phidias, by 452, but lived longer, if it was he who made the Hera for Argos after the temple fire of 422. He was a theoretician too, studying what had always been a preoccupation of Greek sculptors even if not always expressed, the proportions of the human body – that is, of the standing naked male. He wrote a book on the subject of the commensurability (*symmetria*) of parts of the body. The book was called the Kanon and some applied the same title to a statue which, allegedly, he made to demonstrate his theories. This is readily recognized in the Doryphoros (spear-carrier) known from several copies [*184–5*]. It carries a stage further the stance of the Early Classical males, the loose leg trailing more, with the foot turning and barely resting on the ground, the straight but limp arm on the side of the straight but taut leg. There is a clear implication of movement forward although the figure is in balance. The figure is broader, thicker-set and larger-headed than the Phidian and it dated more quickly. Polyclitus' theories were influential in antiquity but his disciples, it seems, did not always follow his prescription to the letter.

Another famous work was a Diadoumenos (youth binding his hair) easily recognized in copies [*186*] both from the action and from the close similarities in anatomy, position of legs and features to those of the Doryphoros. The hair is more plastically conceived than the Doryphoros' (both were bronze originals) probably because the latter is somewhat earlier. Though some extant copies are good there is little from which we can judge the attention to anatomical detail which was also singled out by later writers. From the context in which Plutarch quotes his rather obscure remark that 'the work is hardest when the clay is on (or at) the nail' it seems that the sculptor was stressing the importance to a complete work of attention to the smallest detail.

Many of his recorded works were athlete dedications, which may have included the two works discussed (they both are over life-size), and the originals of other copies which look Polyclitan. A slightly built one [*187*] has been thought a copy of his Kyniskos since it seems to match the preserved base at Olympia of the statue said by Pausanias to be by Polyclitus. The original was even slimmer, to judge from fragments of casts of the original from Baiae. For his Amazon see the next chapter.

There was a younger Polyclitus of Argos, who worked in the early fourth century and who obscures the issue of the length of the elder's career. A crux is the authorship of a group commemorating the Spartan

victory at Aigospotamoi in 404. One of them created a chryselephantine cult statue of Hera for her sanctuary near Argos after 422. She was seated, holding a sceptre and pomegranate, crowned with figures of the Graces and Seasons. See [207]. The natural comparison would have been with Phidias' seated Zeus at Olympia, which Quintilian judged more dignified if less decorative.

Kresilas

was a Cretan, from Kydonia, but he worked in Athens, a contemporary of Phidias. He made a portrait of the Athenian statesman and general Pericles, probably the one seen by Pausanias on the Acropolis, copies of which are identified on inscribed Roman herms [188]. It was no doubt made after Pericles' death and showed him as a standing male warrior (like the Riace pair [38–9]). The head is not a true portrait, and any individuality of features reflects the artist's style rather than the subject's appearance. He also made a wounded figure, life-like in its near lifelessness, perhaps the bronze Dieitrephes pierced with arrows seen on the Acropolis (Paus.) where a base has been found for the dedication of a work by Kresilas, by Dieitrephes' son. It would have been an unusual commemorative statue, showing the father dying in battle. For his Amazon see the next chapter.

Alkamenes

was an Athenian (or perhaps an Athenian colonial from Lemnos), contemporary and pupil of Phidias, working at least to the end of the fifth century since he made a large relief of Athena and Heracles for Thebes after 404/3. Pausanias says that Alkamenes made the west pediment sculptures at Olympia but this must have been another Alkamenes, or probably none at all. Possibly Pausanias meant that Alkamenes and Paionios made akroteria for the temple. Herms found at Pergamum [189] and Ephesus name him as creator of a Hermes Propylaios ('before the gates'). The style is decidedly Archaizing, only the features and beard being Classical. It was influential and often copied, and so is probably the Hermes seen by Pausanias at the Propylaea of the Acropolis at Athens (though he seems to attribute this to Socrates the philosopher, whose father was a mason). It perhaps replaced an earlier statue, hence its Archaism, since other herms of this period are up-to-date. Later writers mention statues by him in Athens: an Aphrodite in the Gardens admired by Lucian for her face and hands, a triple Hecate (set near the Hermes and probably Archaizing), a seated Dionysos, a Hephaistos, perhaps for his temple (lame, but not positively deformed, says Cicero). For what may be his marble Prokne and Itys see [135].

Agorakritos

of Paros was another pupil of Phidias and allegedly rival of Alkamenes, competing with him for an Aphrodite. His unsuccessful statue became the Rhamnus Nemesis, of which we know something from descriptions, original and copy (see on [122]).

Kallimachos

invented the Corinthian capital and made a remarkable golden lamp for the Erechtheion, presumably very late in the fifth century. In his work, it was said, meticulous attention to detail was carried to excess. The fussy dress of the wind-blown styles of the late century would have suited him and his famous Lakonian dancers (Pliny) may well be echoed in the series of popular dancing figures in this very style, known from many Roman reliefs and other works [242, cf. 243].

Lykios

was a son of the sculptor Myron, known from few references in ancient writers and pieces of three bases, in Athens and Olympia. Here Pausanias saw a great group on a semicircular base presenting a Trojan scene with Thetis and Eos supplicating Zeus at the centre, while at the corners their children Achilles and Memnon prepare to fight and four other heroic duels proceed between them. This was an unusually populous group for a free-standing composition of the 440's or later; it must have resembled a pedimental group but composed in depth.

Strongylion

made an Amazon with beautiful legs, and a handsome boy, which aroused the cupidity of Nero and Brutus respectively. On the Acropolis of Athens he made a Trojan horse of bronze with Greek heroes leaning out of it. A description of work such as this, and Lykios' group, are a brisk reminder to us of how little we know, how much we have to imagine, of some of the major sculptures of Classical antiquity. The isolated figures known to us, mainly in copies, or the marble decoration from temples can give no hint of the possible complexity of some monuments.

Paionios

See p. 176 and [139].

180 Coin of Athens (Roman) showing the Acropolis with Athena Promachos (Phidias). (London. Cast)

182 Coin of Elis (Roman) showing the Zeus of Phidias. (London. Cast)

181 Coin of Elis (Roman) showing the head of Phidias' Zeus. (Berlin)

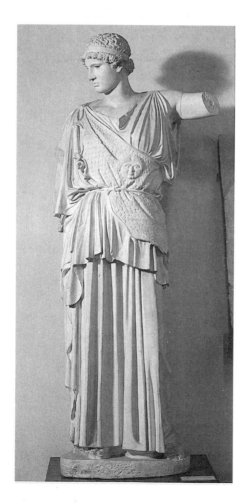

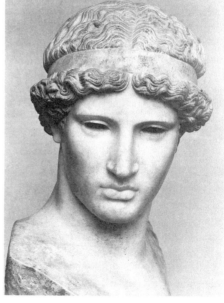

183 Copy of Phidias' Athena Lemnia ? The cross-slung aegis anticipates the Athena of the Parthenon west pediment 79.4. The association of head and body has been disputed and the helmet is conjectural (an owl has also been suggested). Original of about 440. (Dresden 49 with Bologna (head). H. 2.0. Cast of whole figure in Oxford)

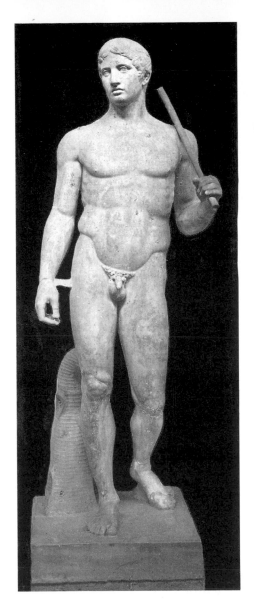

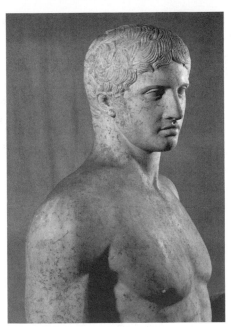

184 Copy of Polyclitus' Doryphoros, the 'Kanon'. From Pompeii. Original of about 440. (Naples. H. 2.12)

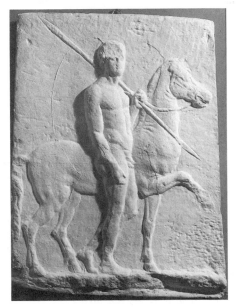

185 Relief from Argos. A figure closely resembling Polyclitus' Doryphoros 184, with a horse. Early 4th cent. (Athens 3153. H. 0.51. Cast in Oxford)

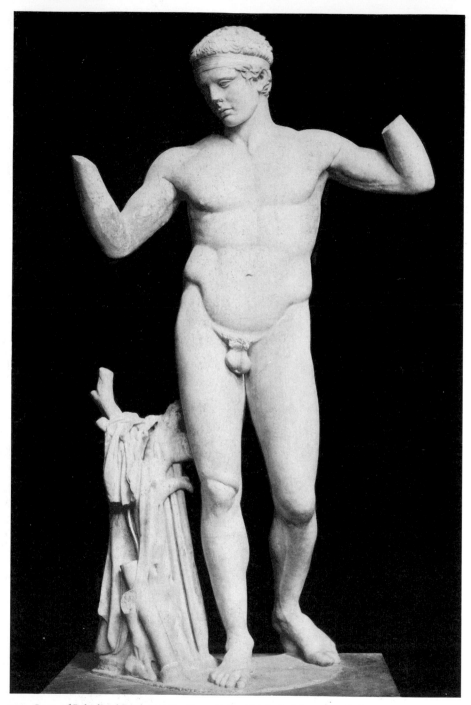

186a Copy of Polyclitus' Diadoumenos. From Delos. Original of about 430. (Athens 1826. H. 1.95)

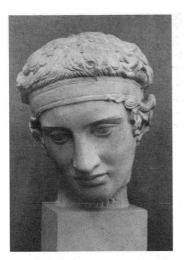

186b Head of a copy as *186a*.
(Dresden)

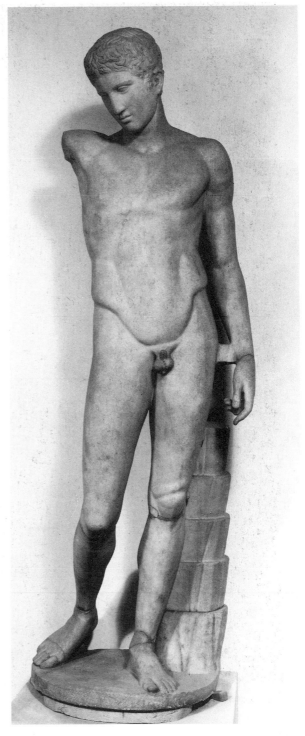

187 The 'Westmacott Athlete'; copy
of Polyclitus' Kyniskos (?), an athlete
dedication at Olympia. The youth is
crowning himself. Original of about
440. (London 1754. H. 1.49)

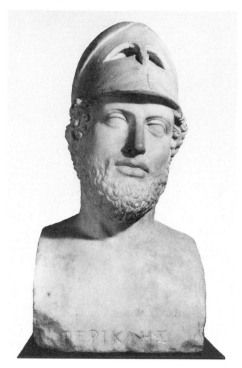
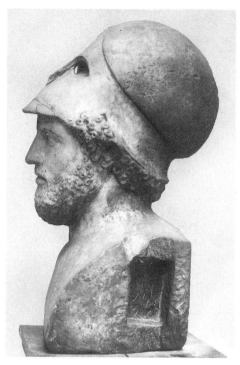

188 Copy (on a herm) of the head from a statue of Pericles by Kresilas. Original of about 425. (London 549. H. 0.48)

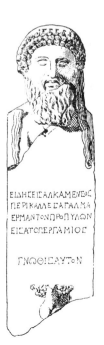
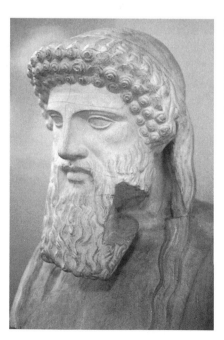

189 Hermes Propylaios from Pergamum, copy of a work by Alkamenes. The inscription reads: 'You will recognise the fine statue by Alkamenes, the Hermes before the Gates. Pergamios gave it. Know thyself'. (Istanbul 527. H. 1.195. Head, cast in Oxford)

Chapter Sixteen

OTHER COPIES OF THE CLASSICAL

Very many statues and other works of Roman date appear to copy originals of the Classical period. We have looked at some already, where they can be safely associated with a sculptor's name, and used them to demonstrate Early Classical styles. It is reasonable to suppose that many others should be associated with known sculptors, or with known monuments (e.g., the cult statues of the Hephaisteion in Athens, see [226]) but there is generally no consensus and it seems wrong in a handbook such as this to impose a selection of the attributions proposed by various scholars, especially since I remain sceptical about the validity of a great part of such exercises. Most of the copies, therefore, are presented with comment only in their captions, where I have recorded only the most popular speculations about their originals, referring to some other attributions in the notes. The reader may be assured that there are commonly very many others. And they are presented simply by type, men, then women: standing, seated, other, alphabetical where identified, by convention or with certainty, putting like with like. Reliefs come last. The date of the presumed originals is necessarily vague.

There are, however, one or two complexes which deserve more discussion than can be offered in captions.

Three statues of wounded Amazons were much copied in the Roman period [195]. They were of the same size and similarly dressed, and although there are stylistic differences indicating different hands these do not seem greater than, say, the differences between the two Riace bronzes, which seem from one group and studio, if different hands. Not only different hands, however, but different dates have been proposed for them, the most extreme being Augustan for [190]. All three (and no others, it seems) are represented at Baiae.

There was a famous group of Amazons at Ephesus and these are surely copies of them. Pliny says there was a competition for them, judged by the artists who all put themselves first, and in second place put Polyclitus (whose own second vote is not recorded), who was therefore judged the winner. Pliny named Polyclitus, Phidias, Kresilas, Kydon and Phradmon as competitors. Kydon is surely a mistake for 'Kresilas of Kydonia' and Phradmon is a little-known Argive. There are several copyists'

variants of the basic types but also a type known only from a copy at Ephesus where she has covered breasts. We cannot tell whether this is a real fourth, or made up to complete a set to decorate the pillars of the theatre (where there were also copies of the types of [190–1] and probably more). Pliny's story of the competition need not be true, but he mentions elsewhere a wounded Amazon by Kresilas, and Lucian one by Phidias leaning on her spear, with a handsome neck and mouth. There has been lively discussion about attribution of the different types to the great names, not surprisingly, but little agreement. Amazons were said to have founded Ephesus. Athenian interest in Amazons we have met already and an attractive suggestion is that the group was an Athenian dedication celebrating, in some way, the peace with Persia; or perhaps better the recent repulse of the Persians from the Greek coastline of Asia Minor.

A special class of reduced copies of cult statues has attracted scholarly attention in recent years, because some seem likely to have been made within the Classical period, or soon afterwards, and so are in a different category from the full-size copies and reduced versions of the Roman period. There are problems of dating here, but that such a practice was common is highly plausible. Major statues could be echoed in reliefs and other media soon after their appearance so there is every reason to suppose that they might also inspire reduced versions. These, however, like the echoes of major statues in reliefs or on vases, are unlikely to be reduced *replicas* and their validity as evidence for the appearance of major originals is in many respects more suspect than that of the Roman-period copies which reproduce their models near-mechanically. One or two of these Classical or Hellenistic reduced versions are illustrated with this chapter. One important group is in Venice, perhaps originally from Crete, and comprises statuettes of Demeter, Kore and an Athena, all it seems after monumental originals of the later fifth and early fourth centuries [196].

Another interesting complex of copies comprises four three-figure reliefs, of each of which several copies are preserved (except [239.4] which is relatively poorly represented). They are the same size and seem likely to be from a single Athenian monument, more probably one in a public place – on the balustrade of the Altar of the Twelve Gods in the Agora has been suggested, than in a cemetery – for a monument to a playwright, as has also been suggested (funeral monuments did not attract the copyist or his market). The quality of execution and composition of the originals must have been exceptional. The moody atmosphere of the grave relief is here carried into mythological scenes which are linked not by personnel but by common though not easily definable themes. Each says something about the achievement of

immortality by heroes or mortals. Each reflects on intimate personal relationships – man and wife [239.1], comrades in arms [239.3], father and children [239.2], hero and admiring nymphs [239.4]. Hermes, as third man in two of them, lends a sepulchral air since he is the usual intermediary between the two worlds, but it is impossible to see this as from a Classical grave monument, though it might have supported a theatrical monument or prize. The originals must be of around 410, near the end of the careers of Sophocles and Euripides. They do not illustrate their plays but they closely reflect the mood of much of the tragedians' work.

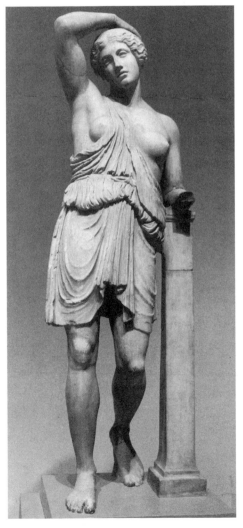

190a Amazon (Berlin/Lansdowne/Sciarra type). Copy of an original of about 440–30. She is wounded beneath the left breast, wears a broken rein in place of a belt and one ankle-spur. Legs restored after the copy in Berlin. The Doria Pamphili (in Rome) variant covers both breasts. (New York 32.11.4 (ex-Lansdowne). H. 2.04)

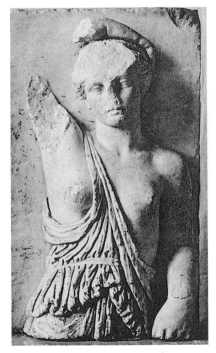

190b Copy of the same type in high relief from a pilaster on the theatre at Ephesus. (Vienna 811. H. 0.65)

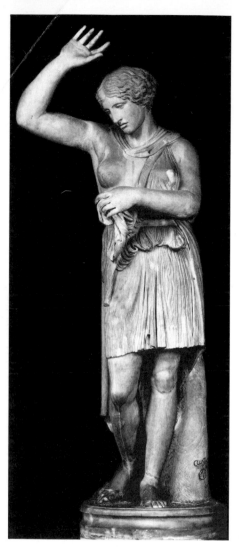

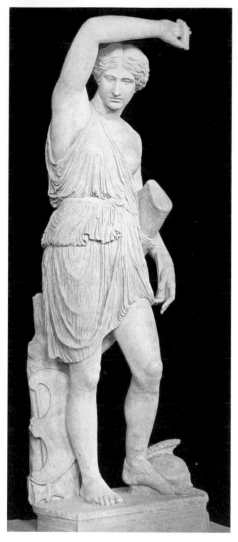

191 Amazon (Sosikles/Capitoline type). Copy of
an original of about 440–30. She is wounded
beneath the right armpit, beside her breast, and
leans lightly on a spear. Restored – right arm and
breast, left forearm, legs.) (Vatican 2272. H. 2.045)

192 Amazon (Mattei type). Copy of an original of
about 440–30. She is wounded on the left thigh,
wears a quiver at her side and one ankle-spur. She
appears to be leaning on her spear (which might
make her Phidias') but, unconvincingly, it has been
suggested that she is mounting her horse, busy
with her bow, even poling a boat. The head
restored after 194 and arms restored. (Vatican.
H. 2.11)

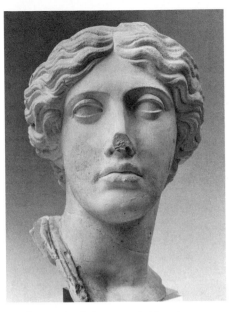

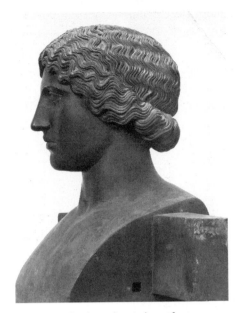

193 Amazon head. A copy probably to be associated with the Mattei type *192*, which, however, is usually restored with *194*. (Petworth. H. of head 0.28. Cast in Bonn)

194 Amazon head on a bronze herm from Herculaneum. See on *192*. Harrison associates this copy with a 'fifth' Amazon type, resembling the Mattei, and which she believes Phidian. (Naples 4899. H. 0.53)

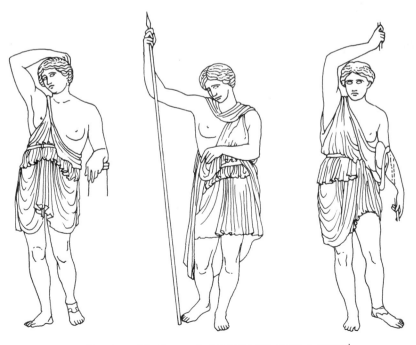

195 Drawings of the three main Amazon types, as *190–2*, restored

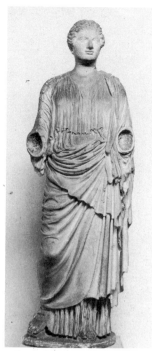

196.1

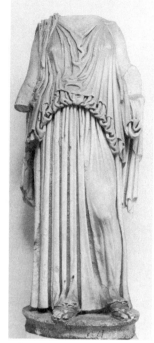

196.2

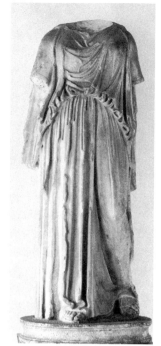

196.3

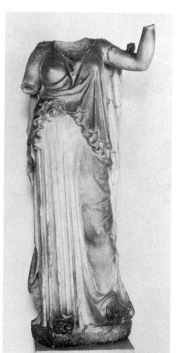

196.4

196 'Grimani statuettes' from Crete. Classical reduced
copies of monumental originals of about 420 (six others
of the group seem to follow 4th cent. types). All may
represent Kore (Persephone). 1. 'Abbondanza'.
Probably Kore, resembling the Kore Albani *210* and
compare *202* for the himation. (Venice 106. H. 1.08). 2.
Resembles the Capitoline Demeter *212*. (Venice 15. H.
0.92). 3. Recalls the Erechtheion Caryatids *125*. (Venice
116A. H. 1.11). 4. (Venice 71. H. 0.88)

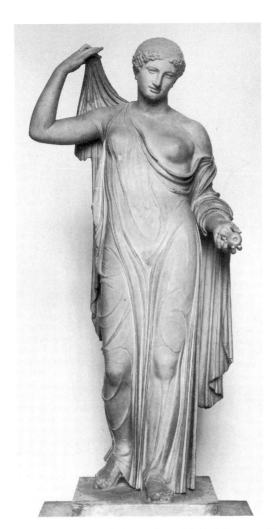
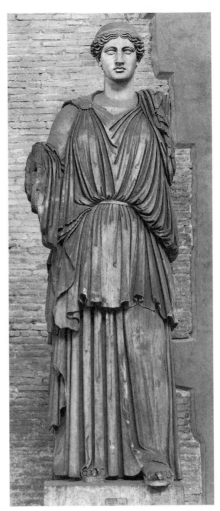

197 'Aphrodite Fréjus'. Copy of an original of about 410. The original probably held an apple (the prize from the Judgement of Paris). The bared breast and the lifted dress (an intimation of veiling met on more modest figures) make a nice symbolic contrast for the goddess of love. An early exploitation of clinging dress for mainly erotic effect. Much copied in the Roman period, as the model for the Venus Genetrix (ancestor of the Julian imperial family) and later serving as a flattering basis for portraits of women (sometimes then covering the left breast). Once thought to be from Fréjus; in fact from near Naples. (Paris 525. H. 1.65)

198 'Artemis Ariccia'. Copy of an original of about 440. Possibly an Artemis – another version carries a quiver and this type probably held bow and phiale. The long peplos overfall is belted in the Attic manner. Associated by some with the temple of Artemis Eukleia in Athens, built to celebrate Marathon. (Rome, Terme 80941. H. 2.86)

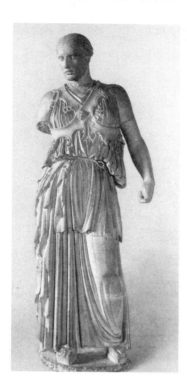

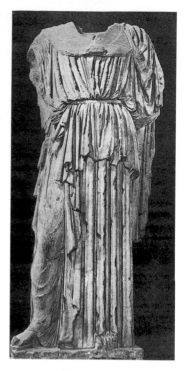

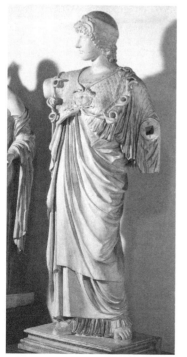

199 Athena from Pergamum. Copy of an original of about 450–30. An unusual figure, the head with touches of the Severe, the dress so restless that the figure has been thought Hellenistic classicising made for the kings of Pergamum. Most unusual the strip aegis worn like a crossed bandolier. Taken by some as Myron's Athena for Samos (see on 72) but surely later. Found close to 209. (Berlin (E). H. 1.87)

200 'Athena Medici'. Copy of an original of about 440–30. She wears a chiton beneath peplos with belted overfall, aegis and cloak hanging at the back, once with shield and spear. Since several other copies are acrolithic it has been thought a copy of an original acrolith (by Phidias for Plataea; or by Kolotes for Elis), but has also been associated with Athena Promachos or the Athena of the Parthenon east pediment. Close to the Parthenon pedimental style. (Paris 3070. H. 2.45)

201 'Athena Albani'. Copy of an original of about 430–20. To be restored with spear in right hand, shield (?) on left arm. The head made separately and does not certainly belong. She wears a wolf-head cap, the 'cap of Hades', which suggests to some the Athena Itonia of Agorakritos set beside Hades (Strabo; or Zeus – Paus.) at Koroneia. Dress and features are Parthenonian (note the himation selvage). (Rome, Villa Albani 1012. H. 1.96)

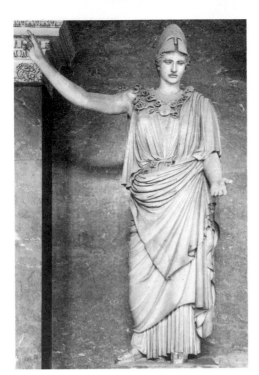

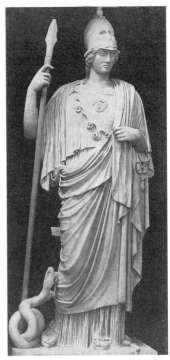

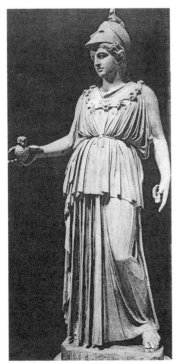

202 'Athena Velletri'. Copy of an original of about 420–10. Several other copies of this size, and reduced copies, are known. She held spear and phiale (hands are restored), wears a brief aegis (most of it hangs behind her), snaky belt, himation over peplos with long overfall, Corinthian helmet. Often now taken as the cult statue which stood beside Hephaistos in his temple, and so associated with Alkamenes, otherwise with Kresilas for the facial resemblance to his Pericles *188*. (Paris 464. H. 3.05)

203 'Athena Giustiniani'. Copy of an original of about 400. Related to the earlier *202* with slightly differently disposed himation. Restored are sphinx on helmet, forearms. (Vatican 2223. H. 2.25)

204 'Athena Ince'. Copy of an original of about 400. Loosely inspired by the Parthenos. Restored helmet sphinx, right forearm and owl. (Liverpool. H. 1.67)

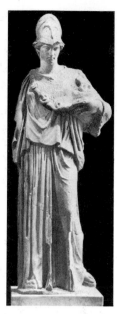

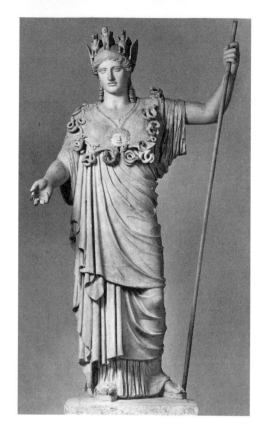

205 'Athena Cherchel/Ostia'. Copy of an original of about 400. Sometimes called Hephaisteia because once taken for the cult statue in the Hephaisteion. Here with a box containing the Erichthonios snake. (Louvre 847. H. 1.40)

206 (right)'Athena Hope/Farnese'. Copy of an original of the early 4th cent. The elaborate helmet is inspired by the Parthenos. Perhaps derived from 201. Restored are the arms, animals on the helmet and cheekpieces, some aegis snakes. (Naples 6024. H. 2.24)

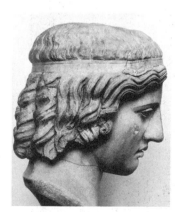

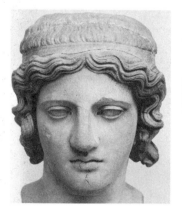

207b

207 'Hera' head. Copy of an original of about 430. Nose restored. Associated by some with Polyclitus' chryselephantine Hera for the Argive sanctuary, where the temple was rebuilt later than the apparent style of this head; nor does it have the elaborate crown described by Paus. Some resemblance to near-contemporary Hera heads on coins where the figure decoration on the cult-statue crown may have been simplified to a floral (b). (London 1792. H. 0.265. Coin – London, cast).

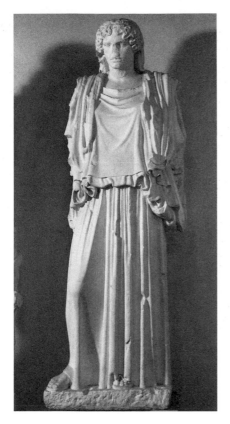

208 'Demeter Cherchel'. Copy of an original of about 450–40. A Classical peplophoros with head veil. The rather matronly figure suggests that 'Demeter' may be correct. Parthenonian style. Cherchel is in Algeria, a prolific source for good copies. (Cherchel. H. 2.10)

209 Woman from Pergamum. Copy of an original of about 450–40. Presumably a goddess with sceptre and phiale (?) – Hera (?). From the Pergamum Library, found close to the Athena 199. Compare Alkamenes' Prokne 135. (Berlin (E). H. 1.76)

210 Kore ('Sappho') Albani. Copy of an original of about 430. A full-size version of a statue of a type similar to that inspiring the Grimani statuette 196.1. (Rome, Villa Albani 749. H. 1.85)

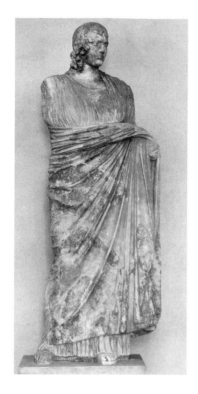

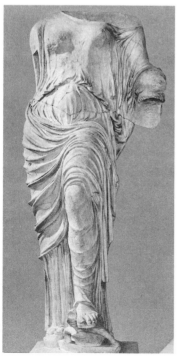

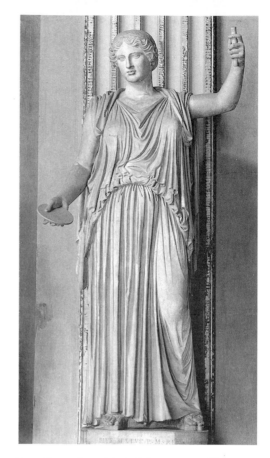

211 Kore. Copy of an original of about 450–40. The size
suggests a cult statue, so possibly Kore. Much of the dress is
still Early Classical but the bunched himation across the front
and pose are not. 'Polyclitan' stance. (Rome, Mus. Nuovo
Cap. 905. H. 2.26)

212 'Capitoline Demeter'. Copy of an original of about 420.
She holds sceptre and phiale. Compare the Grimani statuette
196.2. Restored right forearm, left arm, left breast, below
knees. (Rome, Capitoline 642. H. 2.13)

213 Aphrodite from Smyrna. Copy of an original of about
410. Physique and dress are Parthenonian (cf. *80.3*) but this
could be a much later, classicising figure, though once thought
a Classical original. The turtle on which she rests her foot may
be a correct restoration. Phidias made a chryselephantine
Aphrodite Urania with her foot on a turtle for Elis (Paus.).
(Berlin (E) 1459. H. 1.58)

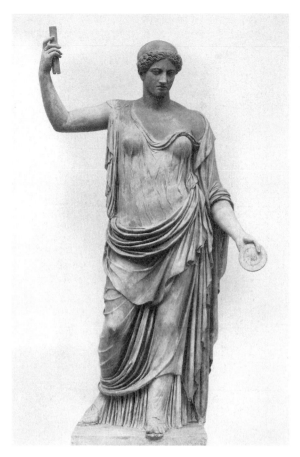

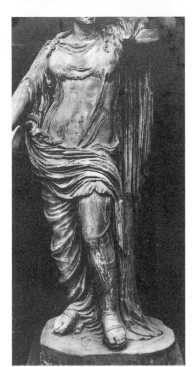

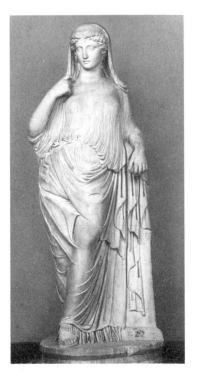

214 'Hera Borghese'. Copy of an original of about 410. Probably not Hera. For the dress cf. the Agora Aphrodite *136*. She holds sceptre and phiale. Restored feet and large parts of dress at front. The head and bare shoulders were carved separately and inserted in the torso. The 'Hera Barberini' in the Vatican is a variant. There are fragments of a cast of the original from Baiae. (Copenhagen, Ny Carlsberg 473. H. 2.13)

215 'Aphrodite Valentini'. Copy of an original of about 420–10. The head is alien, arms and left leg restored. Probably an Aphrodite but also taken for Ariadne. For the treatment and contrast in dress cf. *214* and the closely related type known as the 'Aphrodite Doria'. (Rome, Pal. delle Provincie. H. 1.82)

216 'Aphrodite' ('of Daphne' or 'leaning'). Copy of an original of about 420. She wears chiton and himation, leaning on a pillar. The left leg carried across the front of the body is surprising at this apparent date for a female statue in the round. Once thought to be the type of the cult statue of the sanctuary at Daphne on the Athens–Eleusis road (from which a fragment is preserved) and compared with the Parthenon east frieze goddesses. Cf. *213*. (Naples G 136. H. 1.44)

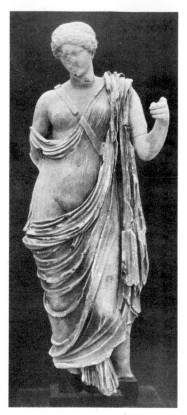

217 Aphrodite, armed. Copy from Epidaurus of an original of about 400. She wears a baldric over her clinging and revealing chiton, whose effect in baring the body is enhanced by the sharp, deep folds of the himation hanging from her left shoulder. Her right hand would have held the sword. (Athens 262. H. 1.15)

218 Old Woman. Copy of an original of about 430. The date is suggested by the treatment of the dress – a heavy himation over a peplos for the stooping, weak-kneed figure. Age or infirmity seem indicated by pose only – later periods would have found opportunity to dwell on physical details also. It has been associated with the copy of a head in London which looks later. Mythical identities might be Aithra (Theseus' mother rescued at Troy, cf. ARFH fig. 172.2) or Eurykleia, Odysseus' old nurse. Demetrios of Alopeke (an Athenian suburb deme) made a statue of Lysimache, who had been priestess of Athena for 64 years, for the Acropolis, but the apparent date of the statue and of Demetrios' work (4th cent.) do not chime. (Basel BS202. H. 1.26)

219 'Aphrodite/Olympias'. Copy of an original of about 440–30. For a head preferred by some see 220. The goddess is seated with unusual (except for Aphrodite, cf. 80.3) nonchalance, on a chair, a dog beneath it (helping support it if the original was marble). A marble fragment on the Acropolis has been thought from the original, which is then identified as Alkamenes' Aphrodite in the Gardens on the Acropolis slopes. Much used as a type for portraits of Roman matrons. (Rome, Mus. Torlonia 77. H. 1.16)

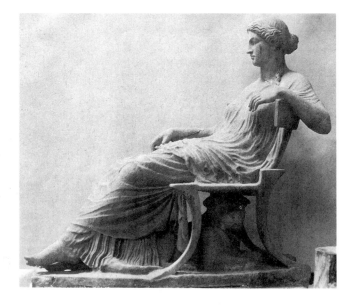

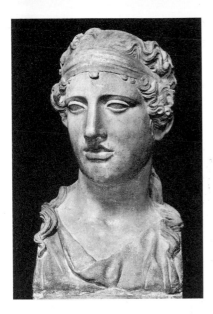

220 Aphrodite head ('Sappho') from Herculaneum. Copy of an original of about 430–20. Associated with the seated figure *219*. (Naples 6369. H. 0.47)

221 'Barberini Suppliant'. Copy of an original of about 430–10. A girl seated on a low base, perhaps an altar, in a pose suggesting weariness rather than grief. Variously identified as Alkmene, Iphigeneia, Penelope, or as Danae receiving Zeus' golden rain, which suits the pose and the erotic suggestion of the bared breast, but not the mood and expression. Possibly indeed a suppliant of some mythical identity, dedicated in gratitude for receiving sanctuary. She wears only one sandal (holds the other ?) – a motif of uncertain symbolism. (Louvre. H. 0.78)

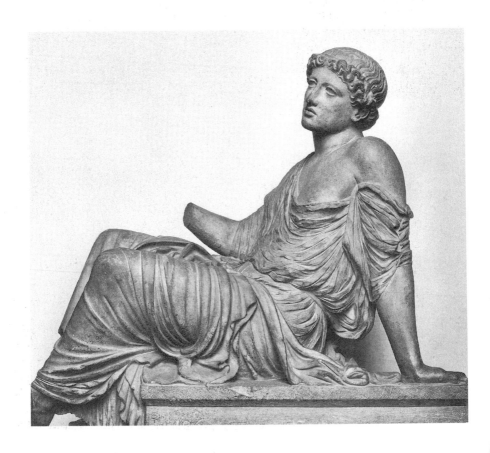

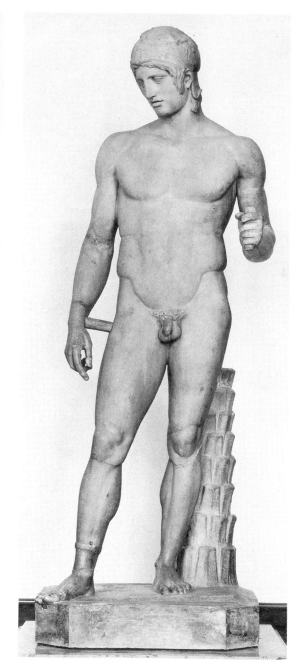

222 Hekataion. Near-contemporary copy of an original of about 430–20. This is taken to be a reduced version of a major group, possibly the Hekate Epipyrgidia by Alkamenes (Paus.) on the Acropolis, said to be the first example of the goddess in triple form. She was rather sinister, worshipped at cross-roads, so faces all ways, holding torches. The figures are strongly archaising, as is Alkamenes' Hermes *189*. The type was frequently copied. (Athens, British School S21. H. 0.33)

223 'Ares Borghese'. Copy of an original of about 430. To be restored with shield and spear in left hand, sword in right. He wears one ankle-ring. A rather introspective study of an unpopular Olympian, if correctly identified. Often taken for the Ares by Alkamenes (Paus.) in the temple ultimately installed in the Athenian Agora. Cf. the pose of *233*. The type was popular in the Roman period for portrait statues. (Louvre 866. H. 2.12)

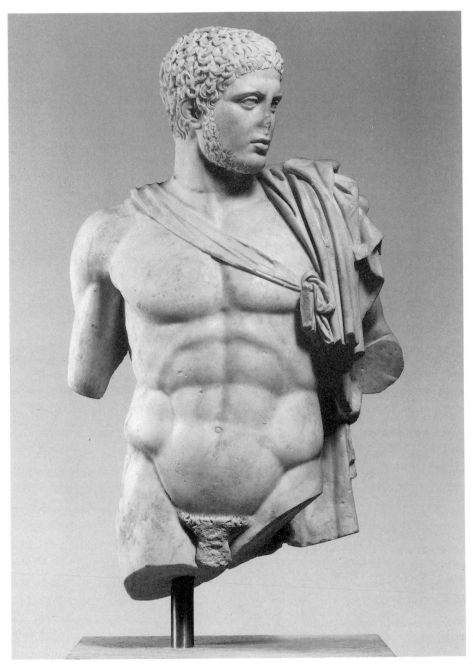

224 'Diomedes'. Copy of an original of about 440–30. Generally restored with the statuette Palladion, stolen from Troy, in the crook of his left arm, but the identity is not certain. A poorer, full-length copy in Naples, from Cumae. (Munich 304. H. 1.02)

226a

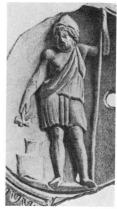

226b

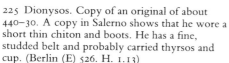

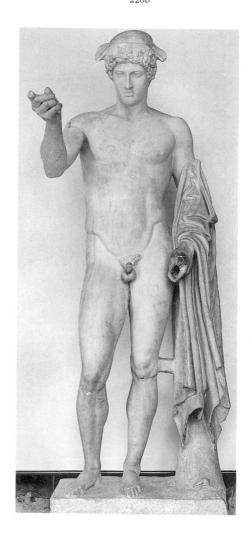

225 Dionysos. Copy of an original of about
440–30. A copy in Salerno shows that he wore a
short thin chiton and boots. He has a fine,
studded belt and probably carried thyrsos and
cup. (Berlin (E) 526. H. 1.13)

226 Hephaistos. Copy of an original of about
420–10. The head (a) is on a herm. He wears a
workman's cap. Other copies give versions of
the whole figure, wearing short working dress
(exomis) with the right shoulder bare, holding
hammer and staff, as on the Roman lamp (b).
Commonly identified as the work of
Alkamenes, who made a Hephaistos, perhaps for
the god's temple in Athens (see also *202*). (a)
Vatican, Chiaramonti 1211. H. 0.55. (b) Athens.

227 'Hermes Ludovisi'. Copy of an original of
about 450–40. He carried a caduceus in the
crook of his left arm; the gesture of the right
hand (restored after other copies) is beckoning.
Identified (Karousou) as a Hermes
Psychopompos, leader of souls, and attributed
to a monument in Athens for the men fallen at
Koroneia (477) for which a verse epitaph has
been identified. Otherwise known as Hermes
Logios. The type was used for an Augustan
portrait of 'Germanicus'. (Rome, Terme 8624.
H. 1.83)

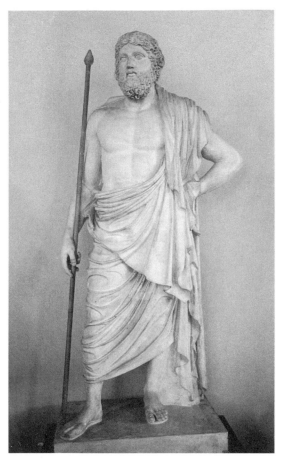

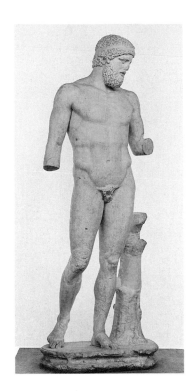

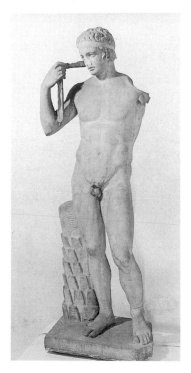

228 Dresden Zeus. Copy of an original of about 450–40. Commonly attributed to Phidias and the head thought to resemble that of his Zeus at Olympia, sometimes to Agorakritos. Compare the Parthenon frieze heroes *96.16*. Otherwise identified as Hades or Asklepios. (Dresden 68. H. 1.95)

229 God or hero. Copy of an original of about 440. Restored holding sword and scabbard, but the original perhaps with shield (as Riace *38–9*) or with club (in right hand, on ground) as Heracles. (Munich 295. H. 2.39)

230 Diadoumenos Farnese. Copy of an original of about 450–40. The motif of the Polyclitan Diadoumenos *186* in the older, Early Classical stance. Variously associated with Phidias and Polyclitus. (London 501. H. 1.48)

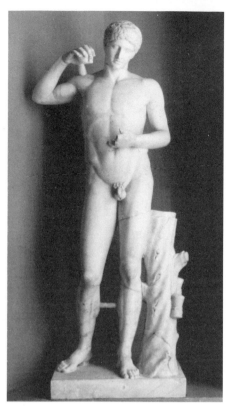

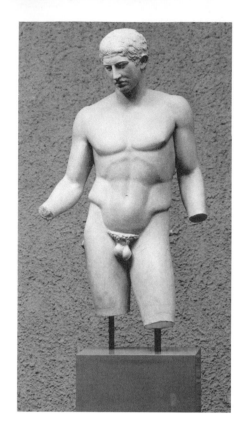

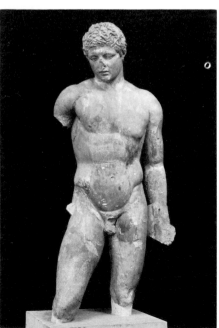

231 Athlete oiling himself. Copy of an original of about 450–40. He pours oil into his left hand. The stance approaches the Polyclitan but the trailing heel is low, the head still quite Severe. Restored below knees. (Petworth 9. H. 1.67)

232 'Diskobolos'. Copy of an original of about 450–40. The style and pose seem Polyclitan. It has been suggested that the type should be restored holding a sword in the right hand rather than a discus in the left, and so possibly a Theseus with the token of his birth, or an Achilles receiving new armour. (Vatican 767. Cast in Basel. Original restored H. 1.73)

233 Diskobolos. Copy of an original of about 410. He stands with discus in lowered left hand, ready to step forward with his right foot in the first move of the throw. Rather plump Polyclitan, associated with a diskobolos made by Polyclitus' brother Naukydes (Pliny). (Rome, Mus. Nuovo Cap. 1865. H. 1.30)

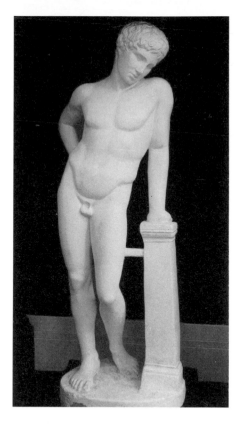

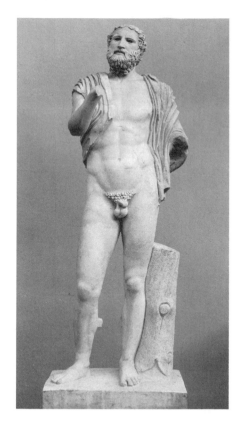

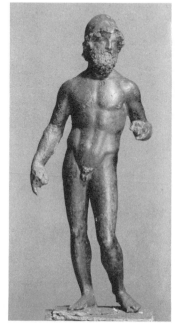

234 Boy athlete ('Narkissos'). Copy of an original of about 410. Much of the weight is shifted on to a pillar (the copyist offers his usual tree trunk), the legs are in a Polyclitan stance. Commonly thought to be from the school of Polyclitus; the weariness of the youth is well conveyed and inspired the modern sobriquet. (Louvre 457. H. 1.07. Cast in Oxford)

235 Anakreon Borghese. Copy of an original of about 440. Identified from an inscribed bust with the head, in Rome (Conservatori). The poet, from Teos in Ionia, spent part of his late life in Athens and died there in the 480s. He held a lyre, as performer in a symposion, thus virtually naked and wearing a hair band. His head is tilted as if tuning his lyre or pausing before singing. (Copenhagen, Ny Carlsberg 491. H. 1.90)

236 Bronze warrior. Reduced version (rather than a copy) of a figure of about 430–20. The stance is Polyclitan, the head (recalling Riace 39) not a portrait, but this could reflect an Athenian strategos (general) statue, and Kresilas' Pericles 188 was probably such a figure. (Hartford, Wadsworth Athenaeum 1917.820. H. 0.29)

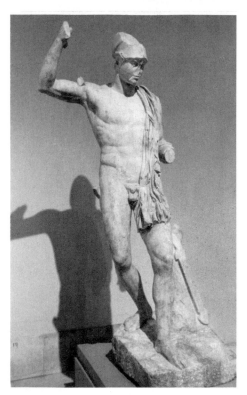

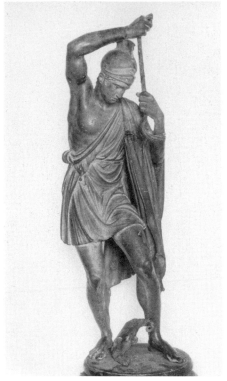

237 Wounded warrior. Copy of an original of
about 440–30. He is wounded below the right
armpit, yet his right arm is raised, more to strike
than to support himself on a spear. The pose
suggests a tentative step down and the plinth
suggests a ship's prow. A plausible identification
is of Protesilaos, the first ashore and first killed
at Troy. Some see this as Kresilas' 'wounded
man' (Pliny). (New York 25.116. H.1.97)

238 Wounded man from Bavai, bronze.
Reduced copy of an original of about 440. A
more freely posed male version of the wounded
Amazon type *192*. He supports himself on a
spear, held vertically, his right forearm bearing
on his helmet crest. Often associated with
Kresilas' 'wounded man' (Pliny), but also
declared a pastiche. (Saint-Germain-en-Laye.
H. 0.35)

239 (*opposite*) Three-figure reliefs. Copies of originals of about 420–10. H. about 1.20.
1. Orpheus, in Thracian dress at the right and holding a lyre, says goodbye to his wife Eurydike
who is being returned to Hades by Hermes, at the left, because Orpheus, who had won her
release, could not forbear to look back at her as they emerged. The inscribed names are wrong.
(Louvre). 2. Medea, at the left in eastern dress, wearing the loose-sleeved Persian jacket over her
shoulders and holding a casket of potions, deceitfully counsels the two daughters of Pelias, one
with cauldron, one pensive with sword (re-worked as a branch, the scabbard cut away), how
they might ensure immortality for their father by cutting him up and boiling him. (Berlin (E)
925). 3. Heracles, at left, is rescuing Theseus, at right, from Hades, but has to leave behind
Theseus' close companion Peirithoos, between them, who was held prisoner with Theseus
when they tried to abduct Persephone. Restored from other copies are the left forearm of
Heracles, head of Peirithoos, head and right hand of Theseus. (Rome, Torlonia, H. 1.20).
4. Heracles seated beside two of the Hesperides, before their tree with its guardian snake. The
face of Heracles and the left figure here restored from other, fragmentary copies. One of
Heracles' labours was to acquire the apples of the Hesperides, which bestow immortality. In this
version of the story he persuades the girls to hand them to him; otherwise he employs Atlas (cf.
Olympia *22.10*) or has to fight the snake (cf. *ABFH* fig. 233 ?). (Rome, Villa Albani 100)

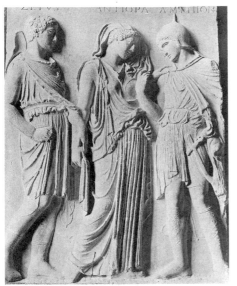

239.1

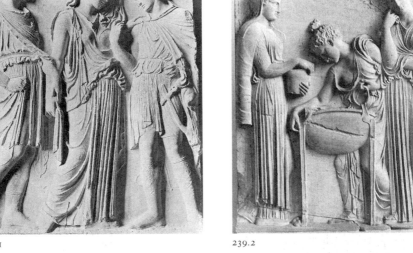

239.2

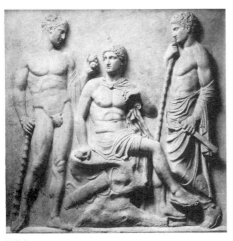

239.3

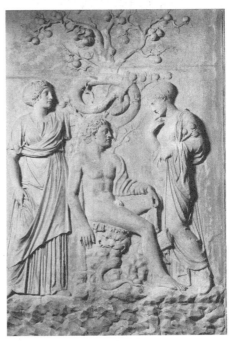

239.4

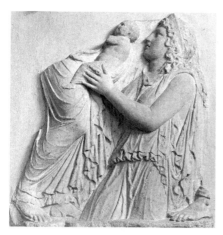

240 Birth of Erichthonios. Copy of an original of about 420. The goddess Ge (Earth) emerges to hand the infant to Athena. With other copies of less merit this yields a frieze with other figures of Athenian myth-history. Given the popularity of birth scenes for the bases of cult statues, the original is attributed by many to the base of the Athena and Hephaistos statues (near-parents of Erichthonios) in his temple, and so associated perhaps with Alkamenes. Cf. the himation-swathed legs of the Athena *202* given to the same group by some. (Vatican, Chiaramonti 1285. Restored H. of original frieze about 0.70)

241 'Medusa Rondanini'. Copy of an original of about 440 (?). The Gorgon Medusa head, for the first time here shown as a beautiful woman, with wings in her hair and snakes around her face (contrast *GSAP* figs. 187–8, 205.3). The style is Classical or classicising. If the former, it might be associated with an Athena-aegis on one of the great statues, or the centrepiece of her shield, but other copies of these heads have her still semi-grotesque *107, 108, 110*; if the latter, it might be from a gilt aegis dedicated on the Acropolis in about 200, but the type is always treated as head alone, not on an aegis. Scholars of style tend now to place it in the 4th cent. (Munich 252. H. 0.39)

242a

243a

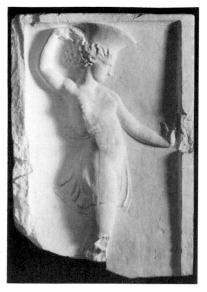

242b Dancer. Copy of an original of about 410. (Berlin 1456. H. 0.95. Cast in Oxford)

243b Dancing maenad. Copy of an original of about 400. (Rome, Conservatori 1094. H. 1.43)

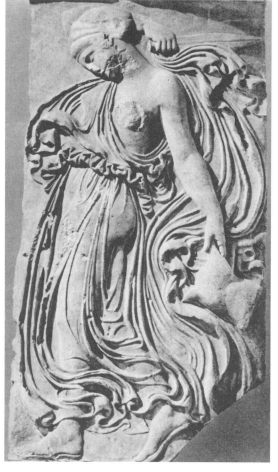

242a (oppposite) A group of dancers, wearing low crowns and short skirts, apparently a late 5th cent. creation copied in several reliefs. Often identified as Kallimachos' 'Lakonian dancers', for whom the dress may be appropriate

243a (opposite) A group of maenads dancing, with flamboyant gestures and clinging dress, apparently, as 242, a late 5th cent. creation copied in several reliefs; also often associated with Kallimachos

Chapter Seventeen

CONCLUSION

Two general problems – nudity and portraiture – call for separate brief discussion here before we assess what we can of the Greek sculptural achievement of the fifth century.

The modern western world accepts the 'artistic' nude, male or female, because it has been conditioned to it by the remains of Classical antiquity and by the Renaissance's and Neo-Classical recreation of Classical antiquity. It is respectable, can even be 'heroic' – a term misguidedly sometimes applied to its use in Classical Greece. In life it is not acceptable and we prosecute streakers or erotic displays, tolerating it on the stage or screen if the story is thought to require it ('art' again). In Classical Greece the nude (men only) *was* acceptable in life. Athletes at exercise or competition went naked and it was possible to fight near-naked. Youths and even the more mature took no pains to conceal their private parts on any festive and no doubt many more ordinary, public occasions, and in the name of religion realistic displays of a phallic character were commonplace – at every street corner (cf. *GSAP* fig. 169; *ARFH* figs 330, 340, 364; and above, p. 177). Foreigners commented on this odd behaviour and the Greeks realized that this was yet another of the respects in which they were different from the 'barbarian'. In Greek art, therefore, the nude could carry no special 'artistic' connotation, nor could it exclusively designate a special class, such as hero or god. The problem is a complex one and the view expressed here is not widely upheld as yet, but it must be clear that the fifth-century attitude to the nude in art and our own must be very different indeed. The male nude recommended itself to artists for the ready accessibility of models, for the tectonic character of the male (not female) body, which lent itself to studies of pattern and proportion, and for its constant use in depiction of myth-history. The female nude, before the fourth century, is used only as a religious (fertility) motif (cf. *GSAP* figs 19, 23, 26–7; *ABFH* fig. 317), for pathetic appeal, or on vases for magic or erotic appeal or for the life of the courtesan (as *ARFH* figs 27, 38, 71, 122, 176, 224–5, 321); not as an 'art form' or exploiting the sensual characteristics of the female body in the way the vigorous characteristics of the male body were emphasized. That said, it is also clear that Classical artists dwelt on the

238

male nude beyond the call of plausible or realistic depictions of life (including life acting as myth). A vigorous or beautiful god, hero or man might, but need not, be shown naked. It depended on the appropriateness of the theme or setting, sometimes on the desire to contrast naked and clothed, as [152].

The idealizing tendency in Classical sculpture, notably in Athens, is readily abetted by the male nude. It is a tendency which militates against individualizing characteristics of body or features. Only when the scale tipped decisively towards realism in art and away from the idealized essay (never quite forgotten in Greece) could real portraiture be readily conceived or executed. In earlier days a figure, mortal or divine, was identified by his age, dress and attributes, or by inscription. There are, however, intimations of portraiture in the fifth century, and caricature was certainly already familiar, so that a figure could be recognized by exaggeration of irregular features. The artist had also achieved some success in delineating ethnic differences (as *ARFH* figs 23, 126, 336; cf. 258, 377 (dwarfs); 222). In the East Greek world we find characterizations, significantly of the male head alone, on coins and gems [244], and sometimes, especially with ethnic characteristics added as for Persians, an identified head which must be a near-portrait [245]. Literature mentions portraits, but, in the fifth century, at least until near its end, only of the dead, even recently dead. Harmodios and Aristogeiton [3], Kresilas' Pericles [188] and Anakreon [235] were no portraits; and they were, as usually for sculpture in the Classical period, a whole figure, not a head or bust. But it is also in the East Greek world that we hear of other fifth-century portraits – Themistocles at Magnesia after he had fled from Athens. It is likely that this part of the world took the lead in introducing something approaching true portraiture, at first perhaps in head studies rather than whole figures. An inscribed herm copy of a Themistocles portrait, in Ostia [246], has some undeniably Severe features, a remarkable achievement if they are anachronistic (he died in about 460) and so often considered a copy of a fifth-century original. Other fifth-century heads in which portraits have been seen by some scholars are (both, be it noted, bronze originals) the Porticello head [37] and one from Cyrene [141].

Incipient portraiture and the expression of mood in features; the adoption of the male nude as a major subject for figure art; the first representation in world art of human figures which show a full understanding of the body's structure; the imposition of theories of proportion on replicas of the natural world; subtle narrative in the service of cult or politics or both; the colossal, in ivory, gold and precious stones; the miniature (coins and gems deserve a place in this story). The many aspects of fifth-century sculpture which have been demonstrated in

this volume in its pictures if not its text have become almost cheapened by their familiarity. Staring at these works, in picture, cast or original, does not explain them; indeed their familiarity to some degree deadens perception. We seize their quality sometimes in detail, sometimes in seeing them as a whole or imagining them in their setting, but the exercise is one of imagination as much as of observation. An understanding of what had gone before, what had been achieved by other ancient cultures, what was to come after to inform the continuing development of western art, is a necessary part of any attempt at appreciation. An understanding too of the life, politics and other arts of a people who chose remarkably to express themselves so freely in images of man, in an art which succeeds in being both humane and in the service of superhuman ideals. Full appreciation is beyond our wit but the attempt is perhaps reward enough.

244 Impression of a blue chalcedony intaglio signed by Dexamenos of Chios. The distinctive head type appears on two other gems attributed to this artist, where he is beardless. About 440. (Boston 23.580. H. 20mm)

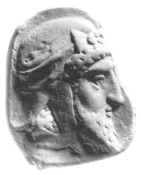

245 Coin of Tissaphernes, Persian satrap-governor of western Asia Minor. Coin dies and 'Greco-Persian' gems cut for western Persian satrapies (provinces) and client kingdoms were heavily influenced by Greek art and many, as this coin, probably were made by Greeks. Late 5th cent. (London. H. 28mm Cast)

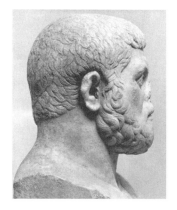

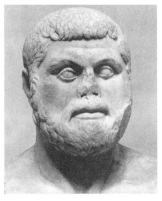

246 Copy of a portrait of Themistocles on a herm, from Ostia. The original of about 460 (?). There was a statue of him in the market at Magnesia (remarked by Thucydides) and one in Athens (Paus.). (Ostia. H. of head 0.26)

ABBREVIATIONS

AA	*Archäologischer Anzeiger*	*Cat. Munich*	B. Vierneisel-Schlörb, *Katalog der Skulpturen* II (1970)
AAA	*Athens Annals of Archaeology*		
ABFH	J. Boardman, *Athenian Black Figure Vases* (1974)	*Cat. New York*	G.M.A. Richter, *Catalogue of the Greek Sculptures* (1954)
A Delt	*Archaiologikon Deltion*	*Cat. Terme*	A. Giuliano (ed.), *Museo Nazionale Romano, Le Sculture* I. 1 (1979)
AE	*Archaiologike Ephemeris*		
AJA	*American Journal of Archaeology*	*GSAP*	J. Boardman, *Greek Sculpture, Archaic Period* (1978)
AK	*Antike Kunst*		
AM	*Athenische Mitteilungen*	Helbig	W. Helbig, *Führer durch die offentlichen Sammlungen klassischer Altertümer in Rom* I–IV (ed. 4, 1966–72)
Ann	*Annuario della Scuola Archeologica di Atene*		
AntPl	*Antike Plastik*		
ARFH	J. Boardman, *Athenian Red Figure Vases, Archaic Period* (1975)	*JdI*	*Jahrbuch des Deutschen Archäologischen Instituts*
		JHS	*Journal of Hellenic Studies*
AvP	*Altertümer von Pergamon*	*LIMC*	*Lexicon Iconographicum Mythologiae Classicae*
BABesch	*Bulletin van de Vereeniging* ...		
Basel	*Parthenon-Kongress Basel. Referate und Berichte* (1984)	Lullies/ Hirmer	R. Lullies/M. Hirmer, *Greek Sculpture* (1960)
BCH	*Bulletin de Correspondance Hellénique*	*RA*	*Revue Archéologique*
Bieber	M. Bieber, *Ancient Copies* (1977)	Richter, *PG*	G.M.A. Richter, *Portraits of the Greeks* (1965)
BSA	*Annual of the British School at Athens*	Richter, *SS*	G.M.A. Richter, *Sculptures and Sculptors of the Greeks* (1970)
Cat. Berlin	C. Blümel, *Katalog der Sammlung antiker Skulpturen* III (1928) K 1–115; IV (1931) K 121–189. K numbers are cited.	Ridgway, *FC*	B.S. Ridgway, *Fifth-Century Styles in Greek Sculpture* (1981)
		Ridgway, *SS*	B.S. Ridgway, *The Severe Style in Greek Sculpture* (1970)
		RM	*Römischen Mitteilungen*
Cat. Boston	M. B. Comstock/C. C. Vermeule, *Sculpture in Stone, Boston* (1976)	Robertson	M. Robertson, *History of Greek Art* (1975)

NOTES AND BIBLIOGRAPHIES

GENERAL

M. Robertson, *History of Greek Art* (1975) gives a good account of 5th century sculpture in its context with the rest of Greek art, with valuable notes. C. Picard, *La sculpture antique* II (1939) is outdated but very full. W. Fuchs, *Die Skulptur der Griechen* (1983) presents the sculpture by types, as does G.M.A. Richter, *Sculptures and Sculptors of the Greeks* (1970) where the literary evidence for the sculptors is well summarized. B. Ridgway's two monographs (*SS* and *FC*) give full, sometimes idiosyncratic accounts of many problems. G. Lippold, *Die griechische Plastik* (1950) is a comprehensive handbook but outdated and being replaced by W. Fuchs. C. Houser, *Greek Monumental Bronze Sculpture* (1983) for large photos of original bronzes.
For subjects: K. Schefold, *Die Göttersage in der klass. und hell. Kunst* (1981) and *LIMC*.
For related media: R.A. Higgins, *Greek Terracottas* (1967); J. Boardman, *Greek Gems and Finger Rings* (1970); W. Lamb, *Greek and Roman Bronzes* (1929).

Notes are selective, leading the reader to further illustration or discussions (with which the writer does not necessarily agree).

I TECHNIQUES AND SOURCES

Techniques

General and stone: S. Adam, *The Technique of Greek Sculpture* (1966); C. Blümel, *Greek Sculptors at Work* (1975); *The Muses at Work* (ed. C. Roebuck, 1969) 96ff. (Ridgway); A. Stewart, *BSA* 70, 199ff. – running drill; D. Haynes in *Wandlungen* (Fest. Homann-Wedeking, 1975) 131 – polishing.
Pointing: G. Richter, *Ancient Italy* (1955) 105ff.; *RM* 67, 52ff.; B. Ridgway, *Cat. Class. Coll. Rhode Island* (1972) no. 8.
Colour: P. Reuterswärd, *Stud. zur Polychromie der Plastik* (1960); S. Karousou, *ADelt* 31, 9ff. – backgrounds.
Material: R.E. Wycherley, *BSA* 68, 349ff. – identifying Pentelic; J. Frel, *AAA* 5, 73ff. – repairs; A. Dworakowska, *Quarries in ancient Greece* (1975); D.R.C. Kempe in *Petrology of Arch. Artefacts* (ed. Kempe, 1983) 80ff.
Stone and wood acroliths: Athena Areia by

Phidias (Paus.); C. Blinkenberg, *Die lindische Tempelchronik* (1915) C29ff. – gorgon; R. Meiggs, *Trees and Timber* (1982) ch. 11.
Bronze: D. Mitten/S. Doeringer, *Master Bronzes* (1968) 7ff.; D. Haynes (mainly for indirect casting) *AA* 1962, 803ff.; 1970, 450ff.; *RA* 1968, 101ff. – on [12]; *JHS* 101, 136ff. J. Hemelrijk (for direct casting but in sections) – *BABesch* 57, 6ff.; C. Mattusch, *Casting Techniques* (Diss. 1975) and *AJA* 84, 435ff.; P.C. Bol, *Olymp. Forsch.* IX (1978) 71ff.; J. Frel, *The Getty Bronze* (1978) – a 4th cent. interior. For the wax: J. Noble, *AJA* 79, 368ff.; R. Raven-Hart, *JHS* 78, 87ff.

Sources

Originals: J.J. Pollitt, *Trans. Amer. Phil. Ass.* 108, 155ff. – Greek statues in Rome; E. Paribeni, *8. Convegno Magn. Grec.* 1968 (1969) 83ff. – Greek originals in Rome; M. Pape, *Gr. Kunstwerke aus Kriegsbeute* (1975).
Copies: Bieber, *Copies*; A.W. Lawrence, *Greek and Roman Sculpture* (1972) 242ff. – Greek styles in Rome; H. Lauter, *Chron. röm. Kopien nach Orig.* (1969). Plaster casts: C. von Hees-Landwehr, *Der Fund von Baia* (1982). Bronze casting of copies: C. Mattusch, *AJA* 82, 101ff. Studios in Athens: *Agora* XIV 187f. Lucian, *Iupp. trag.* 33.
Coins: F. Imhoof-Blumer/P. Gardner, *Num. Comm. on Paus.* (1887; repr. 1964): L. Lacroix, *Les réproductions des statues sur les monnaies gr.* (1949). G. Horster, *Statuen auf Gemmen* (1970). Literary Sources: G. Richter, *SS* – summaries for each sculptor. J. Overbeck, *Die antiken Schriftquellen* (1868; repr. 1971) – complete sources in original. H. Stuart-Jones, *Select Passages . . . Gr. Sc.* (1895) – originals and trans. K. Jex-Blake/E. Sellers, *The Elder Pliny's Chs. on the History of Art* (1896) – orig., trans. and comment. J.J. Pollitt, *The Art of Greece 1100–31 BC* (1985) – selected trans., and *The Ancient View of Greek Art* (1974). *Pausanias* – Penguin Classics (trans. P. Levi; 1971).

3 EARLY CLASSICAL MEN AND WOMEN: I

[3–9] Robertson, 185f.; Ridgway, *SS* 79ff., 90f.; B. Shefton, *BSA* 64, 173ff. – reversing places; S. Brunnsåker, *The Tyrant-Slayers²* (1971); M. Weber, *AA* 1983, 198f. – copies

later group; J. Frel, *AM* 91, 185ff. – Elgin throne [*9*]; von Hees-Landwehr, op. cit. 24ff. – Baiae [*4*].

[*10*] Ridgway, *SS* 41. [*11*] von Hees-Landwehr, op. cit. 21; O. Palagia suggests this is from the original of the copy of a statue of Zeus at Olympia, *AAA* 6, 61. [*12*] A. Wace, *JHS* 58, 90ff. (cf. 255); D. Haynes, *RA* 1968, 101ff. – technique; *LIMC* Apollon 561. [*13*] Mitten/Doeringer, op. cit. no. 83. [*14*] A. Neugebauer, *Kat. Bronzen Berlin* II no. 6. R. Tölle-Kastenbein, *Frühkl. Peplosfiguren* (1980) – originals (copies will appear in *AntPl* XX; review, Ridgway, *Bonner Jb.* 182, 626ff.): no. 13c [*15*], 19b [*16*], 28a [*17*]. L.K. Congdon, *Caryatid Mirrors of ancient Greece* (1981) no. 31 [*16*].

H.G. Niemeyer, *AntPl* III 7ff. – bronzes, men, women, Athena; R. Thomas, *Athletenstatuetten* (1981).

4 OLYMPIA

B. Ashmole/N. Yalouris, *Olympia* (1967); Ashmole, *Architect and Sculptor* (1972) chs 1–3; Robertson, 271ff.; Ridgway, *SS* ch. 2; *Olympia* III (1897) 95ff. and *JdI* 4, 266 – findplaces; S. Stucchi, *Ann* 30/32, 75ff. – repairs, rearranged metopes; H.V. Herrmann, *Olympia* (1972) 128ff., n. 519 – repairs, n. 513 – findplaces; M.L. Säflund, *East Ped. Olympia* (1970); P. Grunauer, *JdI* 89, 1ff. (W. ped.) and *Ol. Bericht* X 281ff. (E. ped.); H. Gertman, *BABesch* 57, 20ff. (metopes); L.H. Jeffery in *Philias Charin* (Misc. E. Manni, 1979) 1233ff. – akroteria sculptors.
Also on id. of figures: C. Kardara, *AE* 1965, 168ff. – Sterope and Hippodamia; *ADelt* 25, 12ff. and *Rel. and Pol. Sign. of the Ol. Ped.* (1978) – young Zeus; K. Schefold in *Class. et Prov.* (Fest. E. Diez, 1978) 177ff. – east E = Chrysippos; E. Simon, *AM* 83, 160ff. – east L = Amythaon; R.M. Gais, *AJA* 82, 355ff. – river gods?

5 EARLY CLASSICAL MEN AND WOMEN: II

[*24–6*] Ridgway, *SS* 101ff.; H. Hiller, *AA* 1972, 47ff.; R. Fleischer, *AA* 1983, 33ff.; Helbig, 123, cf. 341, 1502. [*27*] Ridgway, *SS* 36f. [*28*] ibid. 35f., 64. [*29*] Tölle-Kastenbein, op. cit. no. 8c. [*30*] Ridgway, *SS* 39. [*31*] A.M. Woodward, *BSA* 26, 253f.; Ridgway, *SS* 39. [*32*] *Hesperia* 39, 117ff. [*33*] *Ol. Bericht* V 103ff.; Lullies/Hirmer, pls 105, V. [*34*] F. Chamoux, *L'Aurige* (1955); Robertson, 188ff. [*35*] C. Karousos, *ADelt* 13, 41ff.; Ridgway, *SS* 62f., 111f. (Roman plaque with type as

Poseidon); Robertson, 196f.; R. Wünsche, *JdI* 94, 77ff. – Zeus. [*36*] *AE* 1899, 57ff. [*37*] Ridgway, *FC* 120ff.; *Antike Welt* 4, front. [*38–9*] Ridgway, *FC* 237ff. – late; W. Fuchs in *Praestant Interna* (Fest. Hausmann, 1982) 34ff. and *Boreas* 4, 25ff.; A. Giuliano, *Xenia* 2, 55ff. and 3, 41ff.; C.O. Pavese, *Stud. Class. e Or.* 32, 1ff. – B after A; A. Busignani, *Gli Eroi di Riace* (1981).

6 EARLY CLASSICAL RELIEF

SCULPTURE

Ridgway, *SS* 48ff. [*40–1*], 106 [*43*], 46 [*44*], 53 [*45*], 50, 55 [*46*], 46ff. [*51–2*], and *FC* 65 [*48*], and *AJA* 71, 307ff. [*44*]. E. Berger, *Das Basler Arztrelief* (1970) figs 22 [*57*], 23 [*58*], 37 [*49*], 40 [*50*], 51–3 [*43*], 54 [*44*], 138f. [*54*], 144 (Leukothea, see on [*53*]), 159 [*56*]. G. Neumann, *Probleme des gr. Weihreliefs* (1979) pl. 17b [*53*], 20a [*41*], 20b [*40*], 21 [*44*].
[*41*] F. Chamoux, *BCH* 81, 141ff. – with terma; Robertson, 178 – sed N. Kenner, *Anz. Öst. Akad.* 114, 379ff. – psychopompos, political. [*43–4*] *Guide de Thasos* (1968) 37–9, 126, 168. [*45*] C. Karousos, *JHS* 71, 96ff.; *LIMC* Aphrodite 1112. [*46–7*] Robertson, 203ff.; *Cat. Terme* no. 48; G. Gruben, *Münch. Jb. bild. Kunst* 23, 25ff. – corners; *Cat. Boston* no. 30; W.J. Young/B. Ashmole, *Bull. Boston MFA* 66, 124ff. – ancient; M. Guarducci, *Mem. Lincei* 24, 506 – modern. [*48*] Ridgway, *FC* 65. K.F. Johansen, *Attic Grave Reliefs* (1951) figs 6 [*56*], 62 [*49*], 66 [*51*], 71 [*42*], 73 [*54*], 74 (Leukothea). H. Hiller, *Ion. Grabreliefs* (1975) O11 [*50*], O16 [*49*], K6 [*53*], K7 [*58*], K8 [*51*], 12 (Leukothea). E. Pfuhl/H. Möbius, *Die Ostgr. Grabreliefs* (1977) nos 12 [*50*], 14 [*49*]. [*53*] N. Kontoleon, *Aspects* (1970) 1ff. and *AE* 1974, 13ff.; C. Clairmont, *Zeitschr. Pap. Epigr.* 26, 119ff. [*54*] R. Hampe, *Die Stele aus Pharsalos* (1951). [*54–5*] H. Biesantz, *Die thessalischen Grabreliefs* (1965) K36, K4. [*59*] W. Schild-Xenidou, *Boiot. Grab- und Weih-reliefs* (1972) no. 8; *Cat. Boston* no. 18.

7 NAMES AND ATTRIBUTIONS

Richter, *SS* 154ff. for sources; Ridgway, *SS* ch. 6.
Kritios and Nesiotes: A. Raubitschek, *Dedications Ath. Acr.* (1949) 513ff.
Pythagoras: Ridgway, *SS* 83f.
Kalamis: J. Dörig, *JdI* 80, 138ff. – attributes our [*69, 208, 221, 225, 229*]; W.M. Calder, *Gr. Rom. Byz. Stud.* 15, 271ff. – Athenian; Ridgway, *SS* 87.
Myron: Robertson, 339ff.; Ridgway, *SS* 85f., 89; G. Daltrop, *Il gruppo mironiano* (1980); [*60*]

Cat. Terme no. 120; [*62*] B. & K. Schauenburg, *AntPl* XII 47ff.

8 OTHER COPIES OF THE EARLY CLASSICAL

[*65*] L.K. Congdon, *AJA* 67, 7ff.; *LIMC* Apollon 200a, Apollo 39. [*66–7*] Robertson, 194f.; Ridgway, *SS* 61ff.; G. Richter, *Kouroi* (1960) no. 197; *LIMC* Apollon 599, Apollo 36. [*68*] Ridgway, *FC* 184f.; E. Schmidt, *AntPl* V; *LIMC* Apollon 295, Apollo 41. [*69*] *Cat. Terme* no. 130; Helbig 2253; *LIMC* Apollon 600, Apollo 38. [*70*] Ridgway, *SS* 132. [*71*] Helbig 1771. [*72*] G. Hafner, *AA* 1952, 86ff.; G. Fuchs, *AA* 1967, 407ff.; *Cat. Boston* no. 139. [*73*] Ridgway, *SS* 73; Helbig 2324, head from 1085 (Vatican); *Cat. Terme* I.2 no. 89. [*74*] Helbig 3329; *LIMC* Aphrodite 139. [*75*] P. Orlandini, *Calamide* (1950) 88ff.; Robertson, 192f. and J. *Warburg/Courtauld* 20, 1f.; *LIMC* Aphrodite 148. [*76*] Helbig 351; Ridgway, *SS* 114ff.; W. Fuchs, *Die Vorbilder der neuatt. Reliefs* (1959) 59ff.; T. Stephanidou-Tiveriou, *Neoattika* (1979) 138ff. – Piraeus.
Herculaneum dancers: Ridgway, *SS* 144f.; Robertson, 192f.; L. Forti, *Le danzatrici di Ercolano* (1959).

10 THE PARTHENON

F. Brommer, *The Sculptures of the Parthenon* (1979) is the most convenient source, with his monographs in German (1963–77, see below) for details. *Basel* reports important new theories and discussions about the building and its sculpture, and for reports on the work at Basel see E. Berger in *AK* 19 and later. Useful recent accounts are – Robertson, 292ff.; B. Ashmole, *Architect and Sculptor* (1972) chs 4, 5 (esp. for technique); Ridgway, *FC*; *Parthenos and Parthenon* (Greece and Rome Suppl., 1963, incl. 23ff. for building accounts); R.E. Wycherley, *Stones of Athens* (1978) ch. 4; H. Knell, *Pericleische Baukunst* (1979); G.P. Stevens, *Hesperia* Suppl. 3 – views.
Testimonia in A. Michaelis, *Der Parthenon* (1871). T. Bowie/D. Thimme, *The Carrey Drawings of the P. Sculpture* (1971). Cult – C.J. Herington, *Athena Parthenos and Athena Polias* (1955); D.M. Lewis, *Scripta Class. Israel*, 5, 28f. – peplos to Parthenon? For the theory that there was a pre-Periclean, Kimonian plan, now generally discounted, see R. Carpenter, *The Architects of the P.* (1970), answered by W.B. Dinsmoor jr, *AJA* 75, 339f. F. Preisshofen in *Basel* – a treasury; Brommer in *Basel* – hands; N. Himmelmann in *Bonner Festg.* J. Straub (1977) 67ff. – role of Phidias; G. Despinis, *Parthenoneia* (1982).

PEDIMENTS

F. Brommer, *Die Skulpturen der P.-Giebel* (1963); *Basel*.
West: E. Harrison in *Essays Hist. Art* (Fest. R. Wittkower, 1967) 1ff. – identities; H.A. Thompson, *Hesperia* 19, 103ff. – Agora Triton [*81*] and M; E. Simon in *Tainia* (Fest. R. Hampe, 1980) 239ff. – Zeus' bolt (Pella vase – Despinis, op. cit. 65); N. Yalouris in *Basel* – ketos; W. Fuchs, *Boreas* 6, 79f. – Poseidon; R. Lindner, *JdI* 97, 303ff. – Eleusis [*82*]; R.M. Gais, *AJA* 82, 355ff. – not river gods.
East: E. Berger, *Vorbemerkungen* (1958) and *Die Geburt der Athena* (1974); Despinis, op. cit. – 'Hera' and H (not Hephaistos) put r. of centre, lyre for Apollo, Madrid puteal [*83*]; E. Harrison, *AJA* 71, 27ff. – identities, gods disposed in accordance with places of worship in Athens, and in *Fest. Brommer* (1977) 155ff. – L as Themis; E. Pochmarski in *Basel* – D as Ares; A. Delivorrias in *Praestant Interna* (Fest. Hausmann, 1982) 41ff. – Zeus; H. Walter in *Stele* (Mem. N. Kontoleon, 1979) 448ff.; I. Beyer, *AM* 89, 123ff. and 92, 101ff.

METOPES

F. Brommer, *Die Metopen des P.* (1967); C. Praschniker, *P. Studien* (1928) – esp. N and W.
West: B. Wesenberg, *AA* 1983, 203ff. – Amazons.
North. J. Dörig in *Basel* – identifications, incl. pre-Sack scenes.
East: M. Tiverios, *AJA* 86, 227ff.
South: N. Himmelmann in *Stele* (supra) 161ff.; J. Dörig, *MusHelv* 35, 221ff. – kings/heroes, political; E. Simon, *JdI* 90, 100ff. – Ixion; M. Robertson in *Studies von Blanckenhagen* (1979) 78ff. and *Basel* – Daedalus; B. Wesenberg in *Basel* and *JdI* 98, 57ff. – intended use over porches; B. Fehr, *Hephaistos* 4, 37ff. – Phaidra and Alcestis stories = bad and good wives.

FRIEZE

F. Brommer, *Der P. Fries* (1977); M. Robertson/A. Frantz, *The P. Frieze* (1975).
C. Kardara, *AE* 1961.2, 61ff. – first Panathenaea; R. Holloway, *Art Bulletin* 48, 223ff. – replacing archaic offerings; Boardman in *Fest. Brommer* (1977) 39ff. and *Basel* – Marathon; U. Kron, *Die zehn att. Phylenheroen* (1975) 202ff. and *Basel* – heroes, and Heracles for east 25; P. Fehl, J. *Warburg/Courtauld* 24, 1ff. – rocks (also G. Waywell in *Basel*); E. Harrison in *Gr. Num. and Arch.* (Essays M. Thompson, 1979) 71ff. and *Basel* – rocks, different epochs for N and S; E.G. Pemberton, *AJA* 80, 112ff. – gods and cults; H. Kenner, *Anz. Öst. Akad.* 118, 273ff. – gods, Hecate for

east 26, and *Basel*; W. Gauer in *Basel* – action in Agora; E. Simon, *AM* 97, 127ff. and *Festivals of Attica* (1983) ch. 4 – different sacrifices N and S, east stools for absent Ge and Pandrosos.

AKROTERIA

Ridgway, *FC* 71; J. Binder in *Fest. Brommer* (1977) 29ff.; A. Delivorrias in *Basel*.

ATHENA PARTHENOS

N. Leipen, *Athena Parthenos, a reconstruction* (1971) [*106*]; Bieber, figs 398–408; J. Prag, *JHS* 103, 151f. and *Basel*; C.C. Vermeule in *Basel* [*100*]; Boardman, *Gymnasium* 74, 508f. – water; G. Korres in *Basel* – windows; E. Harrison in *Eye of Greece* (Studies M. Robertson, 1982) 53ff. – Nike head [*105*]; Ridgway, *FC* 161ff., 185 – Nike [*104*]; G. Hafner, *StädelJb.* 5, 7ff. – sphinx on helmet; W.H. Schuchhardt, *AntPl* II 31ff. [*97*]; *LIMC* Athena 212–33, Minerva 142–3.

PARTHENOS SHIELD

Leipen, op. cit. and *Basel*; V.M. Strocka, *Piräusreliefs und P. Schild* (1967) and *Basel*; T. Hölscher/E. Simon, *AM* 91, 115ff.; E. Harrison, *AJA* 85, 281ff. [*110*]; Stephanidou-Tiveriou, op. cit. – Piraeus; J. Floren, *Boreas* 1, 36ff.; A. von Salis, *JdI* 55, 90ff. – interior.

11 OTHER ATTIC ARCHITECTURAL SCULPTURE

Agora XIV; J.S. Boersma, *Athenian Building Policy* (1970) – bibl. and summary of all buildings; A. Delivorrias, *Attische Giebelskulpturen* (1974) – pedimental and other: pls 10a [*115*], 16 [*116*], 36 [*117*], 44 [*118*], 48 [*119*]. [*117*] K. Stähler, *AA* 1976, 58 – from state grave. Hephaisteion: H. Koch, *Stud. zum Theseustempel* (1955); H.A. Thompson, *Hesperia* 18, 230ff. – pediment, and *AJA* 66, 339ff.; C. Morgan, *Hesperia* 31, 210ff. – metopes, friezes, and 32, 91ff. – pediments, cult statues; Delivorrias, op. cit. ch. 2; S. von Bockelberg, *AntPl* XVIII 23ff. – friezes; E. Harrison, *AJA* 81, 137ff., 265ff., 411ff. – cult statues and base, but not for this building; J. Dörig, *AK* 26, 59ff. – E frieze as Erechtheus v. Eumolpos. Sunium: *AM* 66, 87ff. and 73, 88ff.; Delivorrias, op. cit. ch. 3 and *AM* 84, 127ff. Ares: Delivorrias, op. cit. ch. 4. Rhamnus: Delivorrias, op. cit. 188f.; G. Despinis, *Symbole . . . Agorakritou* (1971) – cult statue, and *Ergon* 1977, 7ff.; B. Petrakos, *BCH* 105, 227ff. – base. Demeter/Kore: E. Harrison, *Hesperia* 29, 37ff., pl. 81c – cult statue.

Unplaced metope – *Stele* (supra) pls 226–7. Albani metope – Ridgway, *FC* 30f.; K. Schefold in *Fest. Boehringer* (1957) 555. Stoa of Zeus: clay akroteria – *Hesperia* 6, 37ff. and 39, 120ff. Apollo, Delos: Delivorrias, op. cit. 187f.; U. Wester, *Die Akroterfiguren* (1969); *Expl. Délos* XII 133ff. ·
Erechtheion: Delivorrias, op. cit. 191f.; P. Boulter, *AntPl* X 7ff. – frieze; R.E. Wycherley, *Stones of Athens* (1978) ch. 5. Caryatids: H. Lauter, *AntPl* XVI; E. Schmidt, *AntPl* XIII and Ridgway, *FC* 105ff. – copies; Bieber, figs 38–46; H. Drerup, *MarburgerWPr* 1975/6, 11ff. – meaning.
Athena Nike: Pediments – Delivorrias, op. cit. 185ff.; G. Despinis, *ADelt* 29, 1ff. Akroteria – P. Boulter, *Hesperia* 38, 138ff. Balustrade – R. Carpenter/B. Ashmole, *Sc. of the Nike Temple Parapet* (1929). Friezes – C. Blümel, *JdI* 65/6, 135ff.; E. Harrison, *AJA* 74, 317ff. – S arrangement; 76, 195ff. – N subject; 76, 353ff. – S subject; E. Pemberton, *AJA* 74, 20ff. – N subject and 76, 303ff. – E and W, Megara. Bieber, figs 47–52. Authority for temple – H. Mattingly, *AJA* 86, 381ff. and cf. *JdI* 96, 28ff. Ilissos: A. Krug, *AntPl* XVIII 7ff.; C. Picon, *AJA* 82, 47ff.

12 THEMES IN ATTIC SCULPTURE

See Bibliography to last chapter. Also: T. Hölscher, *Griechische Historienbilder* (1973); E. Thomas, *Mythos und Geschichte* (1976); Boardman in *Eye of Greece* (Studies M. Robertson, 1982) 1ff. – Amazons.

13 OTHER CLASSICAL SCULPTURE

[*133*] Cat. Terme no. 116; Ridgway, *FC* 54ff.; G. Hafner, *Ein Apollo-Kopf in Frankfurt* (1962); Lullies/Hirmer, pls 174–7. [*134*] E. Langlotz/M. Hirmer, *Ancient Greek sculpture in S. Italy* (1965) pls 115–17 ('Apollo'); Helbig 1642; E. la Rocca, *Arch. Laziale* 2, 75f.; *Apollo* June 1981, 364f. [*135*] S. Adam, *Technique* (1966) 89ff.; H. Knell, *AntPl* XVII 9ff. [*136*] E. Harrison, *Hesperia* 29, 373ff.; *LIMC* Aphrodite 162. [*137*] Ridgway, *FC* 123; K. Schefold in *Fest. R. Boehringer* (1957) 563ff. [*138*] Ridgway, *FC* 123f.; H.A. Thompson, *Harvard Stud. Suppl.* 1, 183ff.; *Agora* XIV 191. [*139*] Ridgway, *FC* 108ff.; T. Hölscher, *JdI* 89, 70ff.; A. Gulaki, *Klass. und klassizist. Nikedarstellungen* (1981). [*140*] Ridgway, *FC* 67; *Cat. Boston* no. 22 [*141*] Ridgway, *FC* 179f.; Richter, *PG* figs 453–5. [*142*] *Hesperia* 42, 164f.; *Agora Guide* (1970) fig. 40. [*143*] Ridgway, *FC* 119.

14 OTHER CLASSICAL RELIEF SCULPTURE

Ridgway, *FC* 28, 30–7 – architectural, Thasos gates, 134ff. – landscape; S. Benton, *JHS* 57, 38ff. – Crete, Heracles and boar metope; D.I. Lazaridis, *Odegos Mus. Kavallas* (1969) pl. 54 (fight metope); *Hesperia* 29, pl. 71 (metope in Rome).
[*144*] Ridgway, *FC* 138ff.; L. Schneider, *AntPl* XII 103ff.; *Cat. New York* no. 34; H. Metzger, *RA* 1968, 10ff. – not Triptolemos. [*145*] Ridgway, *FC* 136f.; L. Beschi, *Ann* 45/6, 511ff. [*146*] Ridgway, *FC* 36f.; E. Berger, *AK* 10, 82ff.; R. Thomas, *JdI* 97, 47ff.; *LIMC* Athena 250.
Attic grave reliefs: D.C. Kurtz/J. Boardman, *Greek Burial Customs* (1971) ch. 6 and passim; B. Schmaltz, *Griechische Grabreliefs* (1983); J. Frel, *Les sculpteurs attiques anonymes* (1969); R. Stupperich, *Staatsbegräbnis und Privatgrabmal* (1977); C. Clairmont, *Gr. Rom. Byz. Stud.* 13, 49ff. – warriors on reliefs. K.F. Johansen, *Attic Grave Reliefs* (1951) with figs 4 [*150*], 5 [*151*], 12 [*149*], 13 [*156*], 15 [*152*], 17 [*155*], 21 [*157*], 82 [*154*]; Robertson, 364ff., 368f. [*153*]; Ridgway, *FC* 144ff., 152f. [*147*], 146 [*148*], 144f. [*153*]; C. Clairmont, *Gravestone and Epigram* (1970) nos 22 [*149*], 23 [*150*], 15 [*158*]; *Cat. Berlin* K29 [*155*]; *AM* 79, 93ff. [*147*].
Vase markers: B. Schmaltz, *Untersuch. zu den att. Marmorlekythen* (1970); G. Kokula, *Marmorlekythen* (1974) and cf. C. Dehl, *AM* 96, 163ff.; C. Clairmont in *Studies von Blanckenhagen* (1979) 103ff. [*154*].

Non-Attic grave reliefs: Kurtz/Boardman, op. cit. 223ff.; Ridgway, *FC* 152 [*160*], 148f. – Boeotian; Johansen, op. cit. fig. 60 [*161*]; E. Pfuhl, H. Möbius, *Die ostgr. Grabreliefs* (1977) nos. 54 [*159*], 46 [*160*]; P. Zanker, *AK* 9, 16ff. [*159*]; J. Frel, *AAA* 3, 367ff. and 5, 75ff. [*160*]; G. Rodenwaldt, *JdI* 28, 309ff. [*162*]; W. Schild-Xenidou, *Boiot. Grab- und Weihreliefs* (1972); P.M. Fraser/T. Rönne, *Boeot. and W. Greek Tombstones* (1957); U. Heimberg, *AntPl* XII 15ff. – Boeotian; H. Biesantz, *Die thessalischen Grabreliefs* (1965) nos 19 [*165*], 7 [*166*]; *AAA* 14, 48 and Biesantz, no. 10 – suckling; G. Bakalakis, *AM* 77, 197ff. – Thrace; *Cat. Berlin* K18 [*167*], K21 [*161*], K26 [*163*].
Votive reliefs: U. Hausmann, *Gr. Weihreliefs* (1960); Neumann, op. cit. (ch. 6) 34, 67 [*168*], 49 [*169*], 49, 74 [*170*], 43 [*171–2*], 62 [*175*]; Ridgway, *FC* 131ff. [*168–9*], 141f. [*172*], 135f., 156 [*173*]; H. Möbius, *Studia Varia* (1967) 33ff. [*172*]; L. Beschi, *AJA* 47/8, 85ff.; G. Waywell, *BSA* 62, 19ff. – chariot reliefs; R.B. Thonges-Stringaris, *AM* 80, 1ff. – death-feast; E. Mitropoulou, *Corpus of Attic Votive*

Reliefs I (1977); *Cat. Berlin* K95 [*176*], K81 [*174*].
Record reliefs: Robertson, 373; H. Speier, *RM* 47, 90ff. – list, pls 8, 9.1 [*178*]; R. Meiggs/D.M. Lewis, *Sel. Gr. Hist. Ins.* nos 84 [*179*], 94 [*177*].

15 NAMES AND ATTRIBUTIONS

Richter, *SS* ch. 3 for sources.
Phidias: G. Becatti, *Problemi Fidiaci* (1951). Promachos: Ridgway, *FC* 169; A. Linfert, *AM* 97, 57ff. Zeus: Robertson, 316ff.; Ridgway, *FC* 167f.; Becatti, op. cit. pls 71–3 – head; J. Liegle, *Der Zeus des Ph.* (1952) pls 1, 17 – head on coin. Zeus throne: J. Fink, *Der Thron des Zeus* (1967); Becatti, op. cit. pls 74–6 – Niobids; C. Vogelpohl, *JdI* 95, 197ff. – Niobids; G.V. Gentili, *Boll. d'Arte* 59, 101ff. – Niobids; B. Shefton in *Eye of Greece* (Studies M. Robertson, 1982) 162ff. – Niobids on vase; F. Eichler, *Öst. Jahreshefte* 30, 75ff. and 45, 5ff. – sphinxes. Lemnia – Linfert, op. cit.; Robertson, figs 395–7; K.J. Hartswick, *AJA* 87, 335ff. – doubts reconstruction and identity; *LIMC* Minerva 141.
Polyclitus: Robertson, 328ff.; Ridgway, *FC* 201ff.; D. Arnold, *Die Polykletnachfolge* (1969); A. Stewart, *JHS* 98, 122ff. – the Canon; E. Berger, *AK* 21, 55ff. [*187*]; *LIMC* Apollon 468 [*186*]; *Cat. New York* no. 38.
Kresilas: Richter, *PG* 102ff.; A. Raubitschek, *Dedications Ath. Acr.* (1949) 510ff.; cf. D. Pandermalis, *Untersuch. klass. Strategenköpfe* (1969).
Alkamenes: Robertson, 284ff.; Ridgway, *FC* 174ff.; W.H. Schuchhardt, *Alkamenes* (1977). Herms – D. Willers, *JdI* 82, 37ff.; A. Hermary, *BCH* 103, 137ff.
Agorakritos: see nn. to Chapter 11 (Rhamnus).
Kallimachos, dancers: Ridgway, *FC* 210ff.; Fuchs, *Vorbilder* 72ff.; Bieber, figs 495–507.
Lykios: L.H. Jeffery in *Stele* (Mem. N. Kontoleon, 1980) 51ff.
Strongylion: A. Raubitschek, *Dedications Ath. Acr.* (1949) 524f.

16 OTHER COPIES OF THE CLASSICAL

[*190–5*] M. Weber, *JdI* 91, 28ff.; Ridgway, *AJA* 78, 1ff., *FC* 244f. and E. Harrison in *Eye of Greece* (Studies M. Robertson, 1982) 79ff. – date; W. Gauer in *Tainia* (Fest. R. Hampe, 1980) 201ff. – purpose and setting; T. Dohrn, *JdI* 94, 112ff. – review; Bieber, figs 1–12; *LIMC* Amazones 602–7. [*190*] *Cat. New York* no. 37; Boardman, *AJA* 84, 181f. – belt. [*191*] Helbig 423. [*192*] Helbig 126; M. Weber, *JdI* 93, 175ff. – head

[196] R. Kabus-Jahn, AntPl XI; Ridgway, FC 192ff.; S. Karousou, JHS 92, 68ff. and AM 82, 158ff.; cf. Cat. Munich no. 15. [197] W. Fuchs in Fest. Schweitzer (1954) 206ff.; S. Karousou, AM 89, 151; Bieber, figs. 124–59; LIMC Aphrodite 225–40. [198] Helbig 2130; Cat. Terme I.2 no. 108; Ridgway, FC 243f.; Bieber, fig. 389f. [199] AvP VII no. 22; H. Bulle in Fest. Arndt (1925) 62ff. – Samos group. [200] Ridgway, FC 169f.; G. Despinis, Akrolitha (1975) 23ff.; LIMC Athena 172, M[...]ra 144. [201] Helbig 3243; G. Despinis, Symbole (1971) 146ff, – Ath. Itonia; LIMC Minerva 147. [202] Ridgway, FC 176f.; E. Harrison, AJA 81, 150ff.; cf. Cat. Munich no. 12; Bieber, figs 551–3; LIMC Athena 247, Minerva 146. G. Way-well, BSA 66, 376ff. – Athenas with Corinthian helmets. [203] Helbig 449; Bieber, figs 554–60; LIMC Minerva 154. [204] Waywell, op. cit. 376f.; LIMC Minerva 145. [205] ibid. 377; Bieber, figs 372–85; LIMC Athena 251–2, Minerva 149. [206] A. Preyss, JdI 27, 88ff. and 28, 244ff.; LIMC Minerva 148. [207] Ridgway, FC 234. [208] Ridgway, FC 186; J. Dörig, JdI 80, 24ff. – as Kalamis' Aphrodite; LIMC Aphrodite 140. [209] AvP VII no. 23; Ridgway, FC 186f.; LIMC Aphrodite 141. [210] Helbig 3342; Ridgway, FC 195f.; LIMC Aphrodite 149. [211] Helbig 1758. [212] Helbig 1387; Ridgway, FC 197f. [213] Cat. Berlin K5; Ridgway, FC 217; Bieber, figs 435–7; LIMC Aphrodite 174–81. [214] F. Poulsen, Cat. NyC no. 247; cf. Cat. Terme no. 139; Bieber, figs 160–71. [215] E. Bielefeld, AntPl XVII 57ff. – Ariadne; Ridgway, FC 217f.; LIMC Aphrodite 157 – Doria. [216] Ridgway, FC 116; E. Harrison, AJA 81, 276ff. – Alkamenes; S. Hiller, AK 19, 32ff.; Bieber, figs 438–40; LIMC Aphrodite 185, cf. 200 (Daphni: AntPl VIII 19ff.). [217] E. Bielefeld, RM 76, 96ff.; LIMC Aphrodite 243–5. [218] Ridgway, FC 230f.; E. Berger, AK 11, 67ff. [219] Helbig 3229; Ridgway, FC 234ff.; A. Delivorrias, AM 93, 1ff. – Alkamenes; LIMC Aphrodite 819f. [220] V.M. Strocka, JdI 82, 110ff.; cf. Cat. Munich no. 10; LIMC Aphrodite 822. [221] Ridgway, FC 112ff.; J. Dörig, JdI 80, 143ff. – Alkmene: S. Karousou, AK 13, 34ff. – Danae; Bieber, figs 33–5. [222] F. Eckstein, AntPl IV 27ff.; T. Kraus, Hekate (1960). [223] J. Inan, AntPl XII 69ff.; B. Freyer-Schauenburg, JdI 77, 212ff.; cf. Cat. Munich no. 16; P. Bruneau in Rayonnement grec (Homm. C. Delvoye,

1982) 177ff. – sceptical. [224] Cat. Munich no. 9; Ridgway, FC 183f.; W.H. Schuchhardt, AntPl I 35ff.; J. Dörig, Helvetia Arch. 14, 25ff.; H.v. Heintze, RM 72, 213ff. [225] Cat. Berlin no. 4; Ridgway, FC 237 – classicizing; J. Dörig, JdI 80, 177ff. – Kalamis. [226] Helbig 293; S. Karousou, AM 69/70, 67ff. and RA 1968, 131ff.; E. Harrison, AJA 81, 146ff.; N. Pharaklas, ADelt 21.A, 122ff. [227] Helbig 2326; Cat. Terme I.2, no. 28; Ridgway, FC 216ff.; S. Karousou, AM 76, 91ff. – psychopompos. [228] L. Curtius, Zeus und Hermes (1931) 20ff.; G. Despinis, Symbole 133ff.; cf. Cat. Munich no. 13. [229] Cat. Munich no. 11; E. Berger, AK 13, 89ff. – Myron, Samos. [230] P. Zanker, Klassicizist. Stat. (1974) 13ff. and Ridgway, FC 189 – classicizing. [231] D. Arnold, Die Polykletnach-folge (1969) 53, 169f. [232] Helbig 117; E. Berger, Quaderni ticinesi 11, 59ff. [233] Helbig 1759; Arnold, op. cit. 262f. [234] Monuments Piot 1, 115ff.; Zanker, op. cit. 26; S. Hiller, AK 19, 38ff.; cf. Cat. Munich no. 18 [235] Richter, PG 75ff. [236] E. Bielefeld, AntPl I 39ff. [237] Cat. New York no. 27; J. Frel, Bull. Met. Mus. 39, 170ff.; E. Langlotz, AA 1977, 84ff. – the wound a copyist's variant. [238] M. Weber, JdI 91, 89ff. [239] H. Götze, RM 53, 189ff.; Ridgway, FC 206ff.; H.A. Thompson, Hesperia 21, 47ff. – on altar; E. Langlotz in Festgabe J. Straub (1977) – on tomb ?; Cat. Berlin K186 [239.2] and cf. Helbig 1060; [239.3] Helbig² 1908 and E. Langlotz, AM 12, 91ff.; [239.4] Helbig 3247. [240] Helbig 304. S. Karousou, AM 69/70, 84ff.; E. Harrison, AJA 81, 265ff. [241] Cat. Munich no. 7; E. Buschor, Medusa Rondanini (1958); J.D. Belson, AJA 84, 373ff. and P. Callaghan, BSA 76, 59ff. – Hellenistic; F. Floren, Stud. zur Typ. des Gorgoneion (1977) – 4th cent.; Harrison, AJA 81, 162f. – for Athena in Hephaisteion. [242] Cat. Berlin K184–5; W. Fuchs, Vorbilder (1959) 91ff.; M. Tiverios, AE 1981, 25ff. [243] Fuchs, op. cit. 72ff.

17 CONCLUSION

Richter, PG 33f., 40 [245], 97ff. [246]; Ridgway, FC 178ff., 190f. J. Boardman, Greek Gems and Finger Rings (1970) pl. 466 and Burl. Mag. 1969, 591ff. [244]. [246] Robertson, 187f.; Ridgway, SS 99f., FC 179; A. Linfert, AntPl VII 87ff.; Helbig 3019.

INDEX OF ILLUSTRATIONS

Italic numbers refer to figures

248

INDEX OF ARTISTS

Italic numbers refer to figure captions

ACKNOWLEDGMENTS

The publisher and author are indebted to the museums and collections named in many of the captions for photographs and permission to use them. Other important sources of illustration have been:

German Institute, Athens 10, 27, 56, 58, 79(2,4), 80.4, 82.2, 86, 91.1, 107, 109(1,2), 119, 121, 137, 147, 150, 154, 156, 159, 162, 164–6, 168, 170, 178; German Institute, Rome 145, 196, 212, 219, 239.3, 246; American School of Classical Studies at Athens: Agora Excavations 32, 81, 105, 114.2–7, 115, 116, 118, 136, 138, 142; French School, Athens 17; Basel, Cast Gallery 79.3, 232; Bonn University 193; Chicago Oriental Institute 24; Alinari 34b, 38a, 42, 46, 57, 73, 97b, 109.3, 130.4, 143, 186a, 239.4; A. Frantz 20.5–6, 21(1,5), 23.6, 96.7; Hirmer Verlag 1, 20(1,7), 21(2,3,7,8), 23.3, 44–5, 50, 69, 71, 75–6, 80.2–3, 84, 91(2,5,6,8), 96(1,10,14,19), 134, 151–2, 157, 160, 179, 191, 194, 197–8, 202, 206, 211, 216, 221, 223, 226a, 227; L. Perugi 37, 38b, 39; Tombazi 175; M. L. Vollenweider 103; R. L. Wilkins 4, 8. 11, 31b, 47, 70, 74, 82.1, 97(3,18), 98, 101.2, 180, 182–3a, 185, 201, 207b, 208, 242b, 244–5; G. M. Young 35; Arts of Mankind *Front.*, 2, 20.4, 21.4, 23(2,4,5), 28–9, 33–4a, 36, 40–1, 43.3, 54, 60, 79(1,5), 80(1,5), 91(7,9,10), 96(9,17), 114.1, 115, 118, 124–5, 128.1, 130.1–2, 133, 135, 139a, 141, 144a, 163, 169, 181, 213, 243b; Author 5, 6, 20(2,3), 21.6, 26, 52, 62a, 67b, 88, 96(2,4–6, 12–3), 126, 132, 139b, 144b, 155, 161, 167, 174, 176, 186b, 189b, 190a, 225, 228, 231, 234, 237, 239.2

GENERAL INDEX
Italic numbers refer to figure captions